A HANDBOOK OF SYMBOLS IN CHRISTIAN ART

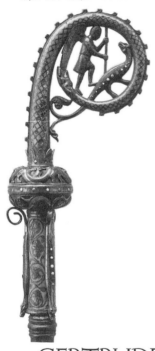

by GERTRUDE GRACE SILL

A TOUCHSTONE BOOK
Published by Simon & Schuster

TOUCHSTONE
Rockefeller Center
1230 Avenue of the Americas
New York, NY 10020

First Touchstone Edition 1996
First Collier Books Edition 1975

TOUCHSTONE and colophon are
registered trademarks of
Simon & Schuster Inc.

Manufactured in the United States of America

15 14 13

Library of Congress Cataloging-in-Publication Data

Sill, Gertrude Grace.
 A handbook of symbols in Christian art.
 Bibliography : p.
 Includes index.
 1. Christian art and symbolism—Handbooks, manuals,
etc. I. Title
N8010.S54 704.948'2 75-26560
ISBN 0-684-82683-6

Cover Illustration: Lucas Cranach the Elder. *Adam and Eve*,
16th cent. German. Courtauld Institute Galleries.
Lee Collection, London.

For all my family

CONTENTS

CONTENTS viii

TO THE READER

Labels identify but do not explain; the mute stones do not speak. Countless times, whether in a famous museum or a remote Romanesque church, I have desperately needed a small handbook of Christian symbols to consult. And so this book evolved, a basic reference guide for museum visitors, travelers, students, and laymen both at home and abroad.

Major cross-references appear in the text. However, the reader is urged to consult the Index for complete references. Space limitations having prohibited extensive quotations from Scripture, chapter and verse are cited in parentheses beside the appropriate subject. All biblical references are to the King James version of the Bible. The reader is urged to consult the biblical text for a better understanding both of the work of art under consideration and of the way the artist met the challenge of turning words into visual images. A selected bibliography is included for further research.

Please note that the abbreviation f.d., which appears with a date following the saint's name in the main entry for each saint, stands for feast day, the date set aside in the Church calendar to honor that specific saint, whose name is included in that day's mass.

G.G.S.

My special thanks go to A. Elizabeth Chase, Assistant Professor Emeritus, Yale University, an outstanding scholar in the field of iconography. Without her help and knowledge, this book would never have seen the light of day.

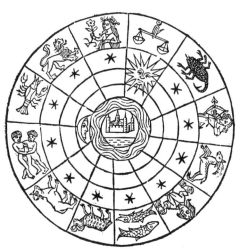

INTRODUCTION

Images are the essence of the visual arts. The purpose of this handbook is to acquaint the reader with basic images or symbols in Christian art, to illustrate and explain the constant themes that occur with variations throughout the history of Western art. Symbolism is the basic vocabulary of the subject matter in the visual arts, just as words are the basic vocabulary of language and notes are the basic vocabulary of music. (*Iconography* is the technical word for the study and identification of images. It originates with the Greek *eikon,* meaning image.)

The major themes in Christian art revolve around the Bible, Old Testament events and the life of Christ, the life of Mary, the lives and miracles of the saints. These themes, once so familiar, have become obscured by time and modern lack of acquaintance with the subject. This handbook attempts to simplify and clarify a complex subject, to reduce it to its most basic components.

In addition to creating impressive environments and beautiful objects, a major purpose of Christian art was to instruct, to inspire and solidify Christian faith. From its inception this art was didactic. Its purpose was to teach Christian lessons to a largely illiterate public, through precise and literal visual images. Chartres cathedral has been called a Bible in stone, because of the multiplicity of its sculptures illustrating events in the Old and New Testaments. The emphasis and composition of Christian imagery was not left to the artist, but based on principles established at the Council of Nicaea in 787 A.D., which stated that "execution alone belongs to the artist." The learned clerics who commissioned many great works of Christian art depended upon the literature of the period as well as the Bible, but it is the basic

themes and their identification that are considered here. Who is the small boy netting a fish and conversing with an angel? Why does the beautiful maiden serenely hold her two eyes on a platter? Why does Mary sometimes kneel and sometimes recline in Nativity scenes? The answers can be found here. The illustrations have been selected from the whole gamut of art to further emphasize the universality of the subject.

The study of iconography, and its offshoot iconology— the study of symbols in relation to a specific period— is part of the tapestry of history. Symbols can have many layers of meaning, can even be contradictory, varying from country to country and century to century. Their study is endlessly various and fascinating. This book is intended only as an introduction and invitation to explore one of the richest aspects of Western Art.

A HANDBOOK
OF SYMBOLS IN
CHRISTIAN ART

ANGELS
APOCALYPSE
APOCRYPHA
APOSTLES

ANGELS

Angels are God's heavenly messengers and companions, creatures of many kinds and colors who worship God in heavenly choirs. (The Greek *angelos* means messenger.) They link God with man and his earthly kingdom. Like man, they were created by God with free will, to be surrendered upon conception, when they must choose irrevocably whether or not to follow God. The followers become eternally good; the others eternally evil. In the Old Testament, angels constituted God's heavenly court. As His servants, they perform such earthly missions as guarding the entrance to the Garden of Eden after the Fall, protecting the faithful and punishing sinners, and primarily conveying God's messages to man. Cherubim and seraphim are especially prominent. They guard God's throne, decorate Solomon's temple, and were placed by Moses on the Ark of the Covenant, the sacred chest of the Jews representing God. In the New Testament, angels assist Christ at major events in his life from the Annunciation to the Ascension.

By the fourth century angels appear in art as men or youths in white robes, with wings and tunics. During the Middle Ages they may carry the Instruments of the Passion, grieving for the suffering Christ. Winged cherub heads, plump children with wings modeled after Cupid or Eros, appear generally with the Renaissance, the result of classic, pagan influence. Female angels also appear about this time, dressed in the latest fashion, an attempt to make angels more human and approachable. In *The Celestial Hierarchy*, written by Dionysius the Areopagite in the fifth century, angels were organized into nine choirs, or orders, based on the political organization of the Byzantine empire.

FIRST TRIAD, THE COUNSELORS

Thrones represent divine justice, and hold the staff of power and authority. Wearing robes, often colored green, they surround God's throne. They receive their glory directly from God, and bestow it on the second triad. Thrones often appear as winged wheels, the hubs of which are studded with eyes.

Cherubim or cherubs represent divine wisdom, intelligence, constancy. They are described in Ezekiel (1:5–14) as having four faces—a man's, a lion's, an ox's, and an eagle's—and four wings. Blue or yellow, they are composed of head, hands, feet, and six wings. Cherubim often alternate with seraphim.

Seraphim or seraphs represent divine love. Red, bodiless beings with six wings, they surround the Throne of God in perpetual adoration. Like cherubim, they probably evolved from the winged beasts that guarded the royal palaces of Egypt and Assyria. (*Seraph* in Hebrew means winged or fiery one.)

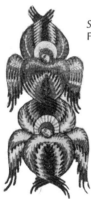

Seraphim,
Florence, Il Duomo

THE SECOND TRIAD

These are the angels of action, who control the stars and the elements.

Powers are warriors, often in suits of armor. As the victors over evil demons, they may carry garlands of flowers.

Virtues carry white lilies, for purity, or censers, sym-

bolizing pleas and prayers. They sometimes carry red roses, symbolic of the Passion of Christ.

Dominions are crowned angels, carrying scepters, croziers, or orbs as symbols of authority.

THE THIRD TRIAD

These are the messengers between man on earth and God in heaven, who execute the will of God.

Angels, guardians of the innocent and the just, carry wands.

Archangels carry swords and orbs as warriors of heaven. They are all saints. The four most prominent—Gabriel, Michael, Raphael, and Uriel—support the Throne of God.

Gabriel, the Angel of Mercy, ruled over Paradise with Michael. He appears as the angel of the Annunciation to Mary, usually holding a lily. He also announced the birth of John the Baptist to his father Zacharias. In the Old Testament, he appeared twice to Daniel. He is the mediator, the bringer of grace.

Archangel Michael, clad in armor and holding his attributes, the scales and sword, in the Last Judgment, is the warrior and judge—"he who is like God." It is he who defeated Satan and his hordes and drove them into Hell *(see Devil)*. The protector of soldiers and Christians in general, he is invoked in battle and during peril at sea.

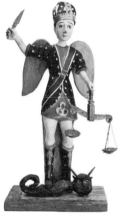

Saint Michael,
19th cent. American

Raphael, whose name means "God heals," holds a pilgrim's staff and a fish or dish. He was the guide of the young exiled Jew, Tobias or Tobit *(see Apocrypha).*

Uriel holds a book and scroll.

The other archangels are less prominent. Chamuel, who supposedly wrestled with Jacob, holds a cup and staff. Jophiel, holding a flaming sword, guards the gates of Eden. Zadkiel, brandishing a sacrificial knife, is supposed to have saved Isaac.

APOCALYPSE

The Apocalypse is the collection of visionary writings in Hebrew and early Christian literature which predict the end of the world. (The Greek word *apokalypsis* means uncovering or revelation.) They are revelations through visions, rather than through fact. While under oppression, the Jews developed the form with vivid imagery, to bolster up the courage of their people and convince them that they would emerge victorious. Old Testament apocalypses are the books of Ezekiel and parts of Daniel.

The last book in the New Testament is known as the Apocalypse of St. John the Apostle, or the Revelation of St. John the Divine, or simply The Apocalypse. It was written in Greek in 95 A.D. on the island of Patmos, where John was exiled by the Roman emperor Domitian "because I had preached God's word and born my testimony to Jesus" (Apoc. 1:9). The first three chapters of Revelations are messages of instructions and warnings to the seven bishops of the churches in Asia Minor. The rest are vivid, detailed visionary prophecies of what is to be, especially toward the end of the world. The Apocalypse was enormously popular during the Middle Ages, and supplied many images that occur frequently in Western medieval art, such as the Last Judgment tympanums at Chartres and Moissac. Among them are the Angel of the Lord appearing to St. John as he sits writing his book on the Isle of Patmos; Christ enthroned on a rainbow surrounded by the Four Living Creatures, the symbols of the four Evangelists; Christ above the

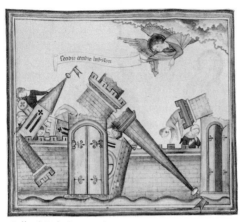

Fall of Babylon, 14th cent. German

Seven Lambs and surrounded by the Twenty-four Elders; the fall of Babylon with buildings and towers toppling in all directions; the Seventh Seal being opened and the seven angels given seven trumpets; the Sea of Glass mingled with fire; the new Jerusalem with twelve fountains of precious stones; the Lamb standing atop Mount Sion, from which flow the Four Rivers of Paradise; and the Four Horsemen—the first a king (Christ) on a white horse; the second a knight (War) on a red, or brown, horse; the third (Famine) on a black horse with a pair of balances in his hand; and the fourth horseman on a "pale horse and the name that sat on him was Death, and Hell followed him" (Rev. 6:2ff.).

In addition to the numerous medieval manuscripts illustrating the Apocalypse, produced in the thirteenth and fourteenth centuries, a great tapestry series was made in the fourteenth century for the cathedral of Angers in France. Albrecht Dürer published an Apocalypse in 1498 using brilliant full-page woodcut illustrations which can be contemplated independent of the text.

APOCRYPHA

Apocrypha are writings of doubtful authority or authorship. (The Greek *apokryphos* means obscure, hidden.)

The Old Testament Apocrypha consist of twelve books of history, philosophy, tales, and poetry. Relegated to a secondary part of the King James Bible, they were finally excluded in 1820. (They are still included in Vulgate and Douay versions and in all contemporary Catholic translations.) Art subjects from the Apocrypha include Tobias and the Angel, Judith and Holofernes, The Book of Daniel, and Susanna and the Elders.

TOBIAS AND THE ANGEL

Tobias was sent by his blind father on a long journey to collect a debt. Tobias and his dog were joined by the Archangel Raphael, incognito. At the River Tigris, Tobias, directed by Raphael, caught a fish. The two ate the fish and saved its heart, liver, and gall. When they arrived at the house of Sara, they burned the fish heart and liver in order to exorcise the demons afflicting her, who had forced her to kill all seven of her husbands on their wedding nights. Tobias courageously married Sara and returned with her to his father's house, where he applied the miraculous fish gall to his father's eyes and restored his sight. Tobias is usually represented carrying a fish, accompanied by his dog and the resplendent Archangel Raphael.

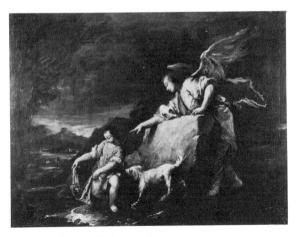

Guardi, *Tobias and the Angel*

JUDITH AND HOLOFERNES

Judith was a beautiful and patriotic Jewish widow who saved Bethulia from Nebuchadnezzar's army. She seduced Holofernes, the army commander, and visited him nightly in his tent. When he fell into a drunken sleep one night, she grabbed his sword and cut off his head (Jth. 13:7).

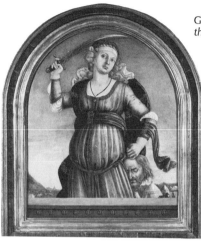

Giovanni, *Judith with the Head of Holofernes*

Greatly encouraged, the Israelites rallied and defeated the Assyrians.

Judith, richly dressed, is shown holding the head of Holofernes by the hair, or drops it into a bag held by her maid. She is not to be confused with Salome, who carries the head of her victim, John the Baptist, on a platter (*see John the Baptist*).

THE BOOK OF DANIEL

The Book of Daniel comprises a series of events in the life of the Old Testament prophet Daniel, a Jew living in the court of Nebuchadnezzar in Babylon. Faithful to his religion in the face of great obstacles, he is a brilliant interpreter of dreams and visions. Dramatic events in the Daniel story that appear in art are:

Daniel and the Men in the Fiery Furnace: Assisted by an angel, Daniel saved from the fiery furnace three recalcitrant companions, Shadrach, Meshach, and Abednego, who had refused to worship idols (Dan. 3:24ff.).

Bel and the Dragon: Daniel discovers that the priests are secretly eating the food left as offerings to the idol Bel. He reveals the fraud, the priests are punished, and the idol is destroyed. The dragon, too, is worshiped as a god; Daniel slays him, and is thrown into the lions' den.

Daniel in the Lions' Den: As punishment for praying to God instead of Nebuchadnezzar, Daniel was thrown into the lions' den. An angel sent by God closed the lions' jaws and Daniel escaped unscathed (Dan. 6:14ff.).

The Handwriting on the Wall: During King Belshazzar's feast, Daniel interpreted the "handwriting on the wall," explaining that the words *mene, mene, tekel, upharsin* foretold the fall of Babylon to the Medes and Persians in 539 B.C., which would be the end of Belshazzar's kingdom (Dan. 5:5ff.).

SUSANNA AND THE ELDERS

Susanna, a virtuous wife of Babylon, aroused the lust of two evil old men who accosted her when she was preparing to bathe in the privacy of her garden. They threatened her with public accusation of adultery if she would not submit to them. She refused, and was brought to trial and condemned to death. Daniel intervened and discovered conflicting evidence in the elders' stories.

Benton,
Susanna and the Elders

Susanna was subsequently freed, and the elders were condemned. This story, from the Old Testament apocrhyphal book of Susanna, was interpreted as a moral tale of an innocent soul saved from evil injustice.

APOSTLES

The Twelve Apostles were the disciples closest to Christ, who became his prime missionaries and were sent forth to preach the gospel. (The Greek word *apostolos* means messenger or envoy.) The number 12 corresponded to the twelve tribes of Israel. The Apostles are often symbolized as a group of twelve doves, twelve sheep, or twelve men with twelve sheep. The Apostles may also be represented as a group of twelve men clustered around Christ, or they stand at either side of Christ as He presents Peter with the law of the Church. They may also surround Christ as He sits on a throne atop a mountain, from which flow the Four Rivers of Paradise. According to the New Testament the Apostles saw the risen Christ and thereby confirmed the Resurrection. The Apostles wear long, flowing tunics, with the pallium, a mantle, slung over their shoulders. They may carry scrolls inscribed with the Apostles' Creed as well as their specific attribute.

An Apostle is one who "had seen the Lord" and had been sent by Him to spread the Good News. Traditionally the Twelve Apostles include Matthias and not Judas; conversely the Disciples include Judas but not Matthias. All the Apostles are saints, with individual attributes, but are seldom individually identified unless the Apostle is designated as a specific patron.

Andrew (1 cent., f.d. Nov. 30) was a fisherman and the first called follower of Christ. He brought his brother Simon, afterward Peter, also a fisherman, to follow Christ. Although he is mentioned several times in the gospels, later accounts of his life are unreliable. Because of the effectiveness of his preaching he is said to have been arrested by a Greek governor and martyred on a X-shaped (saltire) cross at Patras. His attribute is the

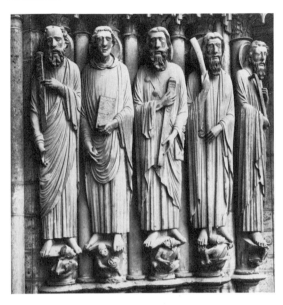

Apostles, Chartres Cathedral, 13th cent. French

saltire cross, or occasionally a fish. He is the patron saint of Scotland, fishermen, and sailors.

Bartholomew (1 cent., f.d. Aug. 24). Little is known of him except that he was called to be one of the Apostles. He has been credited with spreading the gospel in India and Armenia, where he was later flayed alive by the barbarians. He may hold a human skin over one arm, a reference to the flaying. His attribute is a curved knife.

James the Great (1 cent., f.d. July 24) was a fisherman and brother of St. John. (He is called the Great to distinguish him from the other Apostle, James the Less.) He was selected by Christ, along with John and Peter, to be witness to the Transfiguration and Agony in the Garden *(see Jesus Christ)*. The first of the Apostles to be martyred, James's confession was so convincing that his accuser, King Herod Agrippa, a Jew, was converted, and the two were beheaded together.

According to legend, St. James the Great drove the Moors from Spain and established the Christian religion there. Upon his return to Judea he was beheaded. His body was returned to Spain, and lost until the year 800

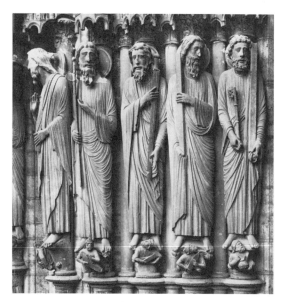

Apostles, Chartres Cathedral, 13th cent. French

when it was taken to Compostela, where a great shrine was built to him. Many miracles were attributed to St. James the Great, known as Santiago in Spain, and his church became one of the most famous pilgrimage centers in Europe. In art he is often dressed as a pilgrim, with wide-brimmed hat, purse, walking staff, and gourd. His attribute is the scallop shell, which may adorn his hat or his purse. He may occasionally be riding a horse and carrying a banner.

James the Less (1 cent., f.d. May 1). Identity is questionable. According to legend he was a relative of Christ and was the bishop of Jerusalem. He was martyred there by being stoned and beaten to death after imploring the Jews from the pinnacle of the Temple to believe in Christ. The Epistle of St. James in the New Testament is commonly attributed to him. His attributes are a fuller's club or hat. (Fulling was a process used to finish cloth by beating.) He may sometimes hold a saw, as it was also believed that he was martyred by being cut in two.

John called the Divine (c. 100, f.d. Dec. 27). *See Evangelists.*

Judas Iscariot (1 cent.) is the disciple who betrayed Christ. Probably not from Galilee, he may have felt himself an outsider among the disciples. His job was to handle the finances. At Bethany, when he upbraided Mary, the sister of Martha, for using all her ointment on Jesus' feet, Jesus rebuked him (John 12:4–6). At the Last Supper Jesus indicated that Judas would betray him. (In representations of the Last Supper Judas usually sits at the front of the table, divided from the other disciples.) "Verily, verily I say unto you, one of you shall betray me" (John 13:12). Judas accepted a bribe of thirty pieces of silver, the price of a slave, from the chief priests and disclosed Christ's presence in the Garden of Gethsemane. During the Passion, as Christ was being led to trial, Judas betrayed him with a kiss (Matt. 26:47ff.; see *Jesus Christ: the Betrayal*). After the trial, Judas repented, threw the silver on the floor of the temple, and went out and hanged himself with a rope. The chief priests used the money to buy a potter's field. His attributes are a rope or a money purse.

Jude (1 cent., f.d. Oct. 28) is also known as Thaddaeus "the brave one" or Lebbaeus (John 24:22; Matt. 10:3). He is thought to be the author of the New Testament Epistle of Jude, and the brother of James the Less. He is reputed to have preached throughout the Middle East, accompanied by St. Simon Zelotes. They were martyred together in Persia, St. Jude by being pierced by a lance or beheaded by a halberd, a long-handled axe. His attribute is the lance or club. He is the patron saint of the desperate and of causes despaired of.

Luke (1 cent., f.d. Oct. 18). *See Evangelists.*

Mark (1 cent., f.d. Apr. 25). *See Evangelists.*

Matthew (1 cent., f.d. Sept. 21). *See Evangelists.*

Matthias (1 cent., f.d. Feb. 24). After the Ascension, Matthias was chosen by lot to replace Judas Iscariot (Acts 1:15–26). According to Greek legend, he converted the Cappadocians and others along the Caspian sea, possibly working with savages. Stoned and then beheaded, his attribute is an ax or an open Bible, a reference to his missionary zeal.

Paul (b. Tarsus ?; d. Rome c. 67 A.D.; f.d. June 29). Paul usually has a long face and straight beard, "small, bald, bow-legged." Originally named Saul, a Jewish tentmaker, he was violently anti-Christian, and passively witnessed the stoning of St. Stephen. En route to Damascus to agitate anti-Christian feeling, Saul was struck blind by a heavenly light and heard a voice cry, "Saul, Saul, why persecutest thou me?" (Acts 9:3ff.) Led into Jerusalem, he was converted there and baptized Paul. After a period of repentance in the desert, he returned to preach in Damascus, where he was forced to escape his Jewish enemies by being lowered over the city walls in a basket. The greatest Christian missionary, he made trips to Asia Minor and Greece and is known as "The Missionary to the Gentiles." Arrested in Jerusalem, he was sent to Rome and imprisoned; his activities are related in the Acts of the Apostles, and he is the author of the Epistles of St. Paul. Eventually he was martyred by beheading, supposedly at the site of the Tre Fontane in Rome—where his head hit the ground, three fountains miraculously sprang up. His body was buried in St. Paul's Outside the Walls. He and St. Peter, with whom he often appears, are considered the real founders of the Christian church,

St. Paul on the Road to Damascus, and Escaping from the City in a Basket, 12th cent. Sicilian

and share the same feast day. St. Paul is often depicted with a sword, an attribute referring to his martyrdom and militant Christianity, or with another attribute, a book or scroll of his Epistles.

Peter (d. Rome 64 A.D., f.d. June 29), the major spokesman for the Apostles, was chosen by Christ as he and his brother Andrew were plying their nets on the sea of Galilee: "Follow me and I will make you fishers of men" (Matt. 4:18ff.). He is generally represented with short thick hair and beard. Jesus changed his original name of Simon to Peter, meaning rock. "Thou art Peter and upon this rock I will build my church" (Matt. 16ff.). During the Passion his loyalty to Christ was followed by denial and later deep repentance. Christ forgave him, and appeared first to Peter at the Resurrection. As related in The Acts of the Apostles, Peter boldly and faithfully led the Christians in Asia, and may have been the first bishop of Antioch. Later leader of the Christian community in Rome, he was martyred under Nero, possibly crucified upside down at his request since, with great humility, he did not want to be crucified the same way as Christ. His body traditionally rests beneath the main altar of St. Peter's in the Vatican. His attributes are two crossed keys, "the keys of the kingdom," and he often wears papal robes and tiara; a cock is another attribute, because of his denial of Jesus when the cock crowed (Matt. 26:75). He is the patron saint of bakers, butchers, and clockmakers. (*See also Jesus Christ.*)

Philip (1 cent., f.d. May 1) appears mainly in the miracle of the Feeding of the Five Thousand (John 6:5) and at the Last Supper (John 14:8–14). He was also present at the gathering of the Apostles in Jerusalem after the Ascension (Acts 1:13). Supposedly a missionary to Scythia, he was martyred there in the city of Hierapolis. Philip rid the city of a great serpent which the people had been worshiping; the dreadful stink left by the serpent killed many people, including the king's son. Aided by a cross, Philip brought the son back to life. For his trouble the priests of the serpent cult martyred him. His attributes are a staff topped by a cross, three loaves of bread, or a great serpent.

Simon (1 cent., f.d. Oct. 28), called the Zealot, may have been one of the shepherds to whom the angels revealed the birth of Christ at the Annunciation to the Shepherds. Traditionally, he and St. Jude, with whom he shares a feast day, preached in Persia and were martyred there. He was either crucified or sawed in half. His attributes are a large saw or cross, or a book with a fish on it, signifying a fisher of men through the Gospels.

Thomas (1 cent., f.d. Dec. 21) is best known as "Doubting Thomas" because of his skepticism concerning the Resurrection. "Unless I see and touch I will not believe" (John 11:16ff.). After putting his fingers in the open wound of Christ's side he was convinced. He similarly doubted the Assumption of the Virgin, and was finally convinced when Mary lowered her belt, or girdle, down from Heaven to him *(see Mary: Assumption)*. Thomas was a man of great courage, and once convinced of the faith, he is supposed to have spread the Gospel as far as India. While there, he was commissioned by the king to build a great palace, but instead he gave the money to the poor. The enraged king promised revenge. Gad, the king's brother, died and ascended to Heaven, and there chose a great heavenly palace to inhabit. The angels denied him the palace, explaining that it had been prepared by Thomas for his brother the king. God related this to the king in a dream, whereupon the king set Thomas free. Thomas explained that by distributing faith and charity in this life one could build up a treasure in Heaven. Because of this legend, Thomas's attribute is a carpenter's rule or square. He is the patron saint of architects, carpenters, and geometricians.

Other incidents in the lives of the Apostles popular in art are the Sending Out of the Apostles by Christ to preach the gospel, or a procession of Twelve Apostles juxtaposed to a procession of the twelve Old Testament Prophets, causing the prophecy of the Old Testament to become reality in the New. The Twelve Apostles are appropriately included in New Testament events such as the Last Supper, the Ascension, and the Pentecost. *(See also Evangelists.)*

BEASTS

The Bestiary is a moralizing natural history of ancient origin, based on the Greek *Physiologus*. It rivaled the Bible in popularity during the Middle Ages, and is divided into three categories: Beasts, Birds, and Reptiles and Fishes. A standard book used by medieval artists, the Bestiary was an important influence in many areas of medieval art.

The original forty-nine beasts described in the Greek *Physiologus* grew to over a hundred in this "naturalist's scrapbook." Moralizing parallels were drawn between the animals and their human counterparts. When animals are used in combination, they are selected to complement each other by their specific strengths.

The Peaceable Kingdom represents the earthly paradise which the prophet Isaiah foretold with the coming of Christ: "The wolf shall dwell with the lamb, and the leopard shall lie down with the kid; and the calf and the young lion and the fattling together; and a little child shall lead them" (Isa. 11:6ff.). The illustration on the facing page depicts this image.

Apes and **monkeys** generally symbolize the baser forces, such as sin and lust. The monkey is often represented as a devil in disguise. When Satan appears as an ape bound in chains, he is the personification of evil being conquered by good.

The **ass** or **donkey** is the most docile, humble (even stupid), stubborn, and long-suffering of animals. The ass and the ox commonly appear in Nativity scenes, indicating that even the simplest and humblest of the animals recognized the Savior.

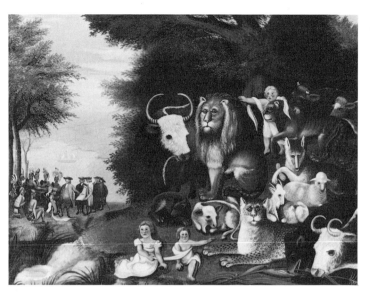

Hicks, *The Peaceable Kingdom*

The **basilisk** is a fabulous conglomerate, a winged animal formed with the three-crested head of a cock and the body of a lizardlike serpent with a three-pointed tail. It is said to have been born of a yokeless egg laid by a cock, hatched by a toad on a bed of dung. It is a symbol of the devil.

The **bee** appears as a symbol of industry, creativity, and wealth, because of the busy organization of its life and its ability to make and store honey. Honey represents wealth and sweetness. During the Romanesque period bees were symbols of eloquence, and the beehive became an attribute of the great preachers, Bernard of Clairvaux and St. Ambrose. It is also used as a symbol for the Christian Church, a united community where all work in harmony.

Because of its "magical" ability to fly, the **bird** represents the soul, or spirit. It appears in Egyptian art in this role, as a bird with a human head, the spirit flying away from the body at the time of death. Many birds have symbolic meanings based on both physical and behavioral characteristics (*see names of specific birds*).

Because of its life cycle, the **butterfly** is a Resurrection symbol. It is a symbol of eternal life, of metamorphosis, the butterfly breaking out of the pupa and soaring toward heaven in a new and beautiful form.

The **cat** is noted for its independence, its quiet, graceful movements, its acute senses. Because of its passivity it is a symbol of laziness; because of its fecundity, a symbol of lust. A black cat is associated with evil and death.

Wild and unruly disciple of Dionysus, god of wine, and of Eros, god of love, the **centaur** embodies qualities of both man and horse; he is swift and sure of foot, lustful, and strong like the horse, but like man he has both intelligence and emotions, can both think and weep. With this schizophrenic make-up the centaur can represent man against himself, passion struggling with reason, good with evil. Centaurs are frequently archers. Savage and uncouth, they symbolize bodily excesses, adultery, heresy.

St. Anthony Abbot, one of the hermit saints, once received directions from a friendly centaur, which pointed its leg in the direction of St. Paul the Hermit's cave. This event often appears in paintings illustrating the saint's life.

The **cock,** alert and crowing at sunrise, is a symbol of vigilance. Linked with St. Peter, the cock represents Peter's denial of Christ, and his subsequent awakening and repentance. The cock drives away robbers, an-

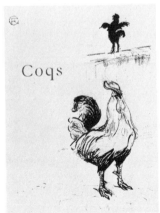

Toulouse-Lautrec,
Coqs

nounces daybreak, and alerts the faithful to work and prayer, a resurrection after the stillness of the night. Appropriately, he appears on weather vanes and at the top of high towers. The cock may be included in the Instruments of the Passion.

The **dog** was probably the first domesticated animal. As a symbol of fidelity, it is often placed at the feet of women on medieval tombs or included in marriage portraits. The dog also symbolizes the priest who guards, guides, and protects his human flock. (*See also St. Dominic, St. Roch.*)

The **dolphin** is a graceful, gregarious mammal related to the whale. Because of its strength and swiftness, the dolphin symbolizes resurrection and salvation, carrying the souls of the blessed across the river to the Island of the Dead. When combined with an anchor, another symbol of salvation, it signifies controlled speed or prudence. When combined with a trident, it becomes a symbol of the Crucifixion.

The **dove** is the symbol of the Holy Ghost, or Holy Spirit (John 1:32). The dove appears in the baptism of Christ, the descent of the Holy Spirit at Pentecost, and at the Annunciation. From the eleventh century onward, the dove may wear a cruciform halo. The dove becomes a peace symbol, with the olive branch in its mouth, from its role in the story of Noah's Ark (Gen. 8:11). As a symbol of purity, the dove is offered as a sacrifice in scenes of the Purification or Presentation in the Temple. The Seven Gifts of the Holy Spirit—"the spirit of wisdom and understanding, the spirit of counsel and might, the spirit of knowledge, of godliness, and the fear of the Lord" (Isa. 11:2)—are personified by seven doves in medieval art. Twelve doves represent the Twelve Fruits of the Holy Spirit—"charity, joy, peace, patience, benignity, goodness, long suffering, mildness, faith, modesty, continency, chastity" (Gal. 5:22–23).

The dove as an attribute appears with several saints, representing the importance of the Holy Spirit in their lives, most particularly St. Gregory, St. Thomas Aquinas, St. Scholastica, and St. Hilarius. The dove by its nature

symbolizes simplicity and gentle affection. In general usage, the dove also symbolized the human soul. When it is seen issuing from the body—as in *The Dormition of the Virgin*—or from the lips of saints, the dove is the soul leaving the body at death. Doves pecking at bread or drinking from a fountain represent the soul nourished by the Eucharist. (*See also Jesus Christ: Pentecost.*)

The **dragon,** common in both East and West, is a composite winged beast with lion's claws, eagle's wings, a serpent's tail, and fiery breath. Violent and dramatic, the dragon is a symbol of Satan and evil. It kills either by blows of its tail or by winding itself around its victim. The mouth of Hell is often shown as a great open, flaming dragon's mouth, devouring the souls of the damned.

Vanquished and under foot, the dragon is the attribute of Sts. Michael Archangel, Margaret, Martha, George, and others who have slain dragons as symbols of evil.

The **eagle** is the symbol of the soaring spirit. According to legend the eagle rejuvenates itself by flying into the circle of the sun and singeing its wings, thereby renewing its plumage, and clearing its dimming eyesight, then returning to earth revitalized and renewed. The eagle therefore becomes a symbol of the Resurrection and of the Christian spirit. The eagle is the attribute of St. John the Evangelist, whose gospel begins with a statement of the divine nature of Christ. John's spirit soared to great heights as he composed his gospel. The eagle incorporated into the design of a church lectern represents the general inspiration of the gospels. (*See also Evangelists, Apocalypse.*)

The Greek initials for Jesus Christ, God's Son, Savior, spell out the word *fish* in Greek (*ichthus*), and the **fish** is the oldest Christian symbol of Christ, used by the persecuted early Christians to identify themselves as believers. To the uninitiated the fish was merely a decoration; to the persecuted Christian it was a secret sign of his faith. The fish is sometimes used as a symbol of baptism, since water is essential for the life of the fish, and baptism is essential for the life of the redeemed Christian. A fish as a symbol for Christ may appear on the table in the

Last Supper. The fish is also an attribute of Tobias (*see Apocrypha*).

The Apostles Peter and Andrew were fishermen, and a single fisherman is a symbol of Christ. The fish he catches refer to the faithful, and a fisherman's net becomes a symbol of the Church. A fish in the hand of St. Peter can have a triple meaning: he was a fisherman, he was converted to Christianity, and he was a Christian apostle—a fisher of men. As a general attribute, it is attached to those renowned for converting and baptizing.

The common **fly** represents a bearer of bad tidings, pestilence, and evil, and is a symbol of sin. In Madonna and Child compositions, it is the evil that Christ will overcome.

The **goldfinch** nests in thorny plants and thrives on prickly vegetation. Thorns being an allusion to the Crown of Thorns and hence the Crucifixion, the goldfinch has evolved as a symbol of the Passion. In the hand of the Infant Christ, the goldfinch is prophetic of the Passion.

The **grasshopper** or **locust** represents the forces of destruction, a reference to the plague of locusts that defoliated Egypt because the Pharoah would not believe the word of Moses (Exod. 10:14ff.).

The **griffin** is an imaginary animal whose front half is an eagle, hind half a lion, and tail long and serpentine. Because of its ambivalent make-up the griffin can represent either Christ, as a fierce guardian of good, a savior, or the anti-Christs, those who persecute Christians with the brutality of the lion and the power of the eagle. In general, it is an emblem of valor popular in medieval design and heraldry.

The **hind, hart,** or **stag** is a symbol of the faithful Christian longing for God (Ps. 42:1). As symbols of solitude and purity of life, hinds often appear in pairs drinking from the flowing waters of Paradise. The stag is an attribute of Sts. Eustace and Hubert, to whom it appeared miraculously. The hind spoke with St. Julian, and a wounded doe hypnotized hounds hunting him and the hermit, St. Giles.

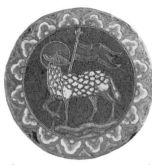

Lamb of God,
12th cent. French

The most common animal symbol in Christian art, the **lamb** as a sacred sacrificial animal originates in antiquity and appears frequently in the Old Testament. As directed by Moses from the word of God, the lamb is the Jewish sacrifice eaten at the Passover before the Jews fled from Egypt. The blood of the lamb, smeared on the doors of the Israelites, protected the first born of the families from the angel of death. This is the ancient foundation for the lamb as a Christian symbol (Exod. 12).

The lamb was an ideal symbol for the early Christians to represent Christ and His sacrifices to save mankind. The lamb reclining is the wounded flesh; standing, he is the Church triumphant. A lamb holding a cross with blood pouring out of its side into a chalice is the Agnus Dei, the Lamb of God. It symbolizes the crucified Christ and the Eucharist. A lamb holding a staff with a banner, decorated with a cross, represents the Resurrection and Christ as the Redeemer (John 1:29). A lamb sitting on a book sealed with seven seals is the Lamb of the Apocalypse (Rev. 5:12).

The lamb standing on a mountain from which four rivers flow is another reference to the Apocalypse (Rev. 14:1). The lamb on the mountain is Christ, the mountain his Church, the rivers the Four Gospels or Rivers of Paradise. A frieze of twelve lambs may represent the Twelve Apostles; a large group of sheep represents Christians. The lamb as a symbol for Christ usually wears a cruciform halo as identification of its divinity (*see Halo*). It can stand alone or be enclosed in a triumphal wreath.

When the lamb is combined with the human figure of Christ as the Good Shepherd, the lamb represents the sinner who is rescued by Christ (Luke 15:4).

The lamb is the attribute of John the Baptist (John 1:29), and refers to John's recognition of Christ as the Savior when he baptizes Him in the Jordan. It is also a reference to John's role as the forerunner of Christ and the spreader of the "good word" of the Gospels. The lamb often appears with the young John the Baptist in scenes of the Holy Family.

In general the lamb by its nature represents purity, innocence, and docility, as well as a sacrificial victim, and can be used to symbolize the virtues of temperance, prudence, and charity. (*See also St. Agnes, St. John the Baptist.*)

The **lion,** "King of Beasts," attained this role because of his majestic bearing, strength, fortitude, valor, and courage. He is the earthly counterpart of the eagle, lord of the skies. St. John the Evangelist likens him to Christ (Rev. 5:5).

Legendarily, lion cubs in litters of three were born dead. After mourning for three days, their father revived them with his breath. In like manner, Jesus, after having been dead three days, was resurrected by his Father. The lion is thus used as a symbol of the Resurrection.

The lion is always on guard, for it is said that he sleeps with his eyes open (Ps. 121:4). Vigilant protectors, lions are placed at the entrances to churches and castles.

When unbridled pride and fierceness are intended, the lion becomes the evil symbol of Satan (Ps. 91:13).

The lion is the attribute of St. Jerome, and the winged lion represents St. Mark (*see Doctors of the Church, Evangelists*). In general, the lion represents fortitude and resolution (this is his role when placed on tombs at the feet of soldiers who had lived with great courage).

The **mermaid, siren,** or **harpy** is a mythological creature whose upper half is a beautiful female torso and bottom half a scaly fish with single or double tail. Traditionally, their enchanting song lures sailors to sleep so that their vessels founder on the rocks. The mermaids then pounce upon the sailors and tear them to bits. Mermaids, either bird-women or fish-women, appear as the eternal symbol of the seductive temptations of life that must be overcome in order to achieve salvation. The mermaid is

also thought to be the symbol for woman, creature of the earth, as opposed to man, the son of Heaven. The mermaid is able to ride the crest of waves while serenely combing her long hair and preening before a mirror.

The **owl,** bird of the night and darkness, symbolizes death, night, cold, solitude. (It also represents wisdom and appears as an attribute of scholarly saints.) Unable to bear the brightness of the sun, the owl may be a symbol for the Jews, who rejected Christ when He came to save them. The owl, according to legend, is very canny and wary, able to entice other birds into the traps set for them by hunters. In this role it becomes a symbol for Satan.

The **ox** or **bullock,** like the lamb, is a sacrificial animal frequently referred to in the Old Testament, and becomes a general symbol for the Jewish people. With the ass, it is a traditional attendant at the Nativity. The ox is a metaphor for patience, strength, docility, and humility. It will willingly submit to the yoke to plow the fields of its master. In this role it represents Christ the Redeemer, or the multitude who without complaint labor diligently for the good of others (Matt. 11:30). The winged ox is the symbol of St. Luke (see Evangelists). (See also Jesus Christ: Nativity.)

The **peacock** is the symbol of immortality, originating in the legend that its flesh is so hard that it does not decay. The haunting wail of the peacock in the night was likened to Christians' crying out to God for help. The "hundred eyes" of the peacock's splendid tail are likened to the all-seeing Church. The feathers of the peacock's tail renew themselves with ever-increasing brilliance—an allusion to resurrection.

The **pelican** is excessively devoted to its offspring. According to legend, young pelicans flap their wings so violently in the faces of their parents that the father pelican, in anger, kills them. The mother then pierces her breast and revives her children with her own blood. Thus the pelican represents an angry, vengeful God punishing His children, but later repenting and granting them salvation (Ps. 102:6). It also, in feeding mankind with its life-sus-

taining blood, represents the Eucharist. (This concept became popular in the Middle Ages, as a result of the mystical writings of St. Gertrude of Helfta, who in a vision saw Christ in this form.) The pelican is sometimes nesting, atop a cross, or near the Crucifixion, representing atonement.

Phoenix, 12th cent. English

The **phoenix** is a mythical bird of great beauty, similar to the eagle but with the head of a pheasant. It was able to live for over five hundred years; when it began to feel old, it built its own funeral pyre of scented twigs in the direct sun, ignited by fanning it with its wings. A small worm was left among the ashes, which within three days developed into another phoenix. The phoenix became a popular symbol for the Resurrection of Christ, the triumph of life over death.

Because of its black color, its guttural, croaking voice, and its habit of scavenging, the **raven** is often associated with evil, the Devil, and death. In another context, the raven is a positive symbol as an attribute of hermit saints, bringing them bread to sustain them in the wilderness (*see St. Anthony Abbott*).

The **snake** or **serpent** is the symbol of wisdom. It also represents evil, and Satan, who tempted Eve in this sinuous form (Gen. 3:1). In Eden the serpent is wound around the trunk of a tree, pointing its head to the apple. It sometimes has a woman's face. A snake with its tail in its mouth, making a circle, represents eternity.

The snake equates with evil and death because of the

venom of its tongue and its ability to strike quickly, si-
lently, and mortally. Traditionally, the snake sheds its
skin annually and emerges with regained youth, once
again able to seduce the unsuspecting.

A serpent wound around a cross is a symbol of Christ
crucified, in reference to the Old Testament story of
Moses and the Brazen Serpent (Num. 21:8).

A serpent with an apple in its mouth encircling the
globe is a symbol of the sin of man which Mary con-
quers with the Immaculate Conception. Mary stands on
top of the globe trampling the serpent beneath her feet.
It was believed that all snakes stayed in their holes on
August 15, the Feast of the Assumption of Mary.

A small snake emerging from a chalice is an attribute
of St. John (see Evangelists).

The **spider** also is synonymous with evil and Satan. The
spider entices the fly into its web, as the Devil traps the
unsuspecting. It is also the symbol for the miser, who
bleeds the life force from those indebted to him. The
delicate and fragile spider web, made out of thin air, is
likened to the fragility and weakness of human nature.

The **stork** arrives in northern Europe at the end of winter,
announcing the coming of spring as the Annunciation
announced the impending arrival of Christ to Mary.
Storks are also symbols of the virtues of prudence, filial
faithfulness, and piety.

The **swallow,** according to legend, hibernates during the
winter in the mud of riverbeds. Because of this habit, it
has become a symbol of spring, the Resurrection, and
the Incarnation of Christ.

The **unicorn** is an ancient mythical animal. Small, swift,
and white, with the body of a horse, it has the beard of
a goat, and a long, single, fluted horn growing from its
forehead. Honorius of Autun, a French seventh-century
theologian, describes the unicorn as "the very fierce
white animal with only one horn. . . . In order to catch
it, a virgin is put in a field; the animal then comes to her
and is caught because it lies down in her lap. Christ is
represented by this animal, and his invincible strength by
its horn. He who lay down in the womb of the Virgin

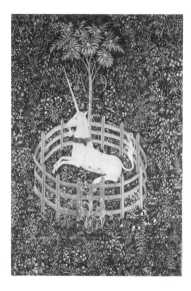

*The Unicorn
in Captivity,*
15th cent. French

has been caught by the hunters; that is to say, he was found in human shape by those who loved him." The unicorn represents the Annunciation and Christ. Alleged unicorn horns were highly prized for their magical properties; ground "unicorn" horns produced a medieval miracle drug, purifying poisons and curing many ailments. A general symbol for purity and chastity, the unicorn is an attribute of virgin saints.

In Christian art the **whale,** the "great fish" of the Old Testament story of Jonah (Jon. 1:17; 2:1, 10) became a symbol of the Resurrection. In early Christian art it is also a symbol for salvation for those who keep their faith in the Lord.

The whale is also likened to the Devil, who draws unbelievers into the depths of Hell. Jonah described the interior of the whale as "the belly of Hell" (Jon. 2:2). Sometimes its great open mouth is used to represent the jaws of Hell.

In general, the whale is symbolic of containment and concealment.

**CHURCH
COLOR
CROSS**

CHURCH

Church, von der Kurst Perspectiva, 16th cent. German

The church is the house of God, the visible symbol of the Church spiritual and invisible. Medieval theologians recognized God as "the best and greatest architect" and made symbolic use of church design: a cathedral floor plan in the shape of a cross; twelve columns representing the Twelve Apostles; seven open bays on a facade standing for the Seven Sacraments; a grouping of three windows symbolizing the Trinity.

The church as a place of salvation can be represented as a boat, or a triumphal chariot. (The word *nave* comes from the Latin *navis,* ship.) The Church Triumphant appears as the Pope, or as a crowned woman carrying a banner, a cross, or a chalice. The Church Triumphant juxtaposed to the defeated Synagogue symbolizes the triumph of Bethlehem over Jerusalem, Christianity over Judaism.

As an attribute, when a saint holds a church building in his hand, it is a reference to the saint's role as founder of a specific church, or its first bishop (*see Doctors of the Church*).

COLOR

Color has been used symbolically by all civilizations. In Christian art, color operates on two basic levels: its inherent characteristics, for example, red, the color of hot coals and fire; and its emotional connotations, i.e., red equals heat, passion, suffering. Color may have opposite symbolic meanings, depending on the context. Red may represent love, as in the cloak of St. John the Evangelist, a man of action and great love of God, or sin, as a red cloak worn by the Devil: yellow can mean glory when worn by St. Peter or Joseph, cowardice when worn by the traitor Judas.

Black is the emblem of mourning, penance, and death. It is a negative color, denoting the negative qualities of evil, death, and the underworld. Black combined with white, as in the religious habits of the Dominicans and Carmelites, connotes penance, humility, and purity of life.

Blue symbolizes heaven, spiritual love, truth, constancy, and fidelity. Appropriately, blue is Mary's color.

Brown and **gray,** lifeless colors, the color of ashes, are used in religious habits to signify mortification, mourning, and humility.

Green represents hope, regeneration, and fertility. As spring follows the dead of winter, so does life triumph over death. It is the color of victory, as in the palm and the laurel.

Purple or **violet** is the color of sorrow and penitence. It may also signify love and truth. The Virgin wears a violet robe after the Crucifixion.

Red is associated with passion, blood, and fire; it is the color of love and hate, of power and action, of sin and suffering. In church hangings and vestments it is used, appropriately, in masses and services relating to the Passion, the Apostles, and martyrs, as well as during the week of Pentecost. Red and black are the colors of purgatory and the Devil. Rubies or other red stones set in

the four terminals of an ornamental cross and at the center signify Christ's wounds at the Crucifixion.

White or **silver** represents light, innocence, purity, joy, virginity, faith, and glory. Christ always wears a white robe after the Resurrection. Mary wears white in the Assumption. White is prescribed for Christmas, Easter, the feast of the Ascension, and other joyous celebrations in the Church, as well as for services related to the Blessed Sacrament, feasts of Mary, of angels, confessors, virgins, and women who were not martyred. It is the color of vestments worn from Holy Saturday until the feast of Pentecost. White vestments were worn at burial services for children, as well as at marriage ceremonies and the nuptial mass. The traditional bridal white is an allusion to purity and virginity, an outgrowth of the Roman custom of white robes for Vestal Virgins. When worn by a judge, white indicates integrity; by a rich man, humility; by a woman, chastity.

Yellow or **gold** is symbolic of the sun and the color of God and divinity. Gold is the image of solar light and divine intelligence. It is the color of marriage, of faith, of fruitfulness. Yellow is the color of illuminated truth, truth removed from the shadows. In a negative sense, yellow signifies deceit, jealousy, instability, cowardice, or treason. Yellow was the color of heretics and nonbelievers in the Middle Ages. Judas often wears yellow.

Light and **brightness** are equated with superior spirit and intelligence, with divinity and holiness. A direct source of light in a painting, such as a candle, often suggests a divine presence, as in the Annunciation. In the Bible light is used as a symbol of goodness and wisdom, a positive force, while darkness is the personification of evil and ignorance, a negative force. (*See also Halos.*)

CROSS

The cross is a universal emblem for Christ and Christtianity. To the Christian it represents salvation, but it appeared on Indian cave walls and in Egyptian tombs long before the birth of Christ. It represents a combination of

opposites: the positive (or vertical) with the negative (or horizontal), life with death, the spiritual (vertical) with the worldly (horizontal).

The cross can be seen throughout the Christian world, from elaborate, gem-encrusted gold altar ornaments to simple wayside calvaries, in handsome stone marketplace crosses, and in the basic floor plan of Christian churches. The cross is sometimes likened to the Tree of Paradise or the Tree of Life, the *arbor vitae,* and as *lignum vitae* is depicted with knots, bark, and flourishing branches.

Crosses important in Christian art are the Latin cross and its variations, and the crucifix.

LATIN OR ROMAN CROSS

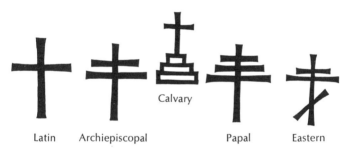

Calvary

Latin Archiepiscopal Papal Eastern

This form, commonly used in scenes of the Crucifixion, symbolizes the Passion, and is a universal attribute of all followers of Christ (Mark 8:34). Latin crosses include the Archiepiscopal, Calvary, Papal, and Eastern crosses.

The **Archiepiscopal cross,** for patriarchs and archbishops, has two crossbars, the upper shorter than the other, alluding to the inscription over the head of the crucified Christ.

The **Calvary cross** is the Latin cross set on a pedestal of three graded steps, which stand for faith, hope, and love.

The **Papal cross,** attribute of Popes and papal saints, is the Latin cross with three graduated, ascending bars.

The **Eastern cross** is the archiepiscopal cross with a short, slanting crossbar at the base, suggesting Christ's footrest (in the Eastern Church, Christ was crucified with his feet together, not crossed).

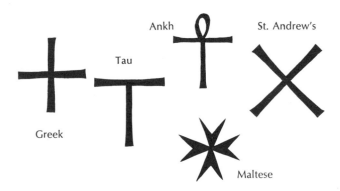

The **Greek cross,** with arms of equal length, is the basic floor plan of many churches.

The **Tau cross** (Old Testament Cross) is based on the Greek letter *tau,* or T. According to legend, this form was used by the Israelites to mark their identity in blood on their doorposts during the Passover. It is thought that Moses raised the brazen serpent on a pole shaped like a tau cross. A variation, sometimes called the Egyptian ankh or *crux ansata,* is a tau cross with a looped handle. The Coptic Christians living in Egypt used it frequently and believed it to have special protective power. It is the amuletic cross of the Western world, worn by the sick in the hope of recovery from illness.

St. Andrew's cross is shaped like an X (*see Apostles: St. Andrew*).

The Celtic cross has a circle at the crossing of the horizontal and vertical bars. It is also called the Cross of Iona, as it was probably taken from Ireland to the Island of Iona in the Irish Sea in the sixth century by St. Columba. It appears throughout Europe at crossroads and marketplaces, made of local stone and often handsomely carved with scenes of the Passion.

The Maltese cross, composed of four spearheads with points together, originated during the Crusades, when the Hospitalers used it as their emblem. It is the insignia of the Knights of Malta, the highest order of the Roman Catholic Church.

CROSS IN COMBINATION

A Latin cross surmounting the orb or globe is the **cross of triumph,** symbolic of the triumph of Christianity throughout the world.

A Latin cross surmounting an obelisk alludes to the triumph of Christianity over the pagan world.

The crown and the cross combined refer to the faithful who shall be rewarded in heaven.

The Infant Christ holding a cross is a prophecy of his destiny, the Crucifixion.

A cross and chalice relate to the Agony in the Garden.

Crosses as attributes are borne by many saints (*see Saints*).

CRUCIFIX

The crucifix is a Latin cross with the body of Christ attached to it. In early Christian art the Crucifixion was represented by the Latin cross alone, but by the fifth century the body of Christ was painted on the cross, and later became sculpture attached by four nails, one in each hand and foot.

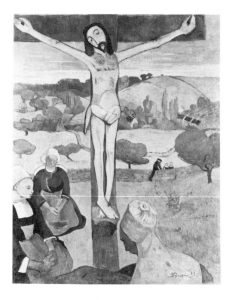

Gauguin, *The Yellow Christ*

DEATH
DEVILS AND DEMONS
DOCTORS OF THE CHURCH
DONORS

DEATH

Death is the creature of night, robed in black, personified by a skeleton or mummified corpse, often carrying a scythe. The Book of Revelations portrays death as one of the Four Horsemen on a pale horse *(see Apocalypse)*.

A very popular theme in the late Middle Ages was the Dance of Death *(Danse Macabre)*, in which Death, in the shape of a lively skeleton or mummified corpse, leads his victims through a procession or dance in which both living and dead take part. This theme appears in sculpture, frescoes, painting, woodblock prints, tapestry, and other mediums.

When a skull or death's head or a skeleton appears with a living person, it is a *Memento Mori,* a reminder of death, of the perishable and transitory quality of life. A skull with wings suggests death's swiftness; crowned by a laurel wreath, the triumph of death. Another symbol of death is the hourglass: as the sand flows from the upper globe to the lower, so time and life flow inexorably. The figure of Death is often merged with that of time.

DEVILS AND DEMONS

The Devil is the concept of evil personified. Jews and Muslims as well as Christians acknowledge the existence of Satan, the supreme spirit of evil, the spiritual enemy of man, the rival of God. (Satan in Hebrew means "adversary.") Originally Satan was one of the major angels in Heaven, chief of the Seraphim, head of the order of Virtues. When he rebelled against God and fell from power, many lesser angels went with him who are called

devils. These fallen angels, usually pictured as demons who accompany Satan, are inhabitants of Hell, the torturers of the damned. Their population varies as well as their appearance, but their power to deceive, torture, and destroy is inflexible.

Satan assumes many guises, from the snake who tempted Adam and Eve to a fierce, many-headed giant, covered with eyes and spouting fire, to a basilisk, or to a dragon.

The medieval imagination excelled at producing Devils of vast and varied horrors. He can be a red manlike figure, with horns, a tail, and cloven hooves for feet, carrying a pitchfork. He appears in Last Judgment and Temptation compositions as a sinister winged figure. The Devil may also appear in temptation scenes disguised as a woman or a monk.

Other symbols of Satan are the raven, because of its color and appetite for decaying flesh; the leopard, because of its stealthiness and cruelty; the fox, for its cleverness and guile; and the spider, which weaves its web for its victim as the Devil plans deceptions to trap the innocent.

Archangel Michael is the warrior saint in charge of the heavenly host of angels who defeated Satan and his hordes (Rev. 12:7). He is shown dressed in armor, slaying the dragon with a large sword, or holding the scales in which the souls of the dead are weighed for judgment (*see Last Judgment*).

DOCTORS OF THE CHURCH
(FOUR CHURCH FATHERS)

These titles have been given to Sts. Ambrose, Augustine, Jerome, and Gregory the Great, who were all distinguished for their wisdom, sanctity, and theological learning. Four dignified figures, they appear holding books inscribed with their major works. St. Ambrose and St. Augustine wear the robes and miters of bishops, St. Gregory those of a Pope, and St. Jerome those of a Car-

dinal. Key incidents in their lives and their attributes may also identify them.

Saint Ambrose (c. 334–397, f.d. Dec. 7) was born in Gaul, the son of a Roman prefect. Educated in Rome, he was appointed governor of provinces in northern Italy, whose capital was Milan. The area was full of unrest because of the conflict between the new Christianity and Arianism, a cult whose followers believed that God had created Jesus Christ simply as a divine creature, neither God nor man. Ambrose was able to pacify the two factions, and was chosen bishop by popular demand in 374, even though he was not yet baptized. A gifted preacher and peacemaker, his primary concern was with the people. He was a great administrator, statesman, theologian, musician, and poet.

St. Ambrose is usually shown with the robes and accouterments of a bishop, and may hold a scourge in his hand, symbolic of his driving the Arians out of Italy. Another attribute is the beehive, an allusion to his eloquence, his "honeyed words," or a scroll engraved with music. He is the patron saint of beekeepers and domestic animals.

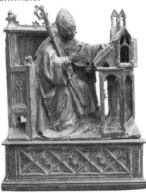

St. Ambrose or Augustine, 15th cent. French

Saint Augustine (354–430, f.d. Aug. 28) was the most influential theologian of the early Church, second only to St. Paul in importance. Son of a pagan father and a Christian mother, St. Monica, he was reared as a Christian, although not baptized. After study in Carthage and Rome he became a master of rhetoric. In Rome he led a wild life, and sired a son to whom he was devoted. In Milan,

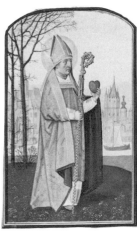

St. Augustine,
14th cent. Flemish

he came under the influence of St. Ambrose, who helped him resolve his spiritual and temporal conflicts, and baptized him and his son. He returned to North Africa and was appointed Bishop of Hippo. A voluminous writer, his most famous works are his *Confessions,* a classic of mysticism, a beautifully written autobiography of his spiritual conversion, and *The City of God,* a view of society and its transformation to new directions by Christianity.

He is a patron saint of theologians and scholars, and often appears in bishop's robes and miter, talking to a small child who, with a small spoon, is trying to put the sea into a hole he has dug. Told by Augustine that his efforts were impossible, the child replied, "Not more impossible than for thee, O Augustine, to explain the mystery on which thou art now meditating." Another attribute may be the book and pen, or a heart, whole or aflame, broken or pierced, which he holds in his hand. The heart is his primary attribute, suggesting his piety and love of God.

Saint Gregory the Great (540–604, f.d. Mar. 12) was born in Rome of a wealthy patrician family, and served as a magistrate there. He gave both land and funds for the foundation of monasteries in Sicily, and became a monk at thirty-five. He turned his Roman palace into a monastery, served as a papal representative in Constantinople, and was elected Pope by popular acclamation in 590.

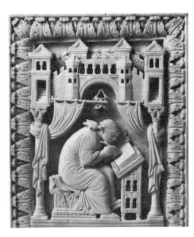

St. Gregory,
10th cent. German

Defending Rome against vandal hordes, he preserved the city and established the independence of the papacy as a temporal as well as a spiritual power. He crystallized the role of the Pope and called himself "the servant of the servants of God." He was a great theologian, statesman, teacher, and administrator, and composer of the Gregorian chant. His major works are the book on pastoral duties, *Regula Pastoralis* (Pastoral Care); the *Moralia,* a lengthy commentary on the book of Job; and the *Dialogues,* relating holy visions and miracles of his time.

In art he wears papal robes and the triple tiara, holding a crozier with the papal cross. His major attribute is the dove, which is sometimes shown hovering near his ear, supplying him with divine inspiration for his writings. *The Mass of St. Gregory* shows him as Pope celebrating mass in front of an altar on which Christ appears surrounded by the Instruments of the Passion, shedding his blood in a sacrificial chalice, a mystical event in his life. He is the patron saint of musicians. (*See also Church.*)

Saint Jerome (c. 342–420, f.d. Sept. 30) was the most learned of the Doctors of the Church. Born in Dalmatia of Christian parents, he was educated in Rome. His life was divided between scholarship and asceticism, between the Holy Land and Rome. His major work was the translation of the Bible into Latin, which came to be known as the Vulgate version.

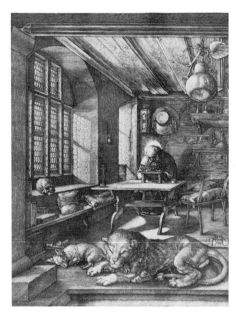

Dürer, *St. Jerome in His Study*

St. Jerome appears in art as an old man, bearded and ascetic. He is portrayed as a hermit in the desert praying before a crucifix, holding a stone with which to beat his breast, or as a scholar writing in his study with his cardinal's hat in view and his lion at his feet. The lion, according to legend, limped one day into the monastery, terrifying all the monks except Jerome, who calmly removed a thorn from the beast's paw. Jerome's attributes are the lion, the cardinal's hat, and the Vulgate Bible held in his hand. He is the patron saint of students.

DONORS

Donors were patrons who commissioned a specific votive work of art, and can usually be identified kneeling in prayer, focusing on the central action of the painting. The specific donor may be accompanied by his wife, his family, or his patron saint, and is often drawn on a smaller scale than the central religious figures.

EARTH AND THE ELEMENTS
EUCHARIST
EVANGELISTS

EARTH AND THE ELEMENTS

The four basic elements were incorporated into Christian thought and art and given allegorical meanings appropriate to their individual characteristics. Fire and air are the ethereal elements, earth is the solid element, and water is the transitional element. The planet earth itself, symbolized by a globe or a human being supporting a weight, is man's physical realm. As a symbol for the Church, the globe, like the Church, provides man with the spiritual nourishment and protection for his faith.

Ashes and dead coals symbolize penance and the transitory nature of life. Repentent sinners donned sackcloth and rubbed themselves with ashes to demonstrate their denial of worldly things. On Ash Wednesday, the beginning of Lent, a smudge of ashes is smeared on the forehead.

Fire is symbolic of religious fervor and martyrdom. Flames, tongues of fire, appeared above the heads of the Apostles during Pentecost, representing the presence of the Holy Ghost (Acts 2:3). (*See Jesus Christ: Pentecost.*) As a saintly attribute, flames suggest religious fervor, or the method of martyrdom. Flames are an attribute of St. Anthony of Padua, patron saint of firemen. St. Lawrence, who was grilled to death, sometimes wears a flaming tunic.

Gold is the symbol of power, of the sun, of Heaven. It is also a symbol of worldly wealth, the material prized above the spiritual. Religious objects were fashioned of gold because of its rarity and its likeness to the color of the sun.

Precious stones, because of their intrinsic value, are

likened to the rare and precious qualities of Christianity and its promise of Redemption. The color of the stone can be significant, as rubies symbolize the blood of Christ.

The **rainbow** is a symbol of union, since it appeared in the sky after the Flood to reassure Noah of God's forgiveness. In general, it is a symbol of God's pardon and forgiveness of man for his sins. A rainbow is used as the throne of the Lord in art, and Christ sits upon it, as described in Revelations 4:2–3 (*see Apocalypse*).

Four **rivers** emerging from one rock represent the four sacred rivers of antiquity or the Four Rivers of Paradise —the Pison, the Gihon, the Tigris, and the Euphrates— and are symbolic of the four gospels which flow from Christ to nourish the faithful who drink from them.

Rocks are symbolic of the Lord, of His solidity, firmness, and strength.

Smoke is ephemeral; it suggests the transitory.

Silver is like the moon, pale and luminous. Because it has to be refined and purified by fire, silver is associated with purity and chastity.

The **sun,** the life-giving force, is symbolic of Christ. It supplies light and heat and is the source of great energy and riches; therefore it symbolizes glory, spirituality, and illumination. The color that corresponds to the sun is gold or yellow. The **moon** symbolizes the passage of time and life; its color is silver.

The Virgin Mary has both the sun and the moon as attributes (Rev. 12:1). A crescent moon alone is a more frequent symbol for Mary; it appears beneath her feet to suggest that she is eternal, above the transitory phases of the moon and its regulating powers. In paintings of the Immaculate Conception, Mary stands on the crescent moon. When the sun and moon appear in the sky at Crucifixions, they refer to the sorrow of all the earth, those in day and those in night, at the death of Christ.

Water, because of its cleansing properties, is symbolic of

purity and innocence. In baptism, water washes away the sins of the past and prepares the baptized Christian for the Last Judgment (see Seven Sacraments). John the Baptist baptized Christ and his many followers by immersion in the River Jordan. The immersion symbolized a return to the original state of grace, with rebirth and regeneration to follow.

The act of washing or accessories of water and washing are themselves symbolic of innocence. Pilate washed his hands while proclaiming his innocence (Matt. 27:24). (See Instruments of the Passion.)

A fountain is a symbol of salvation, inspired by the Old Testament "fountain of life" or the Book of Revelation (Rev. 22:1). During the late medieval period, this concept was enlarged to incorporate the crucified Christ as a living fountain. Blood flows from his wounds into a chalice of the kind used during Mass to contain the wine of the Eucharist.

In paintings of the terrestrial Paradise, a fountain is frequently in the center, the source from which the four rivers flow. (Sometimes they flow from the base of the Tree of Life.) They flow north, south, east, and west. Water gushing forth represents a life force. A fountain in a Romanesque or Gothic cloister or patio occupies the central focal position. The four fonts, from which the water perpetually flows, represent the Four Rivers of Paradise. The water from them falls into a circular or octagonal basin symbolizing the universe. This kind of architectural symbolism was particularly popular during the Romanesque and Gothic periods.

The well, like the fountain, represents baptism, rebirth, and the other qualities associated with water. Three wells, or fountains, grouped together, are an attribute of St. Paul, whose head hit the ground in three places after his martyrdom by beheading. In these three places three fountains, or wells, miraculously appeared.

Symbols relating to water, such as the basin and ewer or pitcher, the fountain, the well, or a transparent vase, are also associated with the Virgin Mary, and allude to her virginity and purity (see Mary).

In its negative aspect water signifies tribulation (Ps. 69:1–2), as illustrated by the Flood.

EUCHARIST

The Eucharist, or Holy Communion, is the most sacred of all Christian sacraments, instituted at the Last Supper. Symbols of the Eucharist are grapes and wheat. The grapes allude to the wine which turns to blood during the sacrament of communion; the wheat or grain relates to the bread or host, the body of Christ. When the Infant Christ holds a bunch of grapes, it is prophetic of His Passion. Similarly, a sheaf of wheat in Nativity or Adoration scenes foreshadows the mission of Christ as savior of mankind.

Manna, or small hostlike rounds of bread, appearing on rays emanating from the hand of God, are also symbolic of the Eucharist. The parallel refers to the Old Testament miracle in which God helped the Israelites, exiled in Egypt, when they were lost and starving in the wilderness, by giving them manna to eat (Exod. 16:14–15).

A basket of bread, or manna, combined with a fish is another symbol of the Eucharist. (*See also Seven Sacraments, Jesus Christ.*)

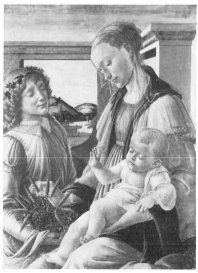

Botticelli, *The Madonna and Child of the Eucharist*

EVANGELISTS

The four Evangelists—Matthew, Mark, Luke, and John —are the authors of the four Gospels in the New Testament, which bear their names. (The word *evangelist* means "bearer of good news." The word *gospel* comes from the Anglo-Saxon "god-spell," i.e., the life of Christ with His message of redemption.) The earliest symbols for the Evangelists, also saints, are four scrolls placed in the angles of a Greek cross, or four books, the books of the Gospels. Later the Four Rivers of Paradise, or four fountains, which flow from a mountain on which Christ stands, symbolize the good news. The Four Creatures, later attributes of the Evangelists, originate in the mystical vision of Ezekiel (Ezek. 1:5ff.) as a composite four-sided creature made up of a lion, a calf, a man, and a flying eagle, known as a *tetramorph* (Rev. 4:6–8). Tetramorphs may hold a book and stand on a wheel.

The authorship of the first Gospel is ascribed to **St. Matthew** (1 cent., f.d. Sept. 21) who is supposed to have written it in about 85 A.D. for his fellow Jews in Egypt and Ethiopia or Persia. He was present at the Ascension.

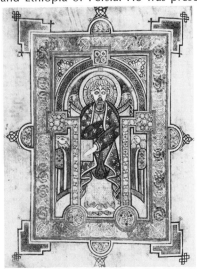

Matthew,
Book of Kells,
9th cent. Celtic

His symbol is the winged man, or angel, since his gospels trace the genealogy of Christ and emphasize Christ's immortality and humanity to his fellows. Other attributes may be the sword or ax by which he was martyred, or a purse for tax money. Matthew (Levi) was the tax collector who left his post to follow Christ, and is the patron saint of bankers and tax collectors (*see also Jesus Christ*).

The Gospel of **St. Mark** (1 cent., f.d. Apr. 25) begins with the words "the voice of one crying in the wilderness" (Mark 1:3), which is likened to the lion's roar, and emphasizes Christ's royal dignity, which was like that of a

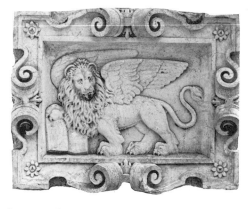

*Lion of
St. Mark,
16th cent.
Italian*

lion. Mark is associated with the lion at the Throne of God mentioned in Revelation and Ezekiel.

Mark was thought to be the son of a prosperous woman in Jerusalem named "Mary the mother of John, whose surname was Mark" (Acts 12:12). She was a friend of Christ, and the Last Supper may have taken place at her house. Mark is also thought to have been the young man who ran away naked from Christ when he was arrested in Gethsemane.

Mark is thought to have been the spokesman for St. Peter, who converted him and called him his son, and with whom Mark spent much time in Rome, as well as on missionary journeys. Named Bishop of Alexandria by Peter, Mark met his martyrdom there by being dragged through the streets by a rope tied around his neck. His presumed relics, stolen from Alexandria, were installed

in the original Church of San Marco in Venice. Venice claimed them because Mark once took refuge in its lagoons during a storm, and an angel appeared to him and said, "On this site a great city will arise in your honor." He is the patron saint of Venice, and his symbol, the winged lion, is its emblem. He is sometimes portrayed in bishop's robes. He is also the patron saint of notaries and glaziers.

St. Luke (1 cent., f.d. Oct. 18) is believed to be the author of the Gospel that bears his name as well as of the Acts of the Apostles. Probably born in Antioch, Syria, of a prosperous Greek family, he was trained as a physician. His Gospels were written about 90 A.D., and are the most poetic and beautiful of all. St. Paul, whom Luke accompanied on his missionary journeys, called him "our beloved Luke the Physician," and refers to him in his letters as "my only companion." Traditionally Luke was also a fine painter, and produced portraits of Mary and Jesus, though none survive. He is often portrayed as an artist painting the Virgin and Infant Christ, or holding a portrait of the Virgin in his hand. His attribute is a winged ox, a reference to the beast in

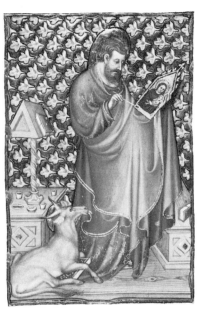

St. Luke Painting the Virgin,
15th cent. Italian

the Book of Revelation. A sacrificial animal, the ox relates to the emphasis Luke's Gospels place on the atonement of Christ. The ox represents Christ's sacrifice. St. Luke is the patron saint of artists, physicians, butchers, and goldsmiths.

St. John (1 cent., f.d. Dec. 27) the Evangelist is considered the author of the Gospel that bears his name, three epistles, and the Book of Revelation (the Apocalypse). John was the youngest Apostle, the brother of James the Great, both sons of Zebedee. They were fishermen, and were called by Christ to follow him and preach his gospel. Jesus named them "the sons of thunder" because of their quick tempers. John may be the unnamed "disciple whom Jesus loved"; in the Last Supper he is the figure who leans his head on Christ's shoulder. He was chosen along with Peter and James to

Poussin, *St. John on Patmos*

be witness to the Transfiguration of Christ and his Agony in the Garden. In groupings of the Apostles, John is usually shown as a beardless young man with fair hair, in a prominent position near Christ. At the foot of the

Cross during the Crucifixion he comforts Mary. He helped place Christ's body in the tomb. Later he took Mary into his home, and cared for her for the rest of her life. It was also John who found the empty tomb on the day of Resurrection.

After Mary's death, John joined Peter and preached throughout the Middle East. The Book of Revelation begins with his letters to the Seven Churches of Asia Minor. He was tortured by Emperor Domitian, who first tried to boil him in a cauldron of oil, then tried to kill him with a cup of poisoned wine. Both attempts failed: John miraculously emerged unharmed from the cauldron, and the poison evaporated from the wine in the form of a snake. (The cauldron and the cup with a snake emerging are both his attributes.) He was exiled as a sorceror to the Greek isle of Patmos, where he wrote the visionary Book of Revelation, the Apocalypse. When this event is recorded, John is shown as a bearded old man, writing in a classical landscape, often with the eagle by his side. The eagle is his attribute, a reference to the soaring majesty and inspiration of his writing as he contemplates the divinity of Christ.

He is also called St. John the Divine, meaning the Theologian.

**FLOWERS
FRUITS**

Flowers and fruits, products of the earth, suggest the cycle of life, death, and resurrection in the round of the seasons. Flowers, springing from seed, suggest perpetual rebirth, and promise of fulfillment in the fruits of autumn. In Christian symbolism the essence of the flower—its growing characteristics, its shape, color, its scent—coordinate to make a unified whole. Yellow flowers relate to the sun and its force. Red flowers denote passion, the life force, blood, and suffering. White flowers reflect purity and innocence. Blue and purple flowers express truth, constancy, and fidelity. Often flowers and fruits are purely decorative. However, when they figure prominently in the main composition, or embellish the borders of a painting or a medieval Book of Hours, they usually make a specific symbolic reference.

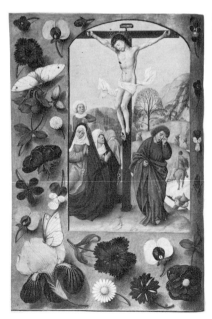

Hours of Ferdinand V and Isabella of Spain, 15th cent. Belgian

Botanical symbolism flourished during the Middle Ages. The Virgin Mary, described by St. Bernard of Clairvaux as "the violet of humility, the lily of chastity, the rose of charity," is often represented in an enclosed garden carpeted with spring flowers, a reference to the conception of Jesus which traditionally is associated with spring—the flower willed in the time of flowers to be born of a flower. Devotions during the Middle Ages connected plants and flowers with the Virgin Mary. They are still evident in the names of plants with the prefix Lady, such as Lady's slipper or Lady's smock. The garden itself is a symbol of nature disciplined, subdued, enclosed, and contained, as opposed to the wildness of the forest or the barrenness of the desert.

The enclosed or walled garden is another symbol of the Virgin, originating from the Song of Solomon, "A garden enclosed is my sister, my love" (Song of Sol. 4:12). In *De Virginibus*, a book devoted to the Virgin, St. Ambrose describes the enclosed garden of holy virginity, where "grow, smell, and shine the vines of piety, the olives of peace and the red roses of chastity."

FLOWERS

The **anemone** is a symbol of death and mourning. It suggests illness and decline. Supposed to have miraculously sprung out of the ground during the Crucifixion, the anemone often appears as a botanical detail at the foot of the Cross. Some botanists have concluded that the biblical "lilies of the field" were in fact a species of anemone that grows profusely in the Holy Land.

The **bluebell** signifies luck, and when suspended above the threshold promises that "all evil things will flee therefrom."

The **carnation,** or pink, is a symbol of pure love, and is believed to have originally sprung up from the tears shed by Mary on her way to Calvary. It became the symbol of motherly love, and in modern times is sold by florists for Mother's Day. The pink also became a sym-

bol of fidelity and marriage, and appears often in betrothal or marriage portraits. During the fifteenth century the carnation was also a popular symbol of Christ or the Virgin. It also represented the nails driven into Christ's hands and feet during the Crucifixion, from its fragrance, like that of the nail-shaped clove.

The **clover** has long been a symbol of both good and evil. A four-leafed clover is good luck; a five-leafed clover, bad. Like all trefoils, the clover also stands for the Trinity.

The **columbine** is a symbol of sorrow, because of its deep blue-purple color. A bunch of seven columbines refers to the Seven Sorrows of Mary. Its name comes from a word meaning dovelike, because of its wing-shaped flower, and thus it becomes a botanical emblem of the Holy Ghost. In a positive context, the columbine stands for the Seven Gifts of the Holy Spirit: "power and riches, and wisdom, and might, and honor, and glory and blessing" (Rev. 5:12).

The **daisy** symbolizes simplicity and innocence, and is known as the "eye of God."

A **flowering rod** or branch is similar to a tall lily stalk topped with flowers. It is an attribute of St. Joseph (*see Mary*).

Forget-me-nots exemplify fidelity in love.

Holly, like all thorny, prickly plants, is a symbol of the Passion and a specific reminder of the Crown of Thorns, and like all evergreen suggests eternity. The red berries relate to Christ's blood and suffering.

Iris, the sword lily in Latin, appears in portrayals of Mary as a prophetic symbol of the Crucifixion, and sometimes replaces the lily in paintings dramatizing an event in the life of Mary.

Laurel, an evergreen, represents immortality. A laurel crown or branch symbolizes triumph and victory, a classical tradition embraced by Christianity. An attribute of the Vestal Virgins of Rome was a laurel branch, in this connection symbolizing chastity.

The **lily** has long been a symbol of purity, innocence, and immortality, and is the major botanical symbol of Mary. It consistently appears in Annunciation compositions, either in a vase or in the hand of the angel Gabriel. (It is his attribute as well.)

The **lily-of-the-valley** is also a symbol of the Virgin and the Immaculate Conception, both for the purity of its white color and for the sweetness of its scent.

Myrtle, a symbol of peace and love, is sometimes entwined with orange blossoms in wedding wreaths. Myrtle represents the Gentiles who were converted by Christ (Zech. 1:8).

The **pansy** appears mainly in connection with the Virgin. It is a botanical symbol for remembrance and reflection.

Primroses are also called "keys of Heaven," or St. Peter's keys.

In Christian art, the **white rose** is a symbol of purity, the gold or **yellow rose** a symbol of impossible perfection and papal benediction, and the **red rose** a symbol of martyrdom. The rose is a frequent symbol for the Virgin Mary, who is called a "rose without thorns" since she was free of original sin. This may refer to St. Ambrose's legend that the rose grew, without thorns, in the Garden of Eden. After the Fall, it became an earthly plant, and the thorns appeared as a reminder of man's sins and fall from grace. The scent and beauty remained as a poignant reminder of the lost perfection of Paradise.

The five petals of the wild rose are equated with the five joys of Mary and the five letters in her name Maria. The Christmas rose, a hardy white flower with five petals that blooms at Christmas when the rest of the garden is dormant, is a symbol of the Nativity and the coming of the Messiah. The Rose of Jericho, or Rose of the Virgin, also known as the Resurrection plant, is supposed to have sprung up wherever the Holy Family stopped during the Flight into Egypt. It is said to have blossomed at the Nativity, closed at the Crucifixion, and reopened at Easter.

On the rosary, the Joyful Mysteries, those relating to

the happy events in Mary's life, were white roses; those relating to her suffering, the Sorrowful Mysteries, were red; and the Glorious Mysteries, the triumphant events, were symbolized by the yellow or golden rose. The rosary can be considered a symbolic wreath of red, white, and yellow roses. (See *Religious Objects: Rosary*.)

Wreaths of roses crowning angels, saints, or the redeemed in Heaven are symbolic of their heavenly joy. (See also *St. Dorothy, St. Elizabeth of Hungary*.)

Because of its habit of growing close to the ground, its blossoms drooping in shyness, the **violet** is the flower of humility. (See also *Strawberry*.)

FRUITS

Fruits and vegetables are often used purely for decoration. However, when a specific fruit or vegetable is an integral part of the composition in Christian art, it may also have a symbolic significance. Like flowers, fruits and vegetables suggest the cycle of nature: fruits contain the seeds for the new generation and are general symbols for the abundance of the harvest, for fertility, and sometimes for earthly desires. (The egg is also a symbol of fertility.) Fruits can have the added dimension of relating to the twelve "fruits of the spirit" in Christianity: love, joy, peace, long suffering, gentleness, goodness, faith, meekness, patience, modesty, temperance, and chastity. A combination of peaches, pears, and cucumbers symbolizes good works in general.

The **almond** and the almond blossom are symbolic of sweetness and delicacy. The mandorla (*mandorla* means almond in Italian) is the name given the oval halo that encloses the body of Mary or Christ. The almond is a sign of divine approval, originating in the Old Testament story of the miraculous blossoming of Aaron's rod, signifying Aaron as God's choice to be priest of the Lord (Num. 17:8).

The **apple** is mainly associated with Adam and Eve and the Fall. Traditionally the forbidden fruit on the Tree of

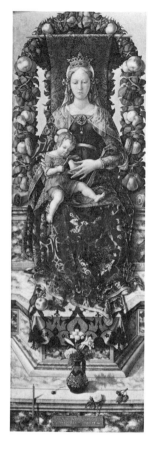

Crivelli, *Madonna and Child,*
15th cent. Italian

Knowledge in the Garden of Eden was an apple, a
botanical impossibility, as apples were not known in
the Holy Land. The fruit may have been an apricot—
apple of gold—or a fig. The Latin word *malum* means
both apple and evil, which may be the origin of the
apple symbol. When Adam and Eve are shown with the
apple, it is a symbol of their disobedience and of original
sin, of indulgence in earthly desires and sensual plea-
sures. Conversely, when near or held by Mary or the
Christ Child, the apple signifies acceptance of man's sins
and salvation. Mary is looked on as the second Eve and
Christ as the second Adam: Christ and Mary take away
the original sin of the first Adam and Eve and restore to
man the promise of eternal life.

The **cherry** has been called the fruit of Paradise because of its beautiful red color, its round shape, and the sweetness of its ripened fruit. It is the symbol of sweet, pleasing character, the result of good deeds. When held by the Infant Christ it refers to the delights of the blessed. As one of the trees in the Garden of Paradise, the cherry with its abundant fruit becomes a symbol of eternal life.

The **fig,** the figleaf, and the fig tree are all symbols of lust, which originated after the Fall, when Adam and Eve "sewed fig leaves together and made themselves aprons" (Gen. 3:7). The Tree of Knowledge is sometimes a fig tree instead of an apple. The fig itself represents fertility as well as lust, because of its many seeds and the use of its leaves. In a positive sense, the tree is used to represent fruitfulness and good works.

The **gourd** figures primarily in the story of Jonah, when God made a gourd grow so fast that overnight it created an arbor to shade Jonah and diminish his grief (Jon. 4:9–10). The gourd, suggesting Jonah's reemergence from the whale, has become a symbol of the Resurrection.

Grapes refer to the sacrament of the Eucharist and to the Passion. Two men laboring under the burden of an enormous bunch of grapes suspended from a pole on their shoulders is an illustration from Numbers 13:23 that occurs in medieval art. (*See also Vine, Eucharist.*)

The **lemon** is a symbol of fidelity in love, and appears often with Mary.

Nuts represent fertility, since they are the seed for a new plant. The walnut was taken as a symbol of Christ, the shell representing His flesh, the wood the Cross, and the inner kernel His hidden divinity.

The **orange** and the orange tree are a symbol of chastity, generosity, and purity, because of the tree's white blossoms. The custom of brides carrying orange blossoms was brought to Europe by the Crusaders, who saw Saracen brides wearing the white, sweet-scented blos-

soms on their wedding day, as a confirmation of their fertility and chastity. When an orange tree appears in the Garden of Paradise it symbolizes, like the apple tree, the fall of man and his redemption.

The **peach** symbolizes the virtues of a charitable tongue and heart—a charitable nature in general, akin to the seed within the pit of the peach. It is also symbolic of the quietness of virtue, which does not call attention to itself. Like the apple, it may represent salvation.

The **pomegranate** is a symbol of eternity and fertility, because of its many seeds. It has long been considered a symbol of royalty, because of its crownlike terminal. The white pomegranate as a Christian symbol refers to the Church, whose many parts are like the many seeds contained within a single whole. When the pomegranate appears opened, with the seeds evident, it becomes analogous to the Resurrection, the opening of the tomb, an allegory of hope. The many seeds in blood-red juice also equate to life out of death. A stylized pomegranate was a popular decorative motif from biblical times.

The **strawberry** suggests the righteousness of the Virgin. Strawberries combined with violets mean that the spiritual and righteous are truly humble, like the violet. The strawberry in general represents good works or the fruits of the spirit. With its trefoil leaf, it can also symbolize the Trinity.

The **vine** is an ancient symbol of peace and plenty. Jesus applied the symbol to himself (John 15:1–5). The vine is also used as a symbol for the Church and Christ as the keeper of the vineyard, and of Judaism in Old Testament references. (See also Grapes.)

GOD THE FATHER,
GOD THE SON,
GOD THE HOLY GHOST

God the Father is represented in early Christian art as a large hand emerging from stylized clouds with the palm open and fingers pointing downward. The human representation of God sometimes shows just a head or head and shoulders, sometimes the whole figure. He may become the Ancient of Days, an old man with white hair and a beard, who looks down on many Old Testament scenes. He may be dressed as a Pope, or a king, His head surrounded by the cruciform or triangular halo. An abstract symbol of God the Father is the triangle surrounded by a circle of rays; the triangle represents the Trinity, the circle of rays, eternity.

God the Son is Jesus Christ. Until Christianity became the state religion in 313 A.D., Christ was represented primarily by the Lamb, the Fish, the Cross, or the Sacred Monogram (*see Initials*). In catacomb wall paintings Christ emerged as the Good Shepherd, an idealized classical youth, beardless and curly-headed, with a lamb slung

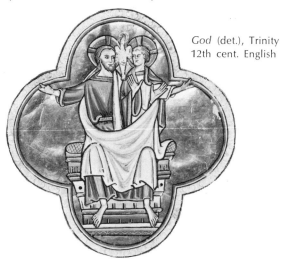

God (det.), Trinity
12th cent. English

over his shoulders. Gradually the figure of Christ as teacher and king with dark hair, a beard, and penetrating eyes develops. A cruciform halo surrounding His head, He sits on a throne, holding a book in His hand, and raises His right hand in blessing. God the Son may also appear as an infant, or a young boy, the Christ Child, either alone or in the company of Mary. As an infant or young child, Christ represents the Incarnation, and often holds a symbolic fruit or bird. (*See also Jesus Christ.*)

God the Holy Ghost, or **Holy Spirit,** the third member of the Trinity, was sent to inspire the Apostles and Christians in general at Pentecost. The dove is described at Jesus' baptism by John the Baptist: "I saw the Spirit descending from heaven like a dove" (John 1:32). The Holy Ghost also appears as a tongue of flame at Pentecost, or a shaft of light rays (Acts 2:3–4). Various combinations of dove and flames all represent the Holy Ghost. (*See also Beasts: Dove; Trinity.*)

HALOS
HEAVEN
HELL
THE HUMAN BODY

THE HALO, OR NIMBUS

Halos are the visual expression of a supernatural light, a mystical force. Familiar in Oriental as well as Western art, halos form a symbolic crown. In ancient art halos identified deities. In their circular shapes, their lightness and brightness, they resemble the sun. (The word *halo* most likely evolves from the Greek *helias,* meaning sun. *Nimbus* is Latin for cloud.) The halo is the attribute of sanctity in Christian art, and identifies important personages. In Eastern art the halo was exclusively an attribute of power. In some early medieval miniatures Satan and the seven-headed beast of the Apocalypse wear halos as symbols of power, not holiness.

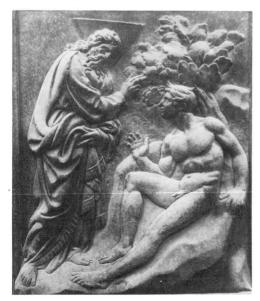

Della Quercia, *Creation of Adam*

The **aureole** or **glory** is an orbit of light that surrounds the entire body of God the Father, God the Son, the Holy Ghost, the Virgin, or a person representing the Trinity. It is the symbol of divinity, or supreme power. The rays of the aureole frequently end in multicolored flames. Aureoles may be gold, white, blue, or rainbow-hued. *Aureus* in Latin means gold.

The **cruciform halo,** used behind the head of Christ or God and Christ in one, suggests redemption through the Crucifixion. The Sacred Monogram may also be included in the cruciform halo (*see Initials*).

Hexagonal or **lozenge-shaped halos** are used to distinguish the Virtues or allegorical figures, Old Testament and Pre-Christian figures of noble life.

The **mandorla** is an oval frame enclosing an important figure. (*Mandorla,* Italian for almond, refers to the seed or womb, a similar shape, as well as the oval frame itself.) In Latin the mandorla is called the *vesica piscis,* or fish bladder, another oval shape. The mandorla often includes Christ in Majesty with the four animal symbols of the Evangelists.

The **square halo** identifies a living person. It is used to distinguish donors and other important living people from saints. The square is an earthly symbol, inferior to the perfection of the circle as the earth is inferior to Heaven.

The **triangular halo** refers to the Trinity and is used to identify God the Father.

Three rays of light emanating from the head are reserved for any of the three members of the Trinity.

HEAVEN

In the Old Testament, Heaven was the uppermost region of the universe, the great concave "firmament" likened to the roof of a tent. Earth was the middle area and Hell the lower section. In the New Testament,

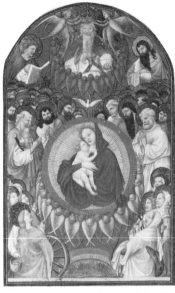

Limbourg,
The Court of Heaven

Heaven is a kingdom, with God as the reigning mon-
arch, populated for eternity with the souls of the blessed.
Heaven is also called the Holy City, Paradise, the New
Jerusalem (*see Apocalypse*). It was also imagined as a

Hell Mouth,
12th cent. English

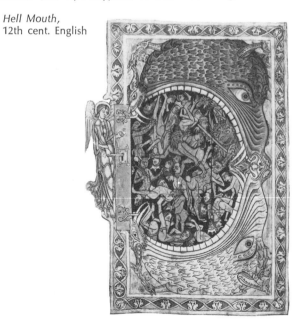

garden of Paradise, a duplicate of the Garden of Eden before the Fall.

The **Court of Heaven** includes God the Father, the Holy Ghost, and the Christ Child, surrounded by saints, apostles, martyrs, and others.

HELL

Hell is presided over by Satan the fallen archangel, and populated by the damned (Rev. 21:8). The entrance to Hell may be the gaping mouth of a fiery dragon, symbol of evil, or great open gates. Hell is the Infernal City, dominated by fire.

THE HUMAN BODY

Honorius of Autun (12 cent.) explains the concept of man as the microcosm, a smaller world within the large world. He states that the flesh and bones of man are derived from the earth, blood from water, breath from air, and body heat from fire. Each part of the body corresponds with a part of the universe: the head to the heavens, the breath to air, the belly to the sea, and the lower extremities to the earth.

THE FOOT

Soiled and worn, the foot is a symbol of humility and bondage, such as that practiced by members of certain religious orders who go barefoot or wear only sandals.

THE HAND

Emerging from the clouds, the hand represents the presence of God the Father. It may sometimes hold bolts or rays, symbols of Almighty power. There are many variations in position: Three extended fingers pointing downward suggest the Trinity and an act of blessing. An open hand enclosed in a cruciform nimbus suggests the

concept of God the Creator giving His blessing. When a closed hand holds tiny bodies, they represent the souls of the righteous (Wisd. 3:1). Clasped hands suggest union, as in the marriage ceremony. A finger held across the mouth indicates the vow of silence.

THE HEAD

In medieval art the head is the symbol for the mind and the spiritual life, as opposed to the vital principle represented by the entire body.

Hair on the head represents energy, vitality, fertility, and the higher forces; hair on the body represents the baser forces. Long, flowing, and abundant hair can also be a symbol of penance, often worn by hermit saints (*see St. Agnes, Mary Magdalene*).

The **ear** is one of the many symbols of the Passion (*see Instruments of the Passion*).

The **eye** is the symbol of an ever-present, all-powerful, all-knowing presence of God. An eye enclosed by a triangle, with emanating rays, is a symbol of the Trinity. Cherubim and seraphim have winged bodies covered with eyes. (*See also St. Lucy.*)

THE HEART

The heart is the symbol for true love, charity, understanding, and piety; for happiness and joy as well as sorrow. It is recognized as the key organ of the human body, one that coordinates the intellect with the emotions. The emblem for devotions to the Sacred Heart is a flaming heart, surmounted by a Cross and enclosed in the Crown of Thorns. As an attribute, the flaming heart generally suggests religious fervor, the pierced heart contrition and repentance. (*See also Doctors of the Church: St. Augustine; Sts. Teresa, Catherine of Siena, Agatha.*)

Blood is the symbol for sacrifice. It often spurts from Christ's side in Crucifixions, to be caught in cups held by angels. In the sacrifice of the Eucharist, the red wine becomes the symbol of Christ's blood, as instituted at the Last Supper (Matt. 26:27–28).

NUDITY

The nude figure has a dual symbolic meaning, invoking either a base or an elevated emotional response. Adam and Eve naked in the Garden of Eden before the Fall represent purity and innocence. A seductive nude figure decorated with jewels and temporal adornments represents lust, vanity, and worldly corruption. During the Renaissance, *nuditas naturalis* referred to the natural state of man as he emerges from the womb, pure, unencumbered, and full of virtue (I Tim. 6:7). *Nuditas temporalis* referred to the state to which man is reduced when he is forced by circumstances to live in poverty. This is a positive condition when it is entered into voluntarily, as a denouncement of temporal possessions.

THE SKELETON

The human skeleton is a symbol of death. Death often holds a scythe, with which he cuts down life, and an hourglass to measure the swift passage of time (*see Death*).

A **skull** is a reminder of death and of the transitory quality of human life. It is an attribute of hermit and penitent saints who embraced the contemplative life. *Memento mori* and *vanitas* compositions often include a skull, stressing the falseness of human vanity and the mercurial quality of life. A skull at the base of the Cross in Crucifixions is a reference to Golgotha, "the place of the skull" where the Crucifixion took place (John 19:17). (The Latin word for skull is *calvaria,* and Golgotha is called Calvary in the Douay Bible.) It was believed that the Cross was implanted over Adam's skull and bones so that by Christ's sacrifice mankind was redeemed from Adam's sin.

STIGMATA

Five wounds on the body of a human person similar to the wounds of the crucified Christ are the Stigmata (*see St. Francis of Assisi, St. Catherine of Siena*).

INITIALS

Initials appear in Christian art, both as monograms and abbreviations, decorative devices as well as identifying labels.

AΩ, alpha and omega, the first and last letters of the Greek alphabet, suggest the immortality of God (Rev. 1:8). These initials often appear with portraits of Christ, and may be incorporated into the sacred monogram (*see Apocalypse*).

The Sacred Monogram **IC** is Christ's personal monogram. (I and C are the first letters of Jesus Christ in Latin; in Greek, the first syllable of Jesus.) First used as a symbol and decorative device for Christ alone, the Sacred Monogram has evolved into a universal sign for the Christian faith. It became general after the vision of Constantine in 312 A.D. and the official recognition of Christianity in 330. It is incorporated into halos and combined with doves, the vine, and the peacock, suggesting immortality. When the sacred monogram is encircled by a wreath, it suggests the triumph of the Resurrection. Variations are:

IC XC combined with a Greek cross and **NIKA** is an ancient monogram. IC is a Greek abbreviation for Jesus, XC stands for Christ, and NIKA is the Greek word for victory. This combination represents Christ the Conqueror, and is common in Byzantine art.

IHS or **IHC,** the first three letters of the Greek for Jesus, appear in many versions, often incorporating a Latin cross. Many meanings have been attached to it, such as Jesus Savior of Men or Humble Society of Jesus, the em-

blem of the Jesuits. It is also an abbreviation for "In this sign conquer." IHS is primarily a monogram for Christ.

INRI is the abbreviation for "Jesus of Nazareth King of the Jews," which was inscribed on a scroll and nailed above Christ's head when he was crucified.

I R stands for "Jesus Redeemer" in Latin.

I S stands for "Jesus Savior" in Latin.

IXθYC is the Greek word for fish, a frequent symbol for Christ in early Christian art. The letters IXθYC are also the initial letters for "Jesus Christ Son of God Savior" in Greek.

M A is an abbreviation for Mary. Variations include an abbreviation sign above the letters (**M'A**), the first three letters of her name, or all four letters combined into an elaborate monogram.

T stands for *Theos,* the Greek word for God. It may appear on the shoulder of St. Anthony Abbot's robe. The founder of monasticism, he devoted his long life to the greater service of God.

XP, the Greek letters chi and rho, the first two letters of the Greek word for Christ. The two letters combine in various combinations to form a cross. (The X and P combined are similar to the Latin word *pax,* meaning peace.)

INSTRUMENTS OF THE PASSION

The objects associated with the Passion of Christ are called the Instruments of the Passion. They may be included in Crucifixions or may appear alone as a reference to the Passion. Instruments of the Passion may appear as accessories in Last Judgment compositions as the heraldic arms of Christ, in devotional images of Christ as the Man of Sorrows or Christ as the Lamb of God. The Instruments of the Passion include the nails, the hammer, the lance, the sponge, the column with cord, the scourges

of the flagellation, the Crown of Thorns, the chalice, Pilate's wash basin, the lantern or torch of the arresting soldiers, the rope, the club, the sword, the pincers, the purse or thirty pieces of silver with which Judas was bribed, the seamless garment of Christ and the dice with which the soldiers cast lots to determine its possessor, the ladder to remove Christ's body from the Cross, the sun and the moon, a vat of vinegar, and Pilate's superscription IHC or INRI on a scroll. The veil of St. Veronica (the vernicle) is sometimes also included (*see St. Veronica*). Other symbols of the Passion may be the ointment jar to hold embalming spices, the heart with five wounds, the ear of Malchus, and the cock of St. Peter's denial.

The Instruments of the Passion appear in paintings illustrating the Mass of St. Gregory (*see Doctors of the Church: St. Gregory*).

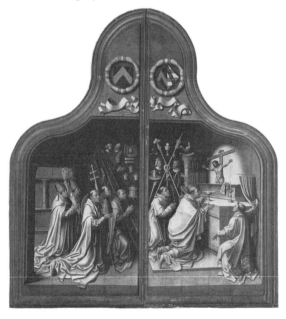

Instruments of the Passion, Mass of St. Gregory,
15th cent. French

JESUS CHRIST:
LIFE
PARABLES
MIRACLES

JESUS CHRIST

The major theme in Christian art is the life of Jesus
Christ. The Gospels provide the story, which can be
roughly divided into categories. The first, the Incarna-
tion—God made man—includes the infancy and child-
hood of Jesus, and is closely interwoven with Mary. The
second category is the public ministry, from Jesus' bap-
tism by John the Baptist to the Passion, in which He
appears as a young man of about thirty with flowing
dark hair, and a dark beard. (In early works he is a classic
Apollo type, often without a halo.) The third category is
the Passion, beginning with the Entry into Jerusalem and
ending with the Ascension. The fourth category concerns
events after the Resurrection and Ascension.

Because of the early Christian antipathy to pictorial
representation, until 313 A.D. Christ was portrayed
mainly by symbols such as the Lamb, the Fish, or the
Sacred Monogram. The earliest figural representation of

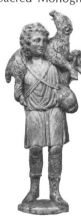

Christ As Good Shepherd,
3rd cent. Italian

Christ shows Him as a young shepherd, a classical beard-less hero. Later He becomes older, a bearded, long-haired, more dignified figure of the Syrian type. Through the centuries He may appear as teacher and king, as a fisherman, or as a victim suffering for the sins of man-kind. In Byzantine art He is the Pantocrator (creator of all), motionless, frontal, a figure of great dignity with a

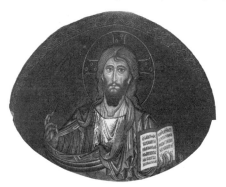

Christ Pantocrator, 12th cent. Sicilian

hypnotic glance, his right hand raised in blessing, his left hand holding the book of the Gospels, a cruciform halo encircling his head. This solemn, bearded image had become common by the twelfth century. The face and expression became more serene in the Gothic period, more anguished and dramatic in the late Gothic and

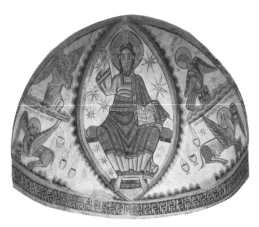

Christ in Majesty with Symbols of the Four Evangelists

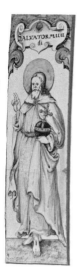

*Christ, Savior of the World
(Salvator Mundi) (det.),
17th cent. Swiss*

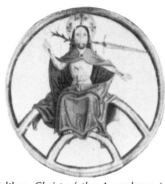

Walther, *Christ of the Apocalypse* (det.)

Baroque, more serene and classical in the Renaissance, and more dramatic and theatrical after the Counter-Reformation. As redeemer of man, Christ may show his wounds from the Crucifixion or his Sacred Heart flaming on his breast, or rays of light may emanate from a wound in his side.

Christ's attributes are the Cross, the book, and the cruciform halo, or three rays of light emanating from his head. (*See Halo. For letters symbolizing Christ, see Initials.*)

LIFE OF JESUS CHRIST

THE NATIVITY

The focus of all Nativities is the infant Christ, with Mary and Joseph as secondary figures. Through an opening in the stable, a hovering angel can be seen announcing the birth of Jesus to the shepherds as they cluster about their hillside fires (Luke 2:8). (*See Mary; Beasts.*)

St. Jeans,
Nativity

THE ANNUNCIATION TO THE SHEPHERDS

The Annunciation to the Shepherds may be presented
as a separate event. Two or more shepherds, their flock
at their feet, follow the directive of the angel Gabriel
(Luke 2:10ff.). The shepherds often carry bagpipes, and
are accompanied by dogs. Two of the shepherds are sup-
posed to have become the Apostles Simon and Jude.

Annunciation to the Shepherds (det.), 12th cent. French

ADORATION OF THE SHEPHERDS

Following the directions of the angel, the shepherds arrived at the stable the following morning (Luke: 2:15ff.). They kneel to worship Jesus and Mary. Joseph rests his head in his hands and dozes. Always represented as much older than Mary, he is usually a passive observer—a subtle reference to Mary's virginity.

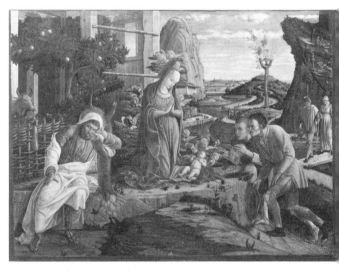

Mantegna, *The Adoration of the Shepherds*

THE MAGI

Scarcely mentioned in the Gospels, the Three Wise Men or Kings are thought to be from a sacred tribe of Persians skilled in astrology and the occult. Their costumes and often elaborate retinues are in sharp contrast with the simple shepherds. As the legend of the Magi evolved from the Psalms and Isaiah, they are portrayed as kings: young Gaspar, middle-aged Balthazar, and old Melchior with white hair and beard. They can therefore represent the three ages of man. They may be of three races, to symbolize the universality of Christianity. Their gifts were of **gold,** symbolizing wealth to a king; **frankincense,** for adoration to one divine (it was also an ancient balm for healing sores); and **myrrh,** emblem of death to

John of Hildesheim,
Journey of the Magi

one who will suffer (myrrh is an herb used in embalm-
ing). Their supposed relics rest in the cathedral of Co-
logne. The Feast of the Epiphany on January 6 commem-
orates their arrival. An older feast than Christmas, it is
also known as Little Christmas, Second Christmas, or
Twelfth Day or Twelfth Night.

THE CIRCUMCISION

Eight days after His birth Jesus was taken to the temple,
as prescribed by Jewish law, and circumcised by the
priests. His mother was not present. In representations

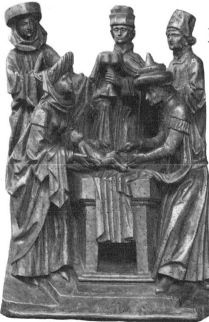

The Circumcision,
15th cent. Flemish

of the Circumcision, Jesus often appears as a tiny victim, on a table resembling an altar, surrounded by high priests. At this same event, Jesus was given his name.

THE PRESENTATION IN THE TEMPLE

Following the law of Moses, thirty-three days after his birth Mary took Jesus to the temple to present him to the high priests. Mary sacrificed two doves, symbols of purity, as well, to satisfy the Jewish tradition for newly delivered women. (*See also Purification in the Temple,*

Giotto, *The Presentation of the Child Jesus in the Temple*

under Mary.) Joseph may hold a dove or the basket of pigeons. Simeon, a devout man who awaited the revelation of Christ before he would submit to death, is often the old man holding the Infant. He becomes the personification of the Church which embraces Christ, as Simeon embraced and blessed the Holy Infant in the temple. The female figure behind Simeon is Anna, a prophetess who legend says was Mary's teacher in the temple.

THE MASSACRE OF THE INNOCENTS

When Herod, king of the Jews, learned from the Magi of the birth of a child who would threaten his throne,

he directed his soldiers to murder all infants of Jesus' age. The Slaughter or Massacre of the Innocents is a brutal scene of infanticide, with mothers desperately clutching their babies, the ground around them littered with dismembered arms, legs, and heads. Herod may direct the action, which may be included as a detail in the Flight into Egypt (Matt. 2:16).

THE FLIGHT INTO EGYPT

Herod's plans for the Massacre of the Innocents were revealed to Joseph in a dream (Matt. 2:13ff.). An angel warned him of the danger to Jesus' life, and advised him to flee to Egypt. Mary rides a donkey, with Jesus on her lap. Joseph leads the way. Occasionally, Joseph will carry the Child on his shoulders. A popular background detail is that of false idols falling off their pedestals as the Holy Family passes by, a reference to worshiping false idols (Isa. 19:1). When a youthful figure brings up the rear, or acts as a guide instead of Joseph, he is St. James the Less.

Flight into Egypt, 12th cent. French

A frequent theme shows the Holy Family pausing to rest, shaded by a palm tree, often attended by angels. Mary may nurse the Baby or feed Him grapes, a prophetic symbol of Christ's future sacrifice—the grapes made wine in the sacrifice of the Mass.

THE REST ON THE FLIGHT INTO EGYPT

When the Holy Family stopped to rest in the shade of the palm, Joseph tried unsuccessfully to reach up and

Tiepolo, *Flight into Egypt*

The Miracle of the Palm Tree,
15th–16th cent. Spanish

pick its fruit. Angels appeared among the branches and bent them down so Joseph could reach the fruit for his family.

After two years, an angel again appeared to Joseph in a dream to announce the death of Herod, and Joseph and his family returned to Nazareth. Pictures of this event are called the Return from Egypt.

THE HOLY FAMILY (SACRA FAMILIA)

Portraits of the Holy Family sometimes include St. John

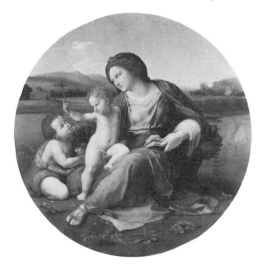

Raphael, *The Alba Madonna*

the Baptist, accompanied by a lamb, an allusion to his role as Christ's forerunner. During baptism, John recognized Jesus as the Lamb of God. St. Anne, Mary's mother, is another frequent participant. In a variety of domestic scenes, Joseph may teach his trade of carpentry to Christ; Mary may teach Christ to read; either parent or both may support Him as He learns to walk.

Zurbaran, *The Holy House of Nazareth*

Another variation is the Holy Conversation (*Sacra Conversazione*), in which several saints may be talking, reading, or focusing directly on the Christ Child.

CHRIST AMONG THE DOCTORS

When Christ was twelve years old his family took him to Jerusalem for the Jewish feast of Passover. While there he became separated from his parents for three days.

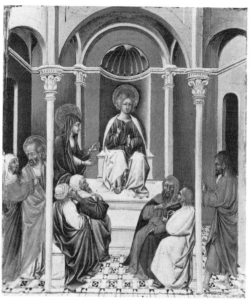

Paolo, *The Child Disputing in the Temple*

They found him in the Temple, involved in discourse with the learned doctors or rabbis (Luke 2:43–49). The public life of Christ begins with this incident (also known as the Disputation in the Temple). Jesus as a youth is seated in a place of prominence, with doctors surrounding him.

THE BAPTISM

John the Baptist was Christ's cousin, the child of Elizabeth and Zacharias (see *Visitation, under Mary*).

Jesus joined the multitudes who journeyed to the river Jordan to be baptized by John, a Jewish preacher. With baptism the pagan became a Jew and later the rite was adopted by Christians. In representations of the Baptism of Christ, Jesus is a young man standing in the River Jordan. (A classical river god, personification of the Jor-

Baptism of Christ,
13th cent. French

dan, may recline to the side.) John pours water over
Christ's head (Matt. 3:16). In some versions a dove
hovers over the head of Christ, or God the Father ap-
pears in clouds. Angels may appear holding the robe of
Christ. When many figures besides Christ appear, it is a
combination of the Baptism of Jesus and that of the mul-
titude (Mark 1:5).

THE TEMPTATION OF CHRIST
(CHRIST IN THE DESERT)

After Christ was baptized, He went out into the wilder-
ness to fast for forty days and forty nights (a New Testa-
ment parallel to the Old Testament sufferings of Moses
and Elijah). At the end of the fast, the Devil appeared
and tempted him to make stones into bread. But Jesus
replied, "Man shall not live by bread alone" (Matt. 4:4).
The Devil then took Him into the city, set Him up on
the pinnacle of the Temple, and dared Him to throw
Himself down so that He might be miraculously rescued
by His angels. But Jesus refused: "Thou shalt not tempt
the Lord thy God" (Matt. 4:7). The third temptation was
to show Jesus all the kingdoms of the world from a high
vantage point. The Devil offered them all to Christ if He
would fall down and worship him. Jesus says, "Get thee
hence, Satan: for it is written, Thou shalt worship the

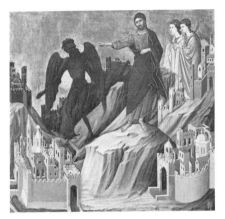

Duccio, *Temptation of Christ on the Mountain*

Lord thy God, and Him only shalt thou serve." (Matt. 4:10). These episodes are called the Temptation of Christ.

CALLING OF THE FIRST APOSTLES

One of the first acts of Jesus' public life was to find some devoted followers who would become apostles and spread the word of Christianity. While walking by

Strozzi, *The Calling of Matthew*

the Sea of Galilee, Christ enlisted the fishermen Simon and his brother Andrew (Matt. 4:18–20). Later, he enlisted Matthew, a tax collector. *(See Apostles; Evangelists.)*

THE TRIBUTE MONEY

Jesus, confronted by a tax collector at Capernaum, directed Peter to catch a fish (Matt. 17:24–26). Peter did so, and took coins from the fish's mouth and gave them to the incredulous tax collector.

The Tribute Money appears again in the Gospels of Luke (20).

THE SERMON ON THE MOUNT

Jesus' most famous and widely quoted sermon, the Sermon on the Mount, contains moral advice concerning matters from adultery to prayer, from love of one's

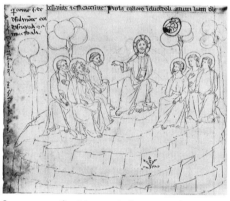

Sermon on the Mount, 14th cent. Italian

enemies to love of worldly goods. In many ways the cornerstone of Christianity, it contains the Beatitudes, the Golden Rule, and the Lord's Prayer. (Matt: 5–7).

CHRIST DRIVING THE MONEYCHANGERS FROM THE TEMPLE

In Jerusalem, business was permitted in the Temple antechambers, but not in the Temple itself. However, gradually the Temple became a place of business filled with moneychangers and livestock dealers. When Jesus could tolerate this sacrilegious behavior no longer, he cast the moneychangers and businessmen out of the temple, overturning their tables and scattering their livestock (Matt. 21:12).

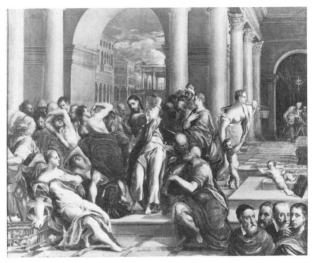

El Greco, *Christ Driving the Money Changers from the Temple*

CHRIST AND THE WOMAN OF SAMARIA AT THE WELL

In the hostile country of Samaria, Jesus paused at Jacob's well for a rest and drink of water, but was denied it by a Samaritan woman drawing water there. After further conversation, during which Jesus revealed the events of the woman's life, she was converted, as were many of her kinsmen. As a result, the Samaritans, despised by the Jews, became accepted, and followers of Christ. The water in the well is symbolic for the water of life (John 4:4–42).

The Woman at the Well, 19th cent. Austrian

THE FEAST IN THE HOUSE OF LEVI

When the Pharisees criticized Jesus for mixing with such lowly company as the sinners and publicans who accompanied Him and His disciples to the feast given by

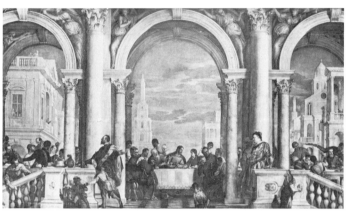

Veronese, *Feast in the House of Levi* (det.)

Levi, a customs collector, Jesus replied, "They that are whole have no need of the physician. . . . I came not to call the righteous, but sinners to repentance" (Mark 2:17).

DELIVERY OF THE KEYS TO PETER

Peter was the leader of the Apostles and affirmed Jesus' identity to a skeptic. Jesus blessed Peter and gave him the keys to the Kingdom of Heaven (Matt. 16:18ff.).

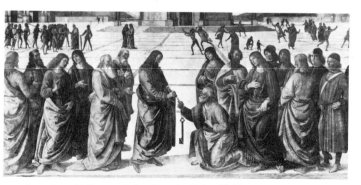

Perugino, *Delivery of the Keys to Peter* (det.)

SUPPER IN THE HOUSE OF SIMON

While Jesus was dining with Simon, a notorious sinner usually thought to be Mary Magdalene (*see Saints*) approached Him and began to wash His feet with her tears. She dried them with her long hair, kissed them, and anointed them with ointment. Simon was amazed that Christ would permit such familiarities from such "matter of woman," but Jesus defended His forgiveness because she had "loved much" (Luke 7:44ff.).

THE TRANSFIGURATION

Peter, James, and John were taken by Jesus up to a high mountain (perhaps Mount Tabor, outside Nazareth), where He "was transfigured before them; and His face did shine as the sun, and His raiment was white as the light." Miraculously, the Old Testament prophets Moses and Elias appeared on either side of Jesus. This event reaffirmed the son-ship of Jesus, and suggests that He brought together the Law of Moses and the words of the Old Testament prophets, represented by Elijah. Peter of-

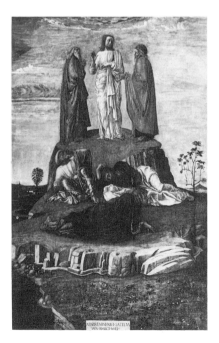

Bellini,
The Transfiguration

fered to construct three shrines, one for Moses, one for Elias, and one for Christ. Suddenly "a bright cloud overshadowed them . . . and a voice out of the cloud . . . said, This is my beloved Son, in whom I am well pleased; hear ye Him" (Matt. 17:5). Terrified, the Apostles fell to the ground. Jesus reassured them, and when they arose, Moses and Elias had disappeared. Jesus charged the Apostles, "Tell the vision to no man until the Son of man be risen again from the dead" (Matt. 17:9).

ENTRY INTO JERUSALEM

Shortly after the Transfiguration, Jesus entered Jerusalem riding on an ass. "And a very great multitude spread their garments in the way; others cut down branches from the trees, and strewed them in the way" (Matt. 21:8). This event is commemorated on Palm Sunday. The ashes from the palm branches are saved and distributed on Ash Wednesday the following year.

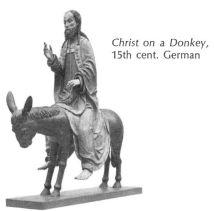

Christ on a Donkey,
15th cent. German

In pictorial versions of the Entry into Jerusalem, a large crowd surrounds Christ as he rides toward the city gates. Children climb trees to get a better view, or throw their cloaks in his path as they wave palm branches.

WOMAN TAKEN IN ADULTERY

"The scribes and Pharisees brought unto Him a woman taken in adultery," and asked Jesus if He did not think she should be stoned (the punishment according to the

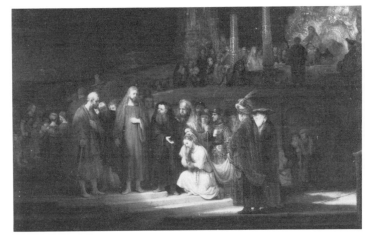

Rembrandt, *Woman Taken in Adultery* (det.)

Law of Moses). He replied, "He that is without sin among you, let him first cast a stone." Chagrined, they departed, leaving Jesus alone with the woman. He directed her, "Go and sin no more" (John 8:3–11).

THE LAST SUPPER

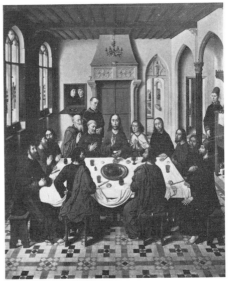

Bouts,
The Last Supper

During the feast of the Passover, Jesus directed two
of his disciples to go and find a "large upper room fur-
nished and prepared . . . and in the evening He cometh
with the twelve." Jesus is in the center with John at His
right; sometimes John leans his head on Christ's shoulder
in a touching gesture of intimacy. In early Christian art
the symbol of the Eucharist on the table is the fish, or
the wafer and chalice, and occasionally a whole lamb,
the Passover meat as well as a Christian symbol. Bread,
in pieces or individual little loaves, is on the table (Mark
14:15ff.). Judas, the betrayer, may be isolated in front of
the table, occasionally hiding a fish behind his back.

WASHING THE FEET OF THE DISCIPLES

After the Last Supper, Jesus washed the feet of His
disciples, an act of humility and purification (John

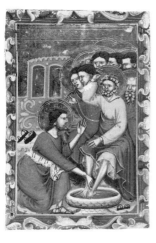

*Christ Washing Feet
of Disciples* (det.),
14th cent. Italo-Hungarian

13:4ff.). This scene is reenacted by the Roman Catholic
Church on Maundy Thursday.

AGONY IN THE GARDEN

After the Last Supper, Jesus took Peter, James, and
John with him to the Garden of Gethsemane to pray.
He went aside, fell on His face, and prayed. Interrupting
His prayer, Jesus returned and found the Apostles fast
asleep. Twice more Christ retired to pray, and both times

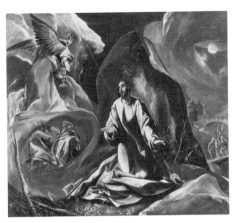

El Greco, *Christ at Gethsemane*

the apostles fell asleep. "Sleep on now, and take your rest: behold, the hour is at hand, and the Son of man is betrayed into the hands of sinners" (Matt. 26:39ff.).

THE KISS OF JUDAS, OR THE BETRAYAL

A belligerent mob, brandishing swords and staffs, attacked Christ and the apostles as they emerged from the Garden of Gethsemane. Judas the traitor leaned over and kissed Jesus, thereby identifying Him. Immediately the mob, sent by the high priests, set upon Him, but Peter protected Jesus by drawing his sword and cutting off the

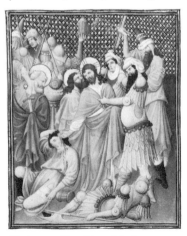

Limbourg, *The Kiss of Judas*

ear of Malchus, one of the attackers. Jesus, in an act of charity, touched the bloody ear and it was miraculously healed (Luke 22:47ff.).

The symbols of an ear, a staff, a rope, a torch, two hands filled with coins (a reference to the payment to Judas by the high priests in return for the betrayal) often appear in the Betrayal.

CHRIST BEFORE PILATE

Jesus was arrested, bound, and taken to be questioned by Pontius Pilate, the Roman governor. When Judas saw Christ, he repented.

Christ was questioned by Pilate but refused to answer. Pilate, reluctant to be responsible for Jesus' death (and personally convinced of his innocence), asked the people which accused prisoner he should release to them, Barabbas or Christ. They chose Barabbas, and ordered Jesus to be crucified, whereupon Pilate took water, and washed his hands before the multitude (Matt. 27:21ff.). Pilate, on a throne, sometimes wears the toga and laurel wreath of the Roman governor, and may wash his hands in a basin.

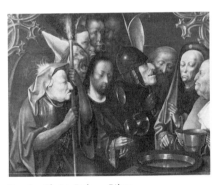

Bosch, *Christ Before Pilate*

A similar scene is Christ Before Caiaphas, when Jesus, led by soldiers, appeared before temple priests to answer their accusations. (The high priests are identified by their robes, hats, and long beards.) Caiaphas sits on a throne, and may tear his garments in frustration at Jesus' blasphemy in asserting that He is the son of God.

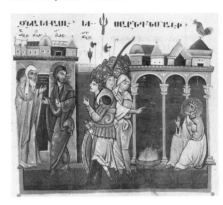

Denial of Peter,
13th cent. Armenian

PETER'S DENIAL OF CHRIST

During Jesus' trial before the high priests, some witnesses began to abuse Him. Peter remained aloof, three times denying any association with Jesus (Mark 14:67ff.). With this, Jesus' prophecy of the Last Supper was fulfilled—Peter, His most beloved disciple, had betrayed him. In the Denial, the cock is always prominently placed. Peter may be outside the courtroom talking with a maidservant, or hovering over a fire.

THE FLAGELLATION

In an attempt to pacify the mob and perhaps avert his crucifixion, Pilate ordered that Christ be scourged. In Flagellation scenes, Christ is bound to a column, or tied over a small pillar and beaten with whips or rods. Pilate frequently supervises, attended by the high priests. These objects are included in the Instruments of the Passion.

The Flagellation,
15th cent. German

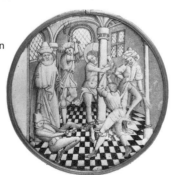

Rouault,
Christ Mocked by Soldiers

MOCKING OF CHRIST

To further humiliate Christ, Pilate's soldiers draped Him in one of their purple togas and taunted Him (Mark 15:18ff.).

CHRIST CROWNED WITH THORNS

As part of the Mocking of Christ, Pilate's troops plaited a crown of thorns, and put it on His head (Mark 15:17–19). The crown was an ancient symbol of power, sovereignty, royalty, and honor. To make it of thorns, rather than the laurel leaves used by the Romans for heroes and poets, was yet another irony.

ECCE HOMO (BEHOLD THE MAN)

After the high priests and the mob had demanded Christ's death, Pilate went before them and attempted to pacify them and absolve himself of any responsibility. "Behold, I bring Him forth to you, that ye may know that I find no fault in Him. Then Jesus came forth wearing the crown of thorns and the purple robe, and Pilate saith unto them, Behold the man" (John 19:4ff.).

ROAD TO CALVARY (BEARING OF THE CROSS OR WAY OF THE CROSS)

Only in the Gospel of John does Christ carry the

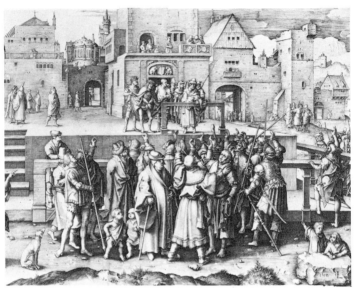

Leyden, *Ecce Homo* (det.)

Cross (John 19:17). A series of devotions initiated by the Franciscans in the fourteenth century, the Stations of the Cross, focused on this event. Pictured in sequence, with specific prayers and devotions for each, they are:

1. Jesus is condemned to death.
2. Jesus receives His cross.
3. Jesus falls the first time under His Cross.
4. Jesus meets His sorrowing mother Mary.
5. Simon of Cyrene helps Jesus to carry the Cross.
6. Veronica wipes the face of Jesus (see *St. Veronica*).
7. Jesus falls the second time.
8. Jesus speaks to the women of Jerusalem.
9. Jesus falls the third time.
10. Jesus is stripped of His garments.
11. Jesus is nailed to the Cross.
12. Jesus dies on the Cross.
13. Jesus is taken down from the Cross.
14. Jesus is laid in the sepulchre.

THE CRUCIFIXION

Crucifixion was adopted by the Romans as a humiliating execution reserved for non-Romans. The Cross itself, therefore, becomes a symbol of deep, self-effacing

sacrifice. The Latin or Roman cross is most common in Crucifixions, as it allows space at the top for the scroll identifying Jesus, as commanded by Pilate. The initials INRI are marked on the scroll (*see Initials*).

All four of the Gospels describe the Crucifixion, differing only slightly in details. After bearing the Cross to Calvary, or Golgotha, "the place of the skull," a burying ground, Jesus was stripped of His garments.

On the Cross, Jesus asked for water and was refreshed with a sponge on a pole saturated with vinegar. After tasting this final humiliation He said, "It is finished," bowed His head, and gave up the ghost. "But one of the soldiers with a spear pierced His side and forthwith came there out blood and water" (John 19:19ff.). This soldier, Longinus, became converted at that moment, and is St. Longinus, whose attribute is the lance. The soldiers then cast lots, probably with dice, for Jesus' garments. The objects connected with the Crucifixion are the Instruments of the Passion.

Picasso, *Crucifixion*

The three women grieving at the foot of the cross are called the Three Marys. They are Mary the Virgin, Mary the mother of James the Less, and Mary Magdalene, identified by her ointment jar. According to John's gospel, he was present at the Crucifixion where Christ entrusted Mary to his care. The sky, whether dark or

Beckmann,
*The Descent
from the Cross*

bright, may contain both the sun and moon, representing universal timeless sorrow for the humiliating death of Christ. (*See also Three Marys at the Tomb.*)

THE DEPOSITION

A disciple of Jesus, Joseph of Arimathea, who may appear at the foot of the Cross with the three Marys, asked Pilate for permission to care for Christ's body. Nicodemus helped him (John 19:38ff.).

After the Deposition, although not recorded in any of the Gospels, the body of the dead Christ was placed in the lap of his sorrowing mother. This composition is the Pietà (*see Mary*).

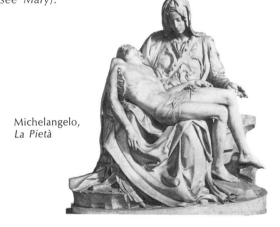

Michelangelo,
La Pietà

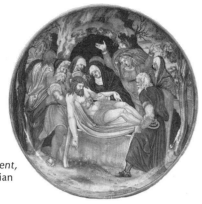

The Entombment,
16th cent. Italian

THE ENTOMBMENT

Once Christ's body had been prepared for burial, Joseph of Arimathea placed it in the tomb. The feet were supported by St. John the Evangelist or Nicodemus, and Mary held an arm. Mary Magdalene, the other Mary, and other mourners lament the death. The open tomb yawns in the background. Three crosses may be seen in the distance.

THE THREE MARYS AT THE TOMB

On the day following the entombment, the Three Marys and another woman, Salome, went to further

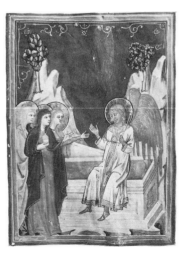

Three Marys at the Tomb,
14th cent. Italian

anoint the body of Christ (Mark 16:1). Mary Magdalene can generally be distinguished by her ointment jar. The stone of the sepulchre was rolled away and the tomb was empty, with an angel sitting on the right side.

THE DESCENT INTO LIMBO,
OR THE HARROWING OF HELL

This is an apocryphal event in the afterlife of Christ which has no basis in the Gospels. The Harrowing of Hell, especially popular in Eastern art, represents the final defeat of the Devil. (Harrow is an Old English word meaning to rob.) Christ descends into Limbo, "the lower parts of the earth," to free the souls imprisoned there since the Fall.

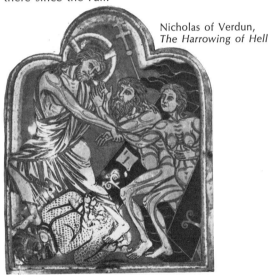

Nicholas of Verdun,
The Harrowing of Hell

The population of Limbo consists of unbaptized infants and righteous souls suffering because of original sin. Angels assist Christ in chaining the Devil and his cohorts. Details of broken locks, loosened chains, and keys symbolize the liberation of the souls from Limbo. Christ may offer his hand to Adam and Eve as he steps over the body of Satan. Old Testament prophets and kings may be identified. Christ may carry the Cross and banner of the Resurrection. The Harrowing of Hell was a popular subject for medieval mystery plays.

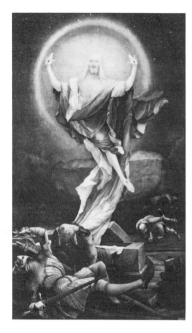

Gruenewald,
The Resurrection

RESURRECTION

The moment when Christ arises from the tomb is not recorded in any of the Gospels. It is part of the Apostles' Creed ("on the third day he arose from the dead") and a basic tenet of Christian belief, and is celebrated on Easter Sunday. Sleeping Roman soldiers guard the tomb (Matt 27:64ff.). A triumphant Christ steps out of the sarcophagus clothed in a glowing white garment, His side and hands bearing the marks of crucifixion. He carries His Resurrection staff, Cross, and banner, sign of His victory over death. Occasionally the Three Marys hover in the background. The Resurrection began Christ's appearances during the forty days before His Ascension.

CHRIST APPEARING TO HIS MOTHER

Mary is interrupted at prayer by the risen Christ, holding the Resurrection Cross with banner, with the wounds of crucifixion clearly visible. In this legendary event, which has no basis in the Gospels, He appears in conversation with Mary.

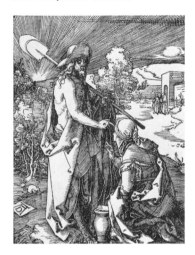

Dürer,
Noli Me Tangere

NOLI ME TANGERE

Christ appeared first to Mary Magdalene, immediately after she examined the empty sepulchre with Peter. Mary Magdalene had remained, weeping, in the company of the two angels guarding the tomb. The words spoken to her by Christ, "Touch me not," in Latin are *Noli me tangere,* and this phrase generally entitles representations of this first appearance. Christ often wears a large pilgrim's hat. He carries a staff with the white-and-red banner of the Resurrection, indicating that the event takes place after the Resurrection (John 20:14–18).

ROAD TO EMMAUS

Peter proceeded with another disciple to the village of Emmaus outside Jerusalem after examining the empty tomb. As they walked and talked, trying to understand the miracle of the Resurrection, "Jesus himself drew near, and went with them." They did not recognize Him, but thought Him just another traveler. Christ is represented as an anonymous figure, not identified by a halo or Resurrection banner. As the three walked, Christ "expounded unto them in all the Scriptures the things concerning Himself." When they arrived at Emmaus, Christ was persuaded to remain with the disciples (Luke 24:16–32).

SUPPER AT EMMAUS

In this favorite subject of Renaissance artists, Christ
is at table with the two disciples, often in the act of
breaking bread. Christ can be identified by a halo and
by the marks of crucifixion on His hands. This event

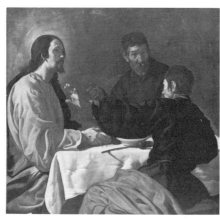

Velázquez,
*The Supper
at Emmaus*

underscores the importance of the holy meal as a basic
part of the Christian doctrine. It was not until the break-
ing of the bread—symbol of the Eucharist—that the
identity of the stranger as Savior was revealed to His
two disciples (Luke 24:30–31).

THE ASCENSION

Christ took the Apostles to Bethany, outside Jerusalem,
"and He lifted up His hands and blessed them. . . . He
was parted from them, and carried up into heaven"
(Luke 24:50ff.). This marks Christ's final appearance on
earth. He is a triumphant figure floating on a platform
of clouds, clad in a shimmering white robe. His hands,
as He raises them in blessing, bear the nail wounds of
the Crucifixion, but His face is jubilant. His eyes look up
toward Heaven and the source of light which illuminates
him. He leaves below the astonished Apostles. Angels
accompany Him, holding candles, playing musical instru-
ments, or holding scrolls (Luke 24:52–53). The back-
ground is usually mountainous, covered with olive trees,
as the Ascension, according to the Acts of the Apostles,
took place on Mount Olivet (Luke 24:50ff.).

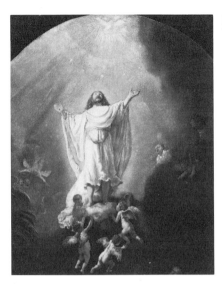

Rembrandt,
The Ascension

PENTECOST

Pentecost commemorates the visitation of the Holy
Ghost, or Holy Spirit, upon the Apostles, giving them the
ability to speak all languages. It is celebrated on the
seventh Sunday after Easter. After the Resurrection, the
disciples were celebrating together the Jewish feast of
Shavuot, commemorating the end of the grain harvest
begun at Passover. Suddenly "there appeared unto them
cloven tongues, like as of fire, and it sat upon each of

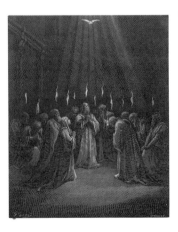

Doré, *The Pentecost*

them. And they were all filled with the Holy Ghost, and began to speak with other tongues" (Acts 2:1ff.).

Peter is often the central figure in Pentecost compositions, with Mary sometimes included. The dove of the Holy Spirit hovers over them, giving them the gift of tongues. Rays emanate from the dove, or from the hand of God, which emerges from Heaven transferring the miraculous power from God to man, or tiny tongues of flame flicker above the heads of the Apostles, signifying the presence of the Holy Ghost.

DOUBTING THOMAS

The Apostle Thomas, who was absent from the Supper at Emmaus (John 20:24), was skeptical and unbelieving. Subsequently, Christ appeared to Thomas. Representations show Christ holding aside his robes, while Thomas puts his finger into the wound in Christ's side. After this, Thomas doubted no more (John 20:24ff.).

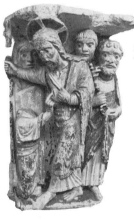

Doubting Thomas,
12th cent. French

THE PARABLES

To set forth his teachings, Jesus often used parables, short stories easily understood by his listeners.

The Prodigal Son tells the story of a foolish young man who squandered his inheritance in profligate living, while his brother, a careful, diligent worker, stayed at home

Murillo, *The Return of the Prodigal Son*

and prospered. The prodigal son returned home repentant and confessed his sins to his delighted father, who ordered the fatted calf to be brought forth for a homecoming celebration. The sober elder son, when he heard this, was angered and refused to join the party. His father replied, "Son, thou art ever with me, and all that I have is thine. It was meet that we should make merry and be glad: for this thy brother was dead, and is alive again; and was lost, and is found" (Luke 15:11ff.). This was Christ's reply to those who criticized him for eating with sinners who sought his help.

The Good Samaritan is Christ's example of how to treat one's neighbor. A traveler on his way to Jericho was robbed, stripped, and left by the side of the road half dead. A priest and a Levite passed by but ignored his

The Good Samaritan, 19th cent. American

plight. But a Samaritan stopped, "and bound up his wounds, pouring in oil and wine . . . and brought him to an inn, and took care of him." The Samaritan departed, but left money to care for the man. Christ then inquired, " 'Which now of these three, thinkest thou, was neighbor unto him that fell among the thieves?' The lawyer answered, 'He that shewest mercy on him.' Then Jesus said, 'Go, and do likewise' " (Luke 10:30ff.).

The Wise and Foolish Virgins illustrates the motto, "Always be prepared." (Christ likened the Kingdom of Heaven to this parable.) Ten virgins went forth to meet

Blake, *The Wise and Foolish Virgins*

the bridegroom, each carrying her lamp. Five were foresighted and brought their lamps filled with oil; the foolish virgins forgot oil for their lamps, and so were unable to light them and go to the wedding feast when the bridegroom finally arrived (Matt. 25:1–13).

The Rich Man and Lazarus. Lazarus was a poor beggar, ill and covered with sores, who waited at the rich man's house daily, hoping to feed on the crumbs from his table. Only the dogs comforted him. When Lazarus died, he was "carried by the angels into Abraham's bosom." But when the rich man died, "he looked up from Hell and saw Lazarus in Heaven. He begged Abraham to release Lazarus so that he could bring him water to cool

his tongue. Abraham refused. Then the rich man begged Abraham to let him warn his five brothers of their fate if they did not reform. But again Abraham refused, replying, "They have Moses and the Prophets" to guide them in their duty to care for the stranger within their gates (Luke 16:19–31).

THE MIRACLES

Miracles are supernatural events that occur beyond the bounds of nature. When miracles occurred through man, with man as the medium, it was believed that man was only the instrument of an omnipotent God. Miracles have played a major role in Christianity, the Resurrection of Christ and the Virgin Birth being two of the most important. In Christian art, two or more miracles often appear in sequence, and in combination with the parables.

The Marriage at Cana was Christ's first miracle, and took place at a wedding feast attended by Mary, Christ, and

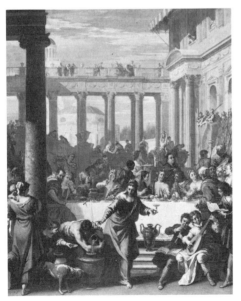

Ricci, *The Marriage at Cana*

the disciples. When the wine ran out, Christ ordered the servants to fill six huge stone water jugs with water. The water miraculously turned into wine (John 2:1ff.).

Miraculous Draught of Fishes is St. Luke's version of the calling of Simon Peter to be the first apostle. While preaching at the lake of Gennesaret, Christ directed Peter to put out his nets for fish. Peter protested but obediently lowered his nets "and they enclosed a great multitude of fishes; and their net brake. . . . And Simon Peter . . . was astonished . . . at the draught of fishes which they had taken. . . . And Jesus said unto Simon, 'Fear not, from henceforth thou shalt catch men' " (Luke 5:4–10). A similar miracle occurred after the Resurrection when Christ appeared for the third time to the disciples at the sea of Tiberias. The sequence is the same, with the disciples following Christ's directions and subsequently eating the fish and bread that were miraculously provided (John 21ff.). In this miracle, Christ usually wears the cruciform halo and carries the banner of the Resurrection.

Christ Healing the Blind Men was an important miracle of healing, an influential part of Christ's mission. "The blind men came to him: and Jesus saith unto them,

Healing of the Blind Man,
12th cent. Spanish

'Believe ye that I am able to do this?' They said unto Him, 'Yea, Lord.' Then touched He their eyes, saying, 'According to your faith, be it unto you.' And their eyes were opened" (Matt. 9:28–29).

Healing the Lame and Halt occurred at the pool of Bethesda, known for its wondrous healing properties. Christ noticed an old man who was too feeble to crawl into the pool in order to be cured. Christ asked him,

Christ Healing the Lame and Halt, 13th cent. Byzantine

" 'Wilt thou be made whole?' The man answered him, 'Sir, I have no man . . . to put me into the pool . . . while I am coming, another steppeth down before me.' Jesus saith unto him, 'Rise, take up thy bed, and walk.' And immediately the man was made whole" (John 5:6–9). The lame man is usually shown picking up his cot and carrying it off.

The Raising of Lazarus. Lazarus had already been dead for four days when Christ arrived in Bethany. (In illustrations Martha, Lazarus' sister, may hold her nose or cover

Van Gogh, *The Raising of Lazarus* (after Rembrandt)

her face.) But Jesus went to the tomb and "cried with a loud voice, 'Lazarus, come forth.' And he that was dead came forth, bound hand and foot with grave-cloths; and his face was bound about with a napkin. Jesus saith unto them, 'Loose him, and let him go' " (John 11:43–44).

Christ Stilling the Tempest. Christ was on a sea voyage with his disciples when a great storm arose and the ship foundered. Terrified, his disciple woke him. Christ rebuked them: " 'Why are ye fearful, O ye of little faith?'

Vellert, *Christ Stilling the Tempest*

Then He arose, and rebuked the winds and the sea; and there was a great calm. But the men marveled, saying, 'what manner of man is this, that even the winds and the sea obey him!' " (Matt. 8:25–27).

The Miracle of the Loaves and the Fishes is Christ's most dramatic miracle of feeding. After the death of John the Baptist, Christ went into the desert to reflect, and was followed by a multitude, to whom He preached. When mealtime arrived, Christ ordered food. "How many loaves have ye? go and see.' . . . They say, 'Five, and two fishes.' And He commanded them to make all sit down upon the green grass. And they sat down in ranks, by hundreds, and by fifties. And when He had taken the five loaves and the two fishes, He looked up to Heaven, and blessed, and brake the loaves. . . . And they did all

Miracle of Loaves and Fishes, 14th cent. Italian

eat, and were filled. . . . And they that did eat . . . were about five thousand men" (Mark 6:38ff.).

The Miracle of Walking on Water occurred when Christ ordered the disciples to cross the Sea of Galilee while He remained behind to pray. A storm arose which threatened to sink the boat. "But the ship was now in the midst of the sea, tossed with waves: for the wind was contrary. And in the fourth watch of the night Jesus went unto them, walking on the sea" (Matt. 14:24–27). The title of this miracle is changed to the **Navicella** when Peter the Apostle is included. Peter, to test Christ, asked if he could walk on the water to join Him. Christ agreed, but Peter lost heart. "And immediately Jesus stretched forth his hand, and caught the sinking Peter, and said unto him, 'O thou of little faith, wherefore didst thou doubt?' " (Matt. 14:30–31). Jesus stands on the surface of the water and stretches His hand out to Peter, who is partially submerged.

The Miracle of Devils Cast Out. People who were emotionally distressed were believed to be possessed with devils, which had to be cast out. The devil-spirit often is shown literally emerging from the mouth or body of the afflicted. In one such instance, "They brought unto Him all that were diseased, and them that were possessed with devils. . . . And He healed many that were sick of divers diseases, and cast out many devils; and suffered not the devils to speak, because they knew Him" (Mark 1:32–34).

KINGS

A king symbolizes the governing principle, a male sovereign of superior judgment, wisdom, and power. One of the duties of the Holy Ghost is to direct the actions of kings. During Coronations in England, a duke passes before the sovereign with a scepter surmounted by a dove, symbol of the Holy Ghost.

King, 12th cent. French

KNIGHTS

The knight personifies a superior human being, master over his mount, his mind, and his morals. The rigorous

training he received according to the traditions of chivalry sought to create a superior being. During the Middle Ages the knights formed a permanent military class, including landholders as well as nobility. The knight is the guardian protector, armor protecting him and his horse both physically and spiritually from evil and destruction. The great saint-knights of Christianity, St. Michael, the archangel, St. George, St. Ignatius Loyola, and St. Joan, illustrate through their lives the triumph of good over evil.

LAST JUDGMENT
LIBERAL ARTS

THE LAST JUDGMENT

The Last Judgment is the final scene in the Christian drama. Since the major emphasis in the Christian religion is on the afterlife, rather than the present, the Last Judgment provides an opportunity to dramatically contrast the glories of Heaven with the torments of Hell. It was an opportunity for the Church to present the rewards of a virtuous life and to make life on earth with its trials and disappointments more bearable. The concept of a Last Judgment scene had its origins in the Old Testament (Job 24:25, Dan. 7:9–10). The concept of a decisive Doomsday, when the meek and humble are judged in the same balance scale with the high and mighty, was incorporated as one of Christianity's basic tenets.

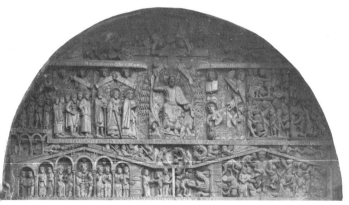

Last Judgment, 12th cent. French

In early Christian art the Last Judgment is a simple composition with Christ clothed in a long robe dividing the sheep, symbolizing the righteous, from the goats, symbolizing the damned (Matt. 25:32–33). A popular

subject for church sculpture, especially in the tympanum above the central doorway on the west facade of a church, Christ as Judge is the top central figure, seated on his throne of glory, or on a rainbow, or enclosed in a mandorla (see *Halo*). Sometimes the four-and-twenty elders, on their thrones with their crowns, are included (Rev. 4:2–3). Christ's right hand blesses the righteous, while His left rejects the damned. He is surrounded by a host of angels, playing musical instruments; Gabriel may sound the trumpet. Mary and John the Baptist may be included as the human intercessors between man and God. Rows of saints, apostles, martyrs, kings, and powerful patrons may be ranged around them. All is joy and serenity in Heaven, as contrasted with the confusion of earth and the fiery torment of Hell. The dead arise from their graves, pushing aside their tombstones. St. Michael, the Archangel, dressed in armor, holds the scale in which the souls are weighed. The damned are jammed onto one balance, which Satan may tip in his favor; the condemned, committed to a life of eternal torment, are driven by demons into the fiery mouth of Hell. On the left, the blessed, serene and unblemished, are attended by angels as they await their assignment in Heaven. Composition varies according to local legend and artistic ingenuity.

LIBERAL ARTS

The classification of the arts into two categories, *artes vulgares* and *artes liberales,* goes back to ancient Greece, when the "liberal" or freeborn citizens could study intellectual subjects, while slaves and foreigners were limited to more practical fields. A handbook by Martinus Capella, an obscure sixth-century African grammarian, formalized the system. The liberal arts were divided into two parts: the *quadrivium,* the sciences, which concentrated on physical reality and included geometry, arithmetic, astronomy, and music; and the *trivium,* which included grammar, rhetoric, and dialectic. The liberal arts are personified as women carrying appropriate attributes,

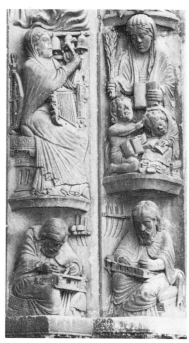

Liberal Arts, 12th cent. French

often accompanied by outstanding masters of their subject. They appear frequently during the Middle Ages and the Renaissance.

THE QUADRIVIUM

Geometry carries a globe and pair of compasses. Her robe is embroidered with the signs of the Zodiac and stars. In front of her is a table with a sand surface upon which she draws geometrical equations. The figure of Geometry is often accompanied by the Greek philosopher Pythagoras.

Arithmetic is a stately goddess with long, agile fingers to aid her in her calculations. A multiplying ray extends from her forehead.

Astronomy is crowned with starbursts emanating from a ring of flame. She has great golden wings, and carries a book and astronomical instruments.

Music (Harmonia) leads a procession of poets, musicians, goddesses, the Three Graces, all singing and making music. She is dressed in a robe covered with twinkling discs.

THE TRIVIUM

Grammar wears a toga, and holds inkpot, pens, candlestick, and scalpel, to correct physical speech defects.

Rhetoric is a beautiful armed maiden. She wears a helmet and carries a shield or other weapons. Her breast is covered with precious stones, her cloak elaborately embroidered. Her companion is often the Roman philosopher Cicero.

Dialectic is a thin woman, with her hair dressed in elaborate rolls which represent syllogism, a Greek form of logic. She holds a serpent, symbol of wisdom, a wax tablet to write on, and a fishhook.

MARY

Mary is the supreme woman, second only to her Son as a popular subject in Christian art. She is more approachable than the three members of the Trinity, and is the major intercessor between man and God.

The cult of the Virgin gained impetus after the Council of Ephesus in 451 A.D., when Mary was officially proclaimed the Mother of God. The few specific references to Mary in the Bible are in the Gospel of St. Luke. Apocryphal writings, such as the Protevangelium of St. James, fill in details in Mary's life. By the thirteenth century the stiff, frontal, formal madonnas of the early Christian, Byzantine, and Romanesque periods had changed into the graceful, bending, gently smiling and human Mary of the Gothic period. This was the height of the cult of the Virgin. Scores of soaring cathedrals and simple parish churches were dedicated to her. Chivalry introduced a romantic note, as well as the title "Our Lady." Brotherhoods and orders were devoted to her. Medieval literature had a strong influence on medieval art relating to the Virgin. *The Golden Legend* was widely used for inspiration. The visions of St. Bridget of Sweden, the writings of Bernard of Clairvaux, and Great Mirror (*Speculum Majus*) of Vincent de Beauvais, all influenced the art devoted to Mary. Religious fervor became humanized, and so were images of Mary.

Mary generally wears a cape of blue, the color of constancy, over a long dress of red, the hue of suffering and love. If her robe is white, it designates purity; if purple, royalty.

The Virgin Mary appears in Christian art in two roles. First, there are the narrative events of her life and parentage, which intertwine with those of Christ. The second

aspect is the devotional one in which Mary, either alone or with the Christ Child and other saints, is venerated as intercessor between man and God.

LIFE OF THE VIRGIN

Joachim and Anna, or Anne, the parents of Mary, were an elderly couple of the royal house of David. They yearned for children, and even Joachim's offer to sacrifice a lamb at the Temple was rejected because of their barrenness. In sorrow Joachim retired alone into the wilderness to fast for forty days. Angels, or the archangel Gabriel alone, appeared to them separately—to Anne in her garden and to Joachim in the fields tending his sheep —to announce the coming of a child, Mary, to them. (This event, sometimes confused with the Annunciation to Mary, is interpreted as a forecast of the Virgin Birth of Christ.)

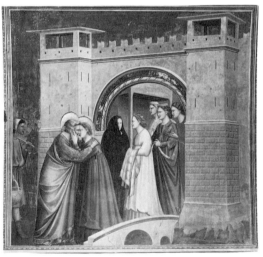

Giotto,
*Meeting of
Joachim
and Anna*

The couple is reunited at the entrance to Jerusalem, the **Meeting at the Golden Gate,** where they solemnly embrace. The Golden Gate or arch to the walled city is itself a symbolic reference to the Immaculate Conception of Mary. Joachim may place his hand on Anne's belly, confirming her pregnancy. Anne often wears a red dress and green cape, symbolizing divine love and immortality. Joachim may carry a lamb or doves in a basket.

The Immaculate Conception of the Virgin Mary is a major devotional theme, and refers to the dogma that "the Blessed Virgin Mary, from the first instance of her conception, was preserved from all stain of Original Sin." Officially accepted by the Roman Catholic Church in 1854, it had been "steadfastly believed by all the faithful" for centuries. In Immaculate Conception compositions the young Mary, wearing blue and white, is bathed in the sun, floating among clouds and surrounded by cherubim, her feet on a crescent moon (Rev. 12:1).

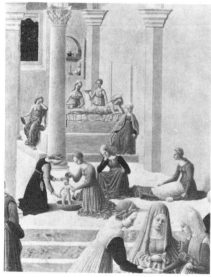

Master of the Barberini Panels,
The Birth of the Virgin (det.)

The Birth of the Virgin shows Anne reclining in bed, receiving the congratulations of her friends while handmaidens attend the infant Mary. The setting is usually sumptuous, as befits a wealthy royal family.

The Education of the Virgin shows Mary being taught to read by her mother. Or she may be shown embroidering or weaving, attended by Anne or angel companions.

Presentation of Mary in the Temple. As Anne prayed in the garden before the conception of Mary, she promised to dedicate her child to the service of God. Accordingly,

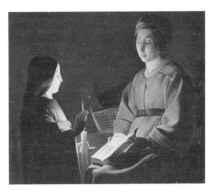

de la Tour,
*The Education
of the Virgin*

when Mary was three or four, she was presented to the doctors in the Temple to begin her service to God. Mary is shown ascending the Temple steps. This was a popular subject because it was a figure for the novice entering the convent. She often holds a cage of doves, symbols of purity and humility. When Mary spins or weaves a purple thread she is preparing the "Veil of the Temple."

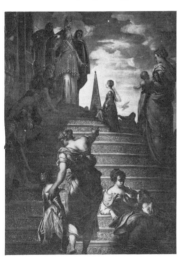

Tintoretto,
*Presentation in
the Temple* (det.)

Betrothal and Marriage of the Virgin. At the age of twelve or fourteen, Mary was told by the high priests that the time had come for her to marry. She was reluctant but Zacharias, the high priest, assured her that he had received instructions from an angel, who directed him to assemble all the eligible men from the House of David.

Betrothal of the Virgin, 14th cent. Italian

The men were to leave their rods or staffs in the Temple overnight. The following morning the staff of Joseph, the carpenter of Nazareth, was found sprouting blossoms (*see also Flowers*). Joseph, the oldest candidate, was the chosen one. In representations the rejected suitors break their staffs in disappointment and frustration. Joseph holds his flowering staff, on which a dove often perches. The marriage takes place as Joseph places a ring on Mary's finger. Mary is attended by her handmaidens, while the rejected suitors stand behind Joseph.

The Annunciation is the moment when the archangel Gabriel informs Mary that she is to be the mother of Christ (Luke 1:28–31). The Annunciation takes place either in an enclosed garden or loggia or in Mary's house. The time is spring—an allusion to St. Bernard's description, "The flower willed in the time of flowers to be born of a flower." The enclosed garden, a reference to Mary's virginity, comes from the Song of Solomon (4:12). A rose and/or a lily in a vase also refers to the Song of Solomon (2:1–2). Other accessories relating to cleanliness may appear in indoor settings—a water jar, a towel, a glass, a washbasin. The Virgin is generally kneeling in prayer, or reading a devotional book. Sometimes she is weaving the Veil of the Temple, a reference to the apocryphal gospel of James. Gabriel appears on the left. He holds a scepter, symbol of power as a herald of God, or a white madonna lily, the Virgin's flower. (In Sienese paintings, Gabriel may hold an olive branch, symbol of

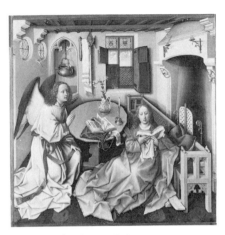

Campin, *The Annunciation,*
The Merode Altarpiece, central panel

peace, instead of the lily, which was the symbol of
Florence, Siena's rival.)

The Holy Ghost, during the act of Incarnation, may be
represented by the dove, or by rays of light supporting a
tiny infant bearing a cross, prophecy of the Crucifixion.
The Incarnation is the moment when the Holy Ghost
enters Mary's body and Christ is conceived. Divine rays
leading to Mary's ear indicate "that the word was made
flesh" (John 1:14).

The Visitation. Mary visited her cousin Elizabeth after the
Annunciation and stayed for three months. In this inci-
dent the two women, obviously pregnant, greet each
other. They embrace, their hands resting on each other's
swelling bellies, as if to reaffirm their wondrous physical
state. Mary, the younger, is generally on the left, wearing
a blue cloak. Elizabeth, an old woman, is now pregnant
with John the Baptist, her first child (Luke 1:43).

The Nativity illustrates the birth of Christ. The key figures
are Mary, Joseph, and the Infant Jesus. The setting is a
barn or stable, with the ox and ass in attendance, al-
though this is not mentioned in the Gospel account. The
holy crib is the manger (Luke 2:7). The symbolism of the
ox and ass varies, but their presence may come from

Att. to Master Heinrich
of Constance,
The Visitation

Isaiah, "The ox knoweth his owner, and the ass his master's crib" (Isa. 1:3). The ox can be a symbol of sacrifice and may refer to the Jews, while the ass represents the Gentiles; conversely, the ass, because of its obstinacy, represents the Jews and the ox the Gentiles. The broken-down stable, as a setting for the Nativity, is a reference to the breakdown of the old law of the Jews. A peacock among the rafters is a reference to immortality. When Joseph holds a lighted candle, it symbolizes the light that is brought into the world by his son. A conical hat identifies him as a Jew. Sometimes the setting is a cave, a reference to the tomb of Christ, or a combination of a stable outside of a cave. When Mary is shown seated, the painless nature of the birth is emphasized. When she reclines,

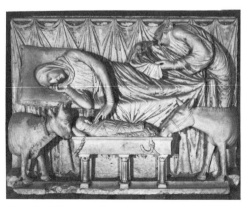

Nativity, 13th cent. French

with Joseph sitting at her side and the Infant raised above her on a kind of manger-altar, it suggests Christ's future sacrifice. Two midwives, Zebel and Salome, are sometimes included. Salome may display a withered hand, her punishment for doubting the virgin birth. In the late Middle Ages, Mary falls to her knees adoring the Christ Child in prayer, with Joseph at her side. The inspiration for this composition came from the *Revelations of St. Bridget,* a very popular inspirational work of 1370.

Other symbolic details included in Nativities are angels singing, "Glory to God in the highest and on earth peace to men of good will" (usually written in Latin on banners surrounding them). The apple tree may be blooming, again a reference to Solomon's song (8:5). The iris, the lily, and straw or wheat may be included (*see Flowers*).

Purification of the Virgin is essentially the same scene as the Presentation in the Temple (*see Jesus Christ*); when Mary dominates, the event is called The Purification of the Virgin. Jewish law forbade women to enter the Temple for thirty-three days after the birth of a son (Lev. 12:4).

The Passion of Our Lady continued after the death of Christ, linking the sufferings of mother and son. The figure of the mourning Mary develops into a subject of devotion called the *Pietà,* as she holds the dead body of her son. In the famous example by Michelangelo, Mary is in the traditional pose of the grieving woman, her eyes downcast, her head bowed, her body numb as she supports the dead weight of the corpse. She is the *Mater Dolorosa,* the mourning mother. The narrative incident that the *Pietà* depicts is both a factual representation and a devotional image.

The Lamentation is an enlarged version of the Pietà, incorporating mourning figures mentioned in the Gospels: Mary Magdalene, St. John, Mary the mother of St. James the Less, and others.

The Death or Dormition of the Virgin. After the Crucifixion, Mary, according to tradition, lived with St. John.

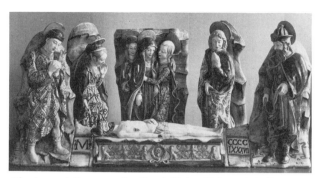

The Lamentation over the Dead Christ, 15th cent. Italian

The two traveled about visiting places associated with the life of Christ, often in the company of disciples and the Apostles. Mary prayed for death, and an angel in reply appeared to her holding a palm, symbol of victory over death. Mary asked that the Twelve Apostles be brought to her, then fell into a deep sleep, the dormition, and died peacefully. Christ appeared surrounded by angels and carried Mary's soul into Heaven. The soul is represented by a small, wrapped figure.

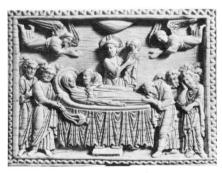

The Death of the Virgin, 11th cent. Byzantine

The Assumption. Three days later Mary's body was raised out of the coffin and reunited with her soul in Paradise. With the doctrine of Assumption, the Roman Catholic Church emphasized the role of Mary as mediator for human beings on earth who hoped for salvation within the protection of the Church. The Assumption of the Virgin was declared dogma by the Catholic Church in 1951.

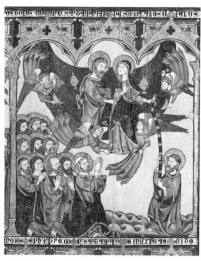

The Assumption of the Virgin (det.),
14th cent. Spanish

In the Assumption, Mary is being received by God while she lowers her belt, or girdle, down to St. Thomas, who requested proof of her assumption. This relates the Legend of the Virgin's Girdle. (The belt, or girdle, was a symbol of chastity when worn by virtuous women.) (*See also Jesus Christ: Doubting Thomas.*)

The Coronation of the Virgin concludes Mary's narrative. Mary kneels before the throne of Heaven, usually sur-

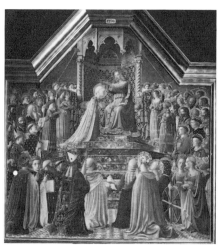

Fra Angelico,
*The Coronation
of the Virgin*

rounded by the Court of Heaven, while Christ crowns
her Queen of Heaven.

DEVOTIONAL IMAGES OF MARY

Portrayed alone, her face calm, her hands folded in
prayer, Mary represents the Ideal Woman, the Human
Mother of Christ, the second Eve. Holding a book, she
becomes the Virgin of Heavenly Wisdom, patroness of
students. Seated on a throne surrounded by angels, she
is the Queen of Angels. Surrounded by a mandorla or
radiance, she is the Virgin in Glory.

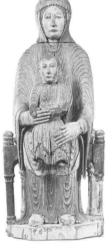

Virgin and Child,
12th cent. French

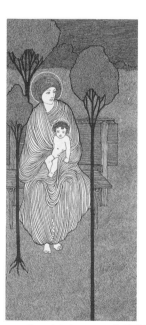

Bradley, *Madonna and Child*

In a group with Christ and John the Baptist, with
Christ in the center, the composition is entitled the
Deesis (Greek for "the entreaty"). Mary is the intercessor
for the flesh, John the intercessor for the spirit.

Madonna in Adoration represents Mary kneeling on the
ground adoring the Infant Christ in prayer. When she is

seated on the ground with Him, the composition is entitled Madonna of Humility.

Madonna Enthroned or in Majesty shows Mary as Queen of Heaven, often surrounded by angels and saints. The Christ Child may be on her lap.

Madonna of Mercy (Misericordia) features Mary as a large figure sheltering within her cloak crowds of the faithful —tiny kneeling figures.

Madonna Queen of Heaven features Mary crowned with twelve stars, holding a scepter, and standing on a crescent moon or suspended in space (*see above, Coronation of the Virgin*).

Madonna of the Rose Garden places Mary in a rose bower or enclosed garden filled with roses.

Madonna of Sorrow is Mary weeping for the death of Christ. Her hands are clasped in prayer, and she may wear the Crown of Thorns.

SYMBOLS ASSOCIATED WITH MARY

The **apple** is a reference to Mary as the second Eve.

A **belt** or **girdle** refers to the Legend of the Virgin's Girdle (*see Life of the Virgin: Assumption*).

A **book,** when closed or sealed, is a reference to Mary's chastity; when open, wisdom.

A **cedar of Lebanon** equates Mary's beauty and dignity with that of the cedar.

A **fountain** is a reference to the Song of Solomon (4:12).

A **garden, enclosed or walled,** is another reference to the Song of Solomon (4:12).

A **closed gate** alludes to Mary's virginity.

The **lily** (*fleur-de-lis*) is the flower of the Annunciation (*see Flowers*).

A **mirror** refers to Mary's nature as a reflection of God.

A **crescent moon** refers to Solomon's song (6:10). Mary

often stands on the crescent moon in compositions representing the Immaculate Conception.

An **olive branch.** *See Life of the Virgin: Annunciation.*

A **palm branch** is a symbol of Mary's triumph over sin and death.

The **rose** is the symbol of Mary as Mystical Rose, the "rose without thorns," i.e., without sin (*see Flowers*).

A **serpent** is used with Mary when she is seen as the new Eve in fulfillment of the Old Testament prophecy.

Stars, in a group of twelve around Mary's head, used in the Immaculate Conception, derive from the Apocalypse (Rev. 12:1). A single star is seen as Mary's virginity—she bore Christ without loss of her chastity as a star sends out its light at night without losing its force and brightness. One star also is the attribute of Mary as Star of the Sea, as Star of Jacob (Num. 24:17).

The **sun** and **moon** are another reference to Mary as the woman from the Apocalypse (Rev. 12:1).

A **tower** is a reference to the Song of Solomon (4:4).

The **unicorn** is a symbol of chastity and Christ since the wild, shy unicorn can be captured only by a virgin. It may appear in Annunciation scenes (*see Unicorn*).

A **well,** closed up, refers to Mary's virginity (Sol. 4:12).

SEVEN JOYS AND SORROWS OF MARY

In the Middle Ages a series of devotions grew up around the events of Mary's life. They were called the Seven Joys of Mary, the happy events in her life as the mother of Christ—the Annunciation, the Visitation, the Adoration of the Magi, the Presentation in the Temple, Christ among the Doctors, the Assumption, and the Coronation. The Seven Sorrows of Mary represent the tragic events in her life—the Prophecy of Simeon at the Presentation in the Temple, the Flight into Egypt, Christ Lost on the Way to Jerusalem, the Betrayal of Christ, the Crucifixion, the Deposition, and the Entombment. (*See also Jesus Christ.*)

MISCELLANEOUS OBJECTS

Anchor. Early Christian symbol for the Cross, for salvation, hope, constancy. (*See Virtue (Hope), St. Nicholas of Myra.*)

Ark of the Covenant. Sacred gold-covered chest containing the tablets of the Law which God dictated to Moses.

Armor. Symbol of chivalry often worn by the warrior saints. An allusion to the protection of the Church against evil. (*See Sts. George, John, Michael.*)

Arrow. Indicates those who have dedicated their lives to God. Also sign of the plague. (*See Sts. Sebastian, Teresa, Ursula.*)

Ax. Symbol of destruction. (*See Sts. Joseph, Matthew.*)

Bag of money. *See Instruments of the Passion.*

Balls, three. *See St. Nicholas.*

Banner. *See Flag.*

Basin and ewer. *See Instruments of the Passion.*

Bat or club. *See Instruments of the Passion, St. James the Less.*

Beehive. Attribute of St. Bernard of Clairvaux. Symbol of eloquence, of "honeyed words."

Bell. Calls the faithful to worship, is the voice of God. General symbol for saints who exorcised devils, and lepers whose bells warn of their approach. (*See St. Anthony Abbot.*)

Belt or girdle. Symbolic of those prepared to serve the Lord. When worn by prophets, it signifies humility: general symbol of chastity. (*See also Cord, and Legend of the Virgin's Girdle, under Mary*).

Boat. *See Ship.*

Book. Symbolizes learning, teaching, and writing. Specifically it represents the Bible, and is held by the Evangel-

ists, the Doctors of the Church, or the Apostles. (Prophets hold the scroll, to represent the Old Testament, as it predates the bound book or codex, which did not come into use until the fourth century.) An open book with the Greek letters AΩ represents Christ (*see Initials*). A closed book means mystery (the sealed book of the Apocalypse, greatest secrecy); an open book means the dissemination of wisdom and truth through knowledge. A book combined with pen and ink indicates a writer. (*See also Sts. Paul and Bartholomew.*)

Bow. Represents war, hostility, or temporal worldly power.

Box. As a container, sometimes symbolizes the heart, the brain, or the womb. (*See also Jar, Sts. Cosmas and Damian.*)

Bread. The staff of life, the Body of Christ in the Eucharist. Attribute of St. Mary of Egypt, who took three loaves with her into the desert; St. Paul the Hermit, whose bread was delivered by a raven; and St. Dominic, who obtained bread for his monks through divine intervention.

Candle. Lighted, a symbol of individual life. When held by St. Joseph in the Nativity, it represents the light which Christ's birth has given the world. (*See also Religious Objects.*)

Carpenter's rule or square. See *Sts. Joseph and Thomas.*

Cauldron. Receptacle for evil forces, the opposite of the skull. (*See St. John the Evangelist.*)

Chains or fetters. May be included in Instruments of the Passion, referring to the Flagellation. Also an attribute of St. Leonard, who worked with prisoners.

City. In medieval decoration, often refers to the City of God, the heavenly Jerusalem described by St. John in the Apocalypse.

Coat or cloak. General symbol of dignity. (*See also St. Martin.*)

Coins. See *Instruments of the Passion.*

Column. A single column included in the Infancy of Christ predicts the Passion and the column to which He will be bound for the flagellation (*see Instruments of the Passion*). Falling columns, topped with statues, may be a detail in the Flight into Egypt (*see Jesus Christ*).

Comb. Attribute of St. Blaise, who was scratched by a carding comb as part of his martyrdom.

Cord. Worn as belts by monks to recall Christ's flagellation; it symbolizes chastity. May have three knots, emblematic of the Trinity.

Cornucopia. Signifies fruitfulness and plenty.

Crown. Emblem of victory, honor, sovereignty, the sign of royalty. As a saintly attribute, the crown denotes royal blood or victory over sin and death. A wreath is another form of a crown. (*See Instruments of the Passion, Mary.*)

Crutch. *See St. Anthony Abbott.*

Cup. Symbol of Christ's Agony in the Garden. Cup with club is an attribute of Archangel Chamuel, who is supposed to have comforted Christ in Gethsemane. Cup with wafer is a symbol of the Holy Eucharist or Holy Communion. (*See St. Barbara.*)

Dagger. *See St. Lucy.*

Dice. *See Instruments of the Passion.*

Door. Symbol of entry. A feminine symbol which often appears in Annunciations.

Egg. Represents purity and chastity, as the chicken is preserved within the shell. Also a symbol of fertility.

Feather. Symbolizes faith and contemplation according to St. Gregory. The quill pen suggests the Word of God. (*See St. Barbara.*)

Flag or banner. White with a red cross symbolizes victory. Such a banner held by the Lamb of God represents Christ's victory over death. Christ always carries this banner after the Resurrection and in the Descent into Hell. (*See Sts. George, James, Ursula, and missionary or military saints in general.*)

Fountain. A symbol of salvation. Christ is identified with the fountain or the "well of living water," and his blood at the Crucifixion may flow from the wounds into a basin and thence into a chalice.

Garden. The walled garden, or *hortus conclusus,* was one of the many metaphors of chastity used to describe the Virgin Mary, based on the Song of Solomon. (*See Mary.*)

Gate. The gate suggests both entrance and exit. Both Paradise and Hell are entered through gates. (*See Mary.*)

Glass. Symbol of the Virgin birth. A medieval hymn likened the birth of Christ to the phenomenon of light passing through a pane of glass without shattering it. Glass is a symbol for the Incarnation and purity in general.

Globe or orb. Symbol of the world. It is a sign of sovereignty and worldly power when held by God the Father or by Christ. Surmounted by a cross, the globe symbolizes the triumph of Christ and His Church over the world.

Grille or gridiron. *See St. Lawrence.*

Hammer. *See Instruments of the Passion.*

Harp. The harp symbolizes all music which glorifies God. Attribute of David. (*See Old Testament, St. Cecilia.*)

Hatchet or halberd. *See Ax.*

Horns. Ancient symbol of strength. When worn on a man's brow or helmet, horns indicate God-given prosperity and power. Moses often wears horns, as may normally unhorned animals. Also an attribute of the devil.

Hourglass. Attribute of Time, signifying the brevity of life. The skeleton, symbol of Death, often holds an hourglass.

Incense. The fumes of burning incense symbolize the ascent of prayer to God.

Jar. *See Mary Magdalene.*

Keys. Two or three crossed keys are the attribute of St. Peter, to whom God gave the "keys to the kingdom." They appear on the papal coat of arms. A bunch of keys hanging from a belt is an attribute of St. Martha, patron saint of good housekeeping.

Kitchen utensils. Attributes of St. Martha of Bethany.

Knife. Associated with vengeance, death, and sacrifice. (*See St. Bartholomew, St. Peter Martyr.*)

Ladder. Symbol for Christ's deposition from the cross. (*See Instruments of the Passion, Old Testament: Jacob's Dream.*)

Lamp or lantern. Symbol for intelligence, wisdom, piety. (*See Instruments of the Passion, Jesus Christ: Parables, Sts. Christopher and Lucy.*)

Lance. Attribute of St. Longinus, the centurion who pierced the side of Christ at the Crucifixion. General attribute of warrior saints. (*See Instruments of the Passion, Sts. George, Theodore, and Thomas.*)

Mirror. Symbol of the Virgin's purity and chastity. (*See Mary.*)

Money (coins). *See Instruments of the Passion, Sts. Lawrence, Matthew, and Nicholas.*

Mortar and pestle. *See Sts. Cosmas and Damian.*

Musical instruments. Angels frequently play musical instruments in paintings of the Virgin and Christ Child. (*See St. Cecilia.*)

Nails. *See Instruments of the Passion.*

Oil. Symbol of consecration. (*See Sacraments.*)

Organ. *See St. Cecilia.*

Palette, brushes, and other artist's materials. *See St. Luke.*

Pen and inkwell or inkhorn. General attributes for the Evangelists, the Doctors of the Church, outstanding scholars and writers.

Pillar. *See Column.*

Pincers, pliers, or shears. *See Sts. Agatha and Apollonia.*

Purse. *See Money.*

Ring. General symbol for an unbreakable union, or for eternity. A bishop's ring signifies his union with the Church, a nun's ring her spiritual marriage to Christ.

Robe. *See Instruments of the Passion.*

Rod. *See Jesus Christ, Mary (Betrothal).* Also an Old Testament symbol of Aaron, whose rod mysteriously burst into bloom and bore almonds.

Rope. *See Instruments of the Passion.* A symbol for Judas, who hanged himself with a rope.

Ruins. Usually classical in style, signs of the decay of the pagan world.

Rule. *See Sts. Joseph and Thomas the Apostle.*

Sandals. *See Shoes.*

Saw. *See St. Joseph.* The Apostle St. Simon Zelotes also has the saw as an attribute, because he was sawed to death.

Scales. Symbol of weighing and of justice. (*See Angels, St. Michael.*) They are also held by Justice, one of the Virtues.

Scepter. Symbol for kingly power, held by angels and kings.

Scourge. *See Whip.*

Scroll. General symbol for authorship, writings, or wisdom. (*See Sts. Ambrose, Gregory, James the Great.*)

Scythe. Destructive symbol, suggesting death; often held along with the hourglass by Time.

Shell, scallop. General attribute of pilgrims who had visited tomb of St. James the Great (Santiago) in Compostela, Spain. A scallop shell with drops of water symbolizes baptism. St. John often pours the water from a scallop shell over the head of Christ. (*See Apostles: St. James the Great.*)

Ship. Symbol for the Church, often with Christ or St. Peter as helmsman. "The world is a sea in which the Church, like a ship, is beaten by the waves, but not submerged," a simile of St. Hippolytus, may have inspired this image. The image lingers in calling the central portion of the church the "nave." As an Old Testament reference, the ship stands for Noah's Ark. It also appears in the catacombs, as a symbol for the Church, which could survive any disaster. General attribute of saints connected with the sea.

Shoes or sandals. Discarded, with the owners standing unshod near them, implies that the owner is standing on holy ground. This may have its origins in God's command to Moses to remove his sandals before approaching the Burning Bush, since it grew in holy ground. Shoes or sandals appear with the hermit saints, as an emblem of humility. Attribute of St. Crispin, patron saint of shoemakers and leather workers.

Skeleton. See *Human Body.*

Skull. See *Human Body.*

Spear. Symbol of spiritual warfare. (*See also Instruments of the Passion.*)

Sponge attached to a pole. See *Instruments of the Passion.*

Staff. Symbol of pilgrims, hermits. In addition to its practical use, the staff suggests that the Incarnation of Christ was a long pilgrimage.

Stake. Refers to burning at the stake as a method of martyrdom.

Stones. When held in the hand of a saint, stones suggest mortification of the flesh. (*See St. Stephen.*)

Sword. General symbol for martyrs who died by the sword, and is frequently held by warrior saints and the Virtue Fortitude. A flaming sword identifies Jophiel, guardian of the Tree of Knowledge, who drove Adam and Eve out of Paradise. (*See Apostles: St. Paul.*)

Sword and scales. Symbols of justice, attributes of St.

Michael. The sword is a reminder of his battle with Lucifer; the scales, of his position as Weigher of Souls in the Last Judgment.

Tablets. Symbolize teaching. Two tablets engraved with letters or numbers represent the Ten Commandments, and the old Jewish faith, Synagogue, as opposed to the new, the Church.

Throne and its accessories. Symbols of the majesty of Christ. (See also Mary.)

Torch. Flaming, represents Christ as the Light of the World. Attribute of martyrs burned at the stake. (See also Instruments of the Passion, Sts. Dorothy and Dominic.)

Towel. White and spotless, suggests purity; often combined with other articles of cleanliness, such as the pitcher and basin. (See Mary.)

Tower. An oblique reference to Mary's chastity. (See Mary, St. Barbara.)

Urn. See Vase.

Vase. A feminine symbol, often seen in Annunciations, holding the lily. (See Mary.)

Veil. Symbolizes modesty and chastity. A veil with the face of Christ imprinted on it, known as the vernicle, is the attribute of St. Veronica. (See Instruments of the Passion, St. Veronica.)

Wafer. Symbol for the Eucharist, or the manna from heaven in the Old Testament.

Wallet. See Sts. Matthew and Nicholas.

Washbasin. Symbol of cleanliness, the washbasin and pitcher are frequent accessories in Flemish paintings of the Virgin Mary. (See also Instruments of the Passion.)

Wheel. A never-ending, revolving circle or ring suggests supreme power. Wheels of fire often support the throne of God as described in the vision of Ezekiel, and were rolled down hillsides as part of medieval midsummer festivals. The Wheel of Fortune is an allegory for the transitory quality of life and of fortune, the futility of the

pursuit of worldly vanities and possessions. (*See also St. Catherine of Alexandria*.)

Whip or scourge. Indicates punishment through flagellation. In the case of St. Ambrose, the whip denotes his expulsion of the heretics from Italy. Attribute of St. Vincent, who was martyred by beating.

Window. Since it is an opening in a wall, suggests penetration without violation and destruction. The glass in the window further emphasizes this concept.

NUMBERS

Numbers represent not only quantities but ideas; their symbolism is very ancient.

Zero is nonbeing, symbolic of potential force, like the egg.

One is the symbol of unity and divinity.

Two suggests the dual nature, human and divine, of Christ.

Three represented the supreme power to the Greeks, the number of completion with a beginning, a middle, an end. Three, an indivisible number, is associated with the Trinity in Christian art. The triangle represents three and the Trinity.

Four is related to the earth, terrestrial space, the material world, and the four points of the compass.

Five represents the five wounds of Christ. It is also symbolic of man, the four limbs of the body with the head controlling them.

Six is the number of the Creation, since the world was created in six days.

Seven, the sum of three plus four, the spirit and the body, represents man. It is the number of perfect order, since on the seventh day, after creating the world, God rested. Seven appears often as a magic number in both the Old and the New Testaments; i.e., Jacob, as an act of submission, bowed seven times before his brother Esau.

Eight is the number of regeneration, its spiraling shape, eternally in motion. It is the number emblem for bap-

tism, and baptismal fonts are often octagonal. Eight represents Resurrection, for on the eighth day after his entry into Jerusalem, Christ arose from the grave.

Nine is the angelic number of the nine choirs of angels.

Ten was believed to be the number of perfection. It is the sum of three (the Trinity, supreme being) and seven (man).

Forty and multiples of forty represent a good round number, a symbolic period of endurance, a test of time. A generation is forty years, a man is mature at the age of forty. Lent, a time of penance, lasts forty days. Forty may also represent the Church militant.

A hundred suggests an ample amount.

A thousand implies eternity.

OLD TESTAMENT PROPHECIES

The Old Testament is a rich literary tapestry from many ancient sources. History, myth, legend, and allegory, the Old Testament is unlike the New Testament, which has one central figure, Christ, and one central theme, the foundation of the Christian Church as a means of eternal salvation. "What the Old Testament shows in the light of the moon, the New shows in the light of the sun," explained St. Augustine in *The City of God*.

The Old Testament, from earliest Christian times, was considered prophetic, forecasting events in the life of Christ. Prudentius compiled the *Dittochaeon* (fourth century), in which a scheme for church decoration was outlined; Old Testament events were paired with the appropriate New Testament counterpart they preceded. (This kind of parallelism is called typology, or symbolic exegesis. The Old Testament figure was called the type and the figure in the New Testament which paralleled it was called the antitype.) Old Testament heroes such as Noah, Adam, and David were regarded as mystical forerunners of Christ; the Prophets were considered ancestors of the Apostles. The legends of Moses and Aaron's rod were considered allegorical prophecies of events in the life of the Virgin.

Typology was popular first in medieval France and England and later spread to the rest of northern Europe. It never achieved great popularity in Italy and Spain. Some illustrated books printed in Germany during the fourteenth century accelerated the popularity of this kind of allegorical symbolism. Principal among them were the *Biblia Pauperum* (or *Biblia Picta,* c. 1300) and the *Speculum Humanae Salvationis* (Mirror of Human

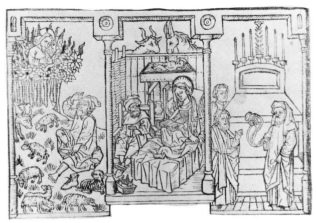

Biblia Pauperum (det.)

Salvation, c. 1334). The *Biblia Pauperum* consisted of about forty sets of subjects, with the New Testament antitype flanked by two Old Testament types, and accompanied by appropriate biblical quotations and an explanatory text in Latin. Its subjects came exclusively from the Scriptures. Published in block book form, i.e., with each page printed from a separate wood block, the *Biblia Pauperum* was widely circulated, and had considerable influence on the subject matter of late medieval art.

The *Speculum Humanae Salvationis* was another influential typological textbook printed in block book form. The illustrated version presents four pictures at the top of the page, the New Testament antitype on the left followed by three Old Testament types on the right. The Speculum includes examples from Jewish legend and secular history as well as from the Scriptures. A more complex work than the *Biblia Pauperum,* it had an extensive influence on the visual arts of the late medieval period and was translated into most of the European languages. Learned theologians claimed that the Bible was simultaneously history and symbol, and maintained that it could be interpreted on four levels: historically, as relating actual facts as they had occurred; allegorically, as the Old Testament prophesies the New; topologically, as the words of the Scriptures conceal abstract moral

truths; and analogically, i.e., with a hidden spiritual sense as the Bible revealed the mysteries of future life and grace. "The Old Testament is nothing but the New covered with a veil; the New is the Old unveiled," St. Augustine said.

This medieval interpretation of the relationship of the Old Testament to the New is vividly illustrated in the story of the Mystic Mill. A man pours grain into a small hand mill while another man collects the flour emerging from the mill into a sack. The first figure symbolizes Moses; the grain he pours into the mill is the Old Law of the Old Testament. The mill that grinds the grain is Christ (symbolized by a millwheel marked with a cross), and the man receiving the flour is the Apostle St. Paul. The flour symbolizes the New Law, derived from the Old. The Law of Moses was truth, but in an obscure form, hidden like the flour in the grain. As a result of the sacrifice of Christ, the grain has been transformed into nourishing flour—the New Law. The mission of St. Paul was to gather the New Law, and explain and distribute it to the people.

The Mystic Mill,
12th cent. French

The major events in the Old Testament appear as prefigurations in art. They are arranged in the following text in the same order as in the Old Testament.

The Creation of the world generally follows quite literally the description in Genesis (1:1–31). Each day is usually a separate unit, creation following upon creation.

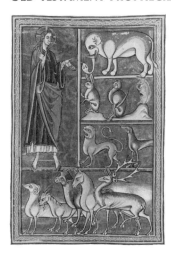

Creation of the Animals,
12th cent. English

The Story of Adam and Eve begins on the sixth day when God created Adam out of dust and breathed life into him (Gen. 2:7). This major event occurs with God extending life, in the form of a ray or a gesture of blessing, into the body of Adam, or transferring the power of life from fingertip to fingertip.

The Creation of Eve shows Adam asleep on the ground, while the torso of Eve emerges genie-like from his rib (Gen. 2:21–24). The creation of Eve was considered a prefiguration for the birth of the Church, since she emerged from the open side of Adam as the Church evolved from the open side of the crucified Christ.

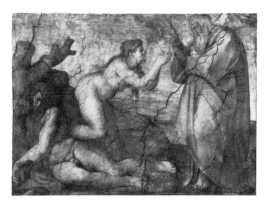

Michelangelo, *Creation of Eve*

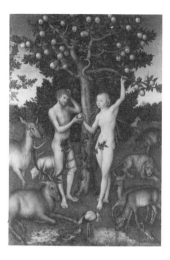

Cranach, the Elder,
Adam and Eve,
16th cent. German

The Temptation and Fall of Adam and Eve shows Adam on one side of the Tree of Knowledge of Good and Evil and Eve on the other, with the wily talking serpent twined around the trunk between them. The serpent tempts Eve with the apple in its mouth (Gen. 3:5). The serpent sometimes has the head of a woman. The temptation and fall of Adam were evolved into the concept of original sin by St. Augustine. Original sin was transmitted throughout eternity to all of mankind, who were descendants of Adam. The only one to escape this burden was Mary.

The Expulsion from Paradise shows Adam and Eve as they are driven from Paradise by the sword of an avenging angel. They wear aprons of fig leaves to cover their newly self-conscious nakedness (Gen. 3:24). Their penalties for succumbing to temptation were that man would forever have to earn his food by the sweat of his brow, while woman would be condemned to painful childbirth and subjection to man. The theme of the expulsion has been interpreted as a symbol of birth.

Cain and Abel were the first two children of Adam and Eve. Cain became a farmer, Abel a shepherd. Cain offered the fruits of the earth to God, but He was not impressed. However when Abel offered up a young lamb for a sacrifice, God was most pleased. (This composition

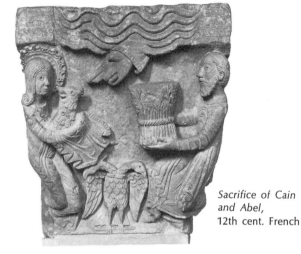

*Sacrifice of Cain
and Abel,*
12th cent. French

is the Sacrifice of Abel.) Abel sacrificing the lamb to God
is paralleled to the Crucifixion, when Christ, "The Lamb
of God," is offered as a human sacrifice.

Cain, enraged, slew his brother Abel. Traditionally, he
killed Abel with the jawbone of an ass, and in art he is
often represented wielding the great bone in fury as he
attacks Abel. In punishment, God made Cain a perpetual
wanderer on the face of the earth (Gen. 4:4ff.).

THE STORY OF NOAH

Noah was a descendant of Adam and Eve through
their third son Seth. God, greatly disillusioned with man's
behavior on earth, decided to destroy him (Gen. 6:7).
Noah was spared and directed to make an ark. The ani-
mals, two by two, march up the ramp and enter the ark.
The floods then engulf the earth, but Noah and his
family ride out the storm safely in their ark.

When the waters subsided and the ark landed on
Mount Ararat, Noah released a dove, which returned to
the ark, since there was no dry earth on which to perch.
After seven more days Noah again released the dove,
which this time returned with an olive leaf. Knowing that
now the floods had receded, Noah followed God's direc-
tive and left the ark with its inhabitants (Gen. 9:16–17).

In return for God's indulgence, Noah built an altar

Noah's Ark
from *La Mer des Histoires,*
15th cent. French

and "took of every clean beast, and of every clean fowl, and offered burnt offerings on the altar" (Gen. 8:20). He then planted a vineyard, made wine, and got drunk on it (Gen. 9:20–21). Noah's son Ham discovered his father drunken and disheveled and told his brothers. When Noah awoke, he was furious with Ham and cursed him (Gen. 9:25). The most popular art subjects in the life of Noah are The Building of the Ark, The Loading of the Ark, or The Debarking, The Ark During the Flood, Noah's Sacrifice, and The Drunkenness of Noah.

The Tower of Babel was the ziggurat of Marduk, a seven-stepped pyramid-like temple built by the descendants of Noah near ancient Babylon in an effort to reach Heaven (Gen. 11:4). God, angry at such presumption on the part of man, took His revenge by "confounding their language" (Gen. 11:7–9). The confusion of tongues has ever after created a communications gap between peoples.

ABRAHAM THE PATRIARCH

Abraham, a descendant of Noah, was the traditional father of the Hebrews, and sometimes included among the great prophets. God promised Abraham that he and his descendants would rule the land of Canaan (Palestine) and would flourish with prosperity and progeny. In Abraham and Melchizedek compositions, Melchizedek, the king and high priest of Salem, offers bread and wine to Abraham, who has returned victor over the kings who

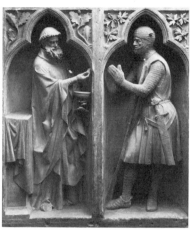

Abraham and Melchizedek (det.),
13th cent. French

had captured his nephew Lot (Gen. 14:18). This offering
was interpreted as a prefiguring of the Eucharist, and
Melchizedek may actually hold the chalice and the Host
used in the Christian Mass.

Abraham and the Three Angels tells of the appearance of
three men at Abraham's tent. Abraham entertains them,
while his wife, Sarah, prepares a meal. One of the men
tells Abraham that his wife, in spite of her great age, will
bear him a son (Gen. 18:10). The three men, often repre-
sented as angels, are considered as types for the Trinity,

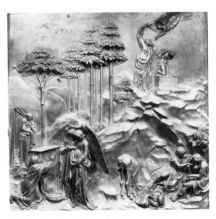

Ghiberti, *Sacrifice of Isaac*

since Abraham saw three figures but spoke to them as one. The event was thought to prefigure the Annunciation to Mary by the Angel Gabriel, with three angels standing in a group opposite the figure of Abraham.

The Sacrifice of Isaac was Abraham's supreme gesture of faith in the Lord. Following God's instructions, Abraham was about to slay Isaac, when "The angel of the Lord" intervened (Gen. 22:11–12). Abraham offered a ram that appeared in a nearby thicket as a "burnt offering" in Isaac's place. Abraham raising his knife to slay Isaac, who lies on an altar or a bundle of twigs, is the moment most frequently illustrated. An angel may wrench the knife from Abraham.

This parallel with the Crucifixion was a popular theme. As Abraham was prepared to sacrifice his son, so God sacrificed His son, Jesus Christ. As Isaac collected the wood for his own death, so Christ carried His own Cross to Calvary.

Rebekah at the Well illustrates the moment when Abraham's servant, Eliezer, meets Rebekah at the well in Chaldea, Abraham's homeland. Rebekah consents to return to Canaan and be Isaac's bride (Gen. 24:16).

Lot and His Daughters. Lot, Abraham's nephew, lived with his family in the wicked city of Sodom. God agreed to save them while destroying the other inhabitants of Sodom and Gomorrah, on condition that they not look back (Gen. 19:17). Lot's wife, unable to resist temptation, did look back and was turned into a pillar of salt. Lot then went to live in a cave with his daughters, who conspired to get him drunk and conceive by him in order to "preserve the seed of our father." Out of these incestuous unions came the sons Moab and Ammon.

THE LIFE AND TIMES OF JACOB

The story of Jacob, grandson of Abraham and father of twelve sons who led the twelve tribes of Israel, dominates the Book of Genesis. Jacob, a patriarch, was the younger of the twin sons of Isaac and Rebekah. His mother's favorite, he conspired with her to usurp the rights of the first-born from his brother Esau, a hunter

and "a hairy man." (Jacob was "a plain man, dwelling in tents.") When Isaac, old, blind, and feeble, was dying, he sent for Esau and ordered him to prepare his favorite venison. This done, Isaac would give Esau his blessing. Rebekah substituted Jacob for Esau, and thus tricked Isaac into blessing Jacob and giving him authority over Esau and all the tribe. This event is called **The Blessing of Jacob.**

Jacob's Dream. Resting at the roadside during his journey to Haran in search of a wife, Jacob dreamed of "a ladder set up on the earth, and the top of it reached to heaven: and behold the angels of God ascending and descending

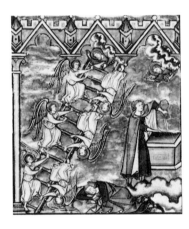

Jacob's Ladder

on it. . . . The Lord stood above it, and said, I am the Lord God of Abraham thy father, and the God of Isaac: the land whereon thou liest, to thee will I give it, and to thy seed" (Gen. 28:12–13). When Jacob realized that God had miraculously visited him, he took the stones he had used for a pillow, built a pillar of them, covered them with oil, and called the place Bethel. The dream of Jacob was interpreted as a prefiguration of the Ascension, or during the Renaissance as a parallel with Christ's promise to Nathaniel: "Hereafter ye shall see Heaven open, and the angels of God ascending and descending upon the Son of man" (John 1:51).

The Meeting of Jacob and Rachel. Jacob, exiled, agreed to work for his uncle Laban in Chaldea for seven years

in order to secure Rachel's hand (Gen. 29:20). However, after his wedding night he found he had been tricked into marrying the older, less beautiful Leah. He patiently waited another seven years before finally claiming Rachel for his wife.

Jacob began the homeward journey to Canaan with his wives, family, and possessions. En route, at Penuel, he spent the whole night wrestling with a strange man, an angel in disguise (Gen. 32:24–25). After he received a blessing, Jacob released the stranger, who said: "Thy name shall be called no more Jacob, but Israel: for as a prince hast thou power with God and with men, and hast prevailed" (Gen. 32:28).

Gauguin,
Jacob and the Angel

In art the stranger may be a man, but usually is a winged angel. **Jacob Wrestling with the Angel,** because of the touching of the "hollow of the thigh," was considered to prefigure the New Testament "Incredulity of Thomas" (*see Jesus Christ*).

Jacob Blessing the Sons of Joseph shows the dying Jacob reunited with his long-lost son Joseph and blessing Joseph's two young sons, Manasseh and Ephraim, who had been born in Egypt. The gesture as Jacob crosses his arms to bestow his blessing on his grandsons has been interpreted as a figure of Christ on the cross. Because Jacob blesses Ephraim with his right hand even though he was the younger of the two, Ephraim is symbolic of the Christians and the New Covenant, while Manasseh, the elder, represents the Jews of the Old Covenant.

JOSEPH THE PATRIARCH

Joseph was the favored son of Jacob and Rachel (he is not to be confused with St. Joseph, the foster father of Christ in the New Testament). **Joseph and His Coat of Many Colors** shows Jacob presenting his favored son with a coat woven especially for him. This sign of favoritism angered Joseph's brothers, who abducted him, threw him into a pit, sold him into slavery in Egypt, and covered the coat of many colors with animal blood to convince Jacob that Joseph was dead. The sale of Joseph into slavery has been interpreted as an Old Testament prefiguration of Christ's betrayal by Judas (Gen. 37:3).

Joseph lost a second coat in an encounter with **Potiphar's Wife** in Egypt. Joseph, an overseer in Potiphar's house, was coveted by Potiphar's wife. When Joseph resisted her advances, slipping out of his coat and out of her embrace, the rejected woman was so enraged that she reported to Potiphar that Joseph had attempted to seduce her. The coat was her evidence. In paintings, Potiphar's wife, often on the edge of a bed, with Joseph's coat at her feet, proclaims her innocence to her irate husband (Gen. 39:14–15).

Joseph Interpreting Pharoah's Dream, 18th cent. American

Joseph was thrown into prison. Since the spirit of God was in him, he had the ability to interpret dreams. When Pharaoh called on him to interpret his dream of the seven fat cattle followed by the seven lean cattle,

Joseph predicted seven years of plenty followed by seven years of famine (Gen. 41:26–27). Acting on Joseph's advice, Pharaoh stored food against the predicted famine, and saved the people of Egypt from starvation. The lean and the fat cattle often appear in a circular dream sphere above the brooding figure of Pharaoh in **Joseph Interpreting Pharaoh's Dream.**

Joseph and His Brethren illustrates Joseph's reunion with his brothers. They had traveled to Egypt to purchase corn because of the famine in their own land. They did not recognize Joseph, who had by then become governor of all Egypt. Before he revealed his identity, Joseph hid a silver chalice in the sack of his brother Benjamin, and then accused him of the theft (Gen. 37:1ff.).

MOSES

One of the major figures in the Old Testament, Moses was the great leader of the Israelites who directed their escape from bondage in Egypt and took them to the Promised Land of Canaan. He was a prophet, a law-giver, and a miracle worker. As the chosen leader of the Jews, in constant touch with God, Moses is the Old Testament prefiguration for Jesus Christ, the Messiah. When Moses appears as prophet or law-giver, he stands alone, a majestic, bearded figure in long robes holding the tablets of the law. He often appears flanking the figure of Christ.

Moses,
13th cent. English

In The Transfiguration, Elijah, another Old Testament prophet, is his companion. The two prominent lumps, resembling horns, that project from Moses' head result from a mistranslation in the Vulgate of a passage in Exodus (34:29), in which the Hebrew word for "rays" was translated as "horns."

The Finding of the Infant Moses illustrates the dramatic salvation of Moses. He was born in Egypt of Hebrew parents, and placed in a basket on the Nile River bank hidden among the reeds in order to escape the wholesale infanticide of the first-born ordered by Pharaoh. Pharaoh's daughter, bathing by the river, rescued the infant Moses and raised him in her household. Unwittingly, she employed Moses' mother as his nurse, and thus the future prophet was raised by his own mother (Exod. 2:5–10).

Moses and the Burning Bush was considered an Old Testament prefiguration of the Incarnation. Moses fled Egypt after inadvertently killing an Egyptian overseer. He settled in the land of Midian, worked as a shepherd, and married Zipporah, one of the daughters of the priest Jethro. While tending sheep on Mount Horeb, the mountain of God, "the Angel of the Lord appeared unto him in a flame of fire out of the midst of a bush . . . and, behold, the bush burned with fire, and the bush was not consumed" (Exod. 3:2). From the midst of the bush God called to Moses and directed him to lead the children of Israel out of Egypt (Exod. 3:7–8). Moses is shown loosening his sandal with the bush burning in the background (Exod. 3:5). This event appears in the *Biblia Pauperum* and in medieval art as a prefiguration of the Nativity. Other popular medieval interpretations are that the bush represents Mary's virginity, or the Church, which was indestructible even by the flames of persecution.

The Plagues of Egypt struck when Pharaoh refused to let the hard-working Jews led by Moses leave Egypt. Moses unleashed an unending series of calamities on the Egyptians: the rivers turned to blood, the fish died, frogs overran the land, lice and flies carried disease to man and beast. Boils, pestilence, hailstorms, and turmoils

afflicted the Egyptians and their lands, but not the Israelites. A plague of locusts destroyed the crops and darkness covered the land for three days. The first-born of all the Egyptians, even cattle, were struck dead (Exod. 12:27). This event is commemorated in the feast of the Passover. (According to Christian tradition, the mark made on the doorposts with lamb's blood was a T cross, a prediction of the Cross of the Crucifixion.) Finally Pharaoh relented and Moses led the Jews into the Promised land of Canaan.

The Exodus and Moses Crossing the Red Sea describes the departure from Egypt of the Jews led by Moses, an incident of divine intervention. Pharaoh changed his mind when he saw the Israelites departing with their animals and possessions, and sent his army to restrain them. Moses implored Jehovah to help, and with His intercession the waters of the Red Sea miraculously parted to permit the Hebrews to walk safely to the other side (Exod. 14:21). As the Egyptian army approached, the sea resumed its normal depths and all of Pharaoh's men were drowned. The Crossing of the Red Sea may appear on baptismal fonts as prophetic of baptism, and the salvation of men's souls by Christ (Exod. 12–14).

Another miracle occurred when manna fell from the heavens, at Moses' request, to feed his starving people (Exod. 16:14–15). The manna, small berry-like particles, has been variously described as "wafers made of honey" or as "fresh oil." It was the main staple of the Israelites' diet in their forty years of wandering about the desert, and reappears in the New Testament as a symbol of the Eucharist.

Moses Striking the Rock shows Moses miraculously obtaining water in the desert for his thirsty people (Exod. 17:5–6). The picture of Moses holding a divining rod and standing by a rock out of which water flows occurs more than two hundred times in the catacombs. During the Middle Ages, it became an Old Testament symbol either of the water of baptism, or of the Crucifixion with blood flowing from Christ's side.

Moses on Mount Sinai receiving the Tablets of the Law

is the most important incident in Moses' life. At the command of the Lord, Moses climbed Mount Sinai and received the Ten Commandments dictated directly by God. Moses may be shown kneeling, receiving the tablets from God, or descending the mountain triumphantly displaying the stones. The tablets then become an attribute of the Synagogue, as compared with the New Law of the Church.

Ironically, while Moses was absent receiving the Lord's commandments, his people became impatient and approached Aaron who, at their bidding, made a **Golden Calf** for them to worship. Moses, when he returned, was so furious at this idolatry that he smashed the tablets on the ground, then destroyed the golden calf (Exod. 31–32).

The Israelites, hungry and homeless, turned on Moses during the wanderings. In revenge, God sent a plague of fiery serpents among them, killing many. In desperation, once more they approached Moses, who "made a serpent of brass, and put it upon a pole, and it came to pass that if a serpent had bitten any man, when he beheld the serpent of brass, he lived" (Num. 21:9). In this miracle of **Moses and the Brazen Serpent** the Israelites were saved and their faith in Moses' effectiveness as a leader and miracle-worker was restored. This is considered an Old Testament type for the Crucifixion.

Joshua and the Battle of Jericho. Joshua, Moses' successor, followed his instructions and led the Jews into the Promised Land, the land "flowing with milk and honey." The most dramatic event during Joshua's command was the Fall of Jericho. The Jews, having crossed the Jordan River, which miraculously parted to let them walk through, found themselves barricaded from the city of Jericho. Following instructions from the Lord, Joshua and his people marched around the walls of the city, in silence, every day for six days, carrying with them the Ark of the Covenant. On the seventh day they marched around Jericho seven times, and then followed Joshua's directions: "The people shouted when the priests blew with the trumpets. . . . The wall fell down flat, so that

people went up into the city . . and they took the city" (Josh. 6:16ff.).

Samson is a major hero in the Book of Judges, a super-man of extraordinary physical strength. The Jews, sinful and weak after the death of Joshua, were subjected to the rule of the Philistines. God commanded Samson to deliver them. Samson had demonstrated his extraordinary

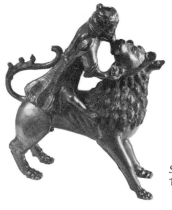

Samson and the Lion,
14th cent. German

strength even as a youth when he tore a lion apart with his bare hands, and killed a thousand Philistines with the jawbone of an ass. He fell in love with a Philistine temptress, Delilah, who seduced him and extracted from him the source of his strength, his hair, which had never been cut. In **Samson and Delilah** compositions, Samson lies asleep in Delilah's lap, while a Philistine approaches Samson, shears in hand, to cut his hair and divest him of his strength. The Philistines then put out Samson's eyes, threw him in prison, and chained him to a wheel with other slaves. But as his hair grew back, Samson's strength returned. By the time Samson was taken by the Philistines to their temple as a spectacle to be ridiculed, his strength had returned fully. "And Samson said, O Lord God, re-member me . . . that I may be . . . avenged of the Philistines for my two eyes. And Samson took hold of the two middle pillars upon which the house stood. . . . And he bowed himself with all his might; and the house fell upon . . . all the people that were therein" (Judg. 16:28ff.). Samson appears as an Old Testament type

paralleling Christ, since Samson, in dying, destroyed his enemies, just as Christ, in being crucified, died to defeat his. The story has also been used to show that sexual passion leads to destruction.

THE STORY OF DAVID

As the royal musician playing his harp David was the traditional frontispiece illustration for the medieval psalter; in fact, the authorship of many of the Psalms

King David with the Harp, 15th cent. German

has been attributed to David. David's reign marked the evolution of the Jewish people from a group of nomad tribes to a consolidated national state with a capital at Jerusalem.

In **The Anointing of David** the young shepherd is being anointed with oil by the prophet Samuel, following instructions from God. The youngest son of Jesse, David was the last one to be presented to Samuel. He was chosen to replace the great warrior Saul, originally chosen by God to lead the Israelites but rejected because of his idolatries (1 Sam. 16:12–13).

David Playing the Harp for Saul shows the young musician playing the harp to cheer up Saul, who often fell into moods of violent depression (1 Sam 16:23).

David and Goliath represents the confrontation of the young David with the giant Goliath. Goliath had issued a challenge to the Israelites which was continually re-

fused until David's acceptance. David "took a smooth
stone from the riverbank, put it in his slingshot, and
slew the great Goliath" (1 Sam. 17:49). Goliath may wear
the uniform of a Roman soldier or medieval armor and
be engaged in battle with David. The young David,
slight and adolescent, may stand alone, triumphant,
holding the great head of the giant in his hand, or
casually resting his foot on it. This conquest was likened
to Christ's conquest of the Devil by His sacrifice on the
Cross.

In another contest, **David Kills the Bear and the Lion** that
had been attacking the flocks, thereby proving his
strength to the doubting Saul. In the Middle Ages this
event was considered a parallel to Christ's repulsing the
temptations of the Devil, or of Christ's rescuing the just
from limbo as David rescued the lamb from the jaws of
the lion.

The Triumphs of David shows David and Saul together
receiving the adulation of the crowd after defeating the
Philistines. Saul was jealously enraged at this demon-
stration, since the crowd said, "Saul has slain his thou-
sands, and David his ten thousands." Shortly afterward
Saul committed suicide and David became king of Israel.
In this incident David is alone, bearing into Jerusalem
the Ark of God which has been rescued from the Philis-
tines. This was interpreted as a clear forecast of Christ's
entry into Jerusalem in the New Testament.

David and Bathsheba is another Old Testament incident
concerning the weakness of the flesh (2 Sam. 11:2ff.).
Artists have delighted in painting the nude, beautiful
Bathsheba innocently bathing while the lusting David
looks on unobserved. The washing of Bathsheba was
interpreted as an image of the Church purified by bap-
tism and saved from the Devil, personified by David.
David contrived to have Bathsheba's husband Uriah
killed, and he then married the pregnant Bathsheba. But
"the thing that David had done displeased the Lord"
(2 Sam. 11:27) and the child died. After David repented,
a second child, Solomon, was born, who was named
David's royal successor.

SOLOMON

Solomon was the wisest and most spectacular of the kings of Israel, noted both for his wisdom and for the size of his harem, "seven hundred wives, princesses, and three hundred concubines" (1 Kings 2–9). Solomon has also been credited with writing the Song of Songs, also known as the Song of Solomon, the most beautiful poetry in the Bible.

The Judgment of Solomon shows Solomon demonstrating his wisdom when faced with two harlots, both claiming the same child: "And the king said, 'Bring me a sword.

Poussin, *The Judgment of Solomon*

. . .' And the king said, 'Divide the living child in two, and give half to the one, and half to the other.' Then spake the woman whose the living child was . . . and she said, 'O my lord, give her the living child, and in no wise slay it. . . .' Then the king answered and said, 'Give her the living child. . . . She is the mother thereof.' And all Israel heard of the judgment . . . and they feared the king: for they saw that the wisdom of God was in him to do judgment" (1 Kings 3:24ff.).

Solomon and the Queen of Sheba. Solomon's reputation for great wisdom reached the Queen of Sheba in her kingdom in what is now Yemen. The queen, with an

elaborate retinue, journeyed to visit Solomon and test him, "to prove him with hard questions." Before departing she showered Solomon with presents, including trees brought from her country. According to legend, Solomon and the Queen of Sheba had a child, whose descendants came to be the reigning dynasty of Ethiopia.

Another legend concerning the Queen of Sheba connects the Old and New Testaments. The queen, during her visit to Solomon, crossed a stream on a wooden bridge which she felt possessed miraculous qualities. She was right, as the wood of the bridge had come from a seed of the Tree of Life planted by Seth, the son of Adam, at his father's instruction. The tree flourished and centuries later was cut down for use in a temple being built by Solomon. However, the tree was discarded and used instead as a bridge across a stream. The Queen of Sheba prophesied that the wood would eventually serve to make a cross which would destroy Solomon's people. To prevent this, he dismantled the bridge and had the wood buried deep in the ground. A well sprang up at the site, disgorging waters with miraculous powers. Eventually the queen's prophecy was fulfilled when the wondrous wood floated to the surface and was indeed used to construct the cross on which Christ was crucified.

DANIEL

In seventeenth-century Europe the Old Testament prophet Daniel became very popular because of the accuracy of his prophecies regarding the universal oppression of the Jews. **The Vision of Daniel** shows Daniel with the archangel Gabriel, observing "a ram which had two horns. . . . I saw the ram pushing westward, northward, and southward. . . . he did according to his will, and became great. . . . I was afraid and fell on my face: but he [Gabriel] said unto me . . . 'Behold, I will make thee know what . . . the end shall be' " (Dan. 8:3–4; 17; 19). The other vision was at **Belshazzar's Feast** when Daniel interpreted the "handwriting on the wall." He explained that the words spelled the doom of Babylon at the hands of the Medes and the Persians in 539 B.C.

King Nebuchadnezzar had flung three men into a **Fiery Furnace** for refusing to worship a golden idol (Dan. 3:21). The three men, Shadrach, Meshach, and Abednego, were joined by a fourth figure, that of an angel, and the four stood in the furnace with the flames licking around them but were untouched, because of the intervention of Daniel. Only the ropes that bound them disintegrated. After the miracle, Nebuchadnezzar freed the three men and gave them great gifts and honors.

Daniel in the Lion's Den shows Daniel wrestling and taming lions, into whose den he had been thrown by Nebuchadnezzar because he prayed to his God instead of to the king (Dan. 6:16). Habakkuk, another prophet, is shown bringing bread and fish to Daniel, sometimes accompanied by an angel. This act was interpreted as prefiguring the Eucharist. Daniel's principal attributes are the lion and the ram, or the figure of Daniel flanked by two lions, and Daniel and the Bel-Dragon (see *Dragon, under Beasts*). In early catacomb paintings he is a youth, his arms raised in prayer. His name, Daniel, in Hebrew means "God is my judge." (*See also Apocrypha.*)

OTHER BIBLICAL FIGURES

The Book of Esther tells of the beautiful Jewish girl Esther and her adventures in the harem of the Persian King Ahasuerus. She had been selected from all the virgins in the country for her beauty. Keeping her race secret, on the advice of her old uncle Mordecai, she married the king. Haman, an official, persuaded the king to slaughter all the Jews in his kingdom. When he heard this, Mordecai "rent his clothes, put on sackcloth with ashes, and went out into the midst of the city, and cried with a loud and bitter cry" (Esther 4:1). This event is called **The Affliction of Mordecai.** Esther, revealing her identity as a Jew, interceded with Ahasuerus, and the scheming Haman was hanged on the gallows he had prepared for Mordecai. In the illustration of this event, **Esther and Ahasuerus,** the king may be touching Esther with his royal scepter, freeing her from the punishment of death for having dared to enter the royal chamber without proper summoning.

Jonah was commanded by God to preach to the people of Nineveh and get them to give up their wicked ways. Jonah reluctantly proceeded there by boat. En route there was a violent storm, and Jonah, thinking God's wrath toward him had caused the tempest, offered himself as a sacrifice to be tossed into the sea. "Now the Lord had prepared a great fish to swallow up Jonah. And Jonah was in the belly of the fish three days and three nights" (Jon. 1:16ff.). Jonah prayed, "And the Lord spake unto the fish, and it vomited out Jonah upon the dry land" (Jon. 2:10). Jonah may be shown being thrown into the sea, or emerging from the mouth of the "great fish," which tradition has turned into a whale. This incident of

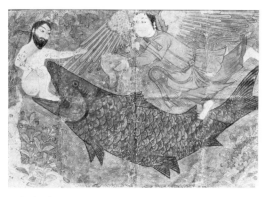

Rashid ad-Din,
Jonah Cast Up by the Whale

Jonah and the Whale was a favorite for catacomb and other early Christian decoration, as it symbolized the Resurrection of Christ after the three days' entombment (Matt. 12:40).

Jonah and the Gourd shows Jonah resting under an arbor miraculously grown from a gourd. "And the Lord God prepared a gourd, and made it to come up over Jonah, that it might be a shadow over his head, to deliver him from his grief" (Jon. 4:6). (The gourd vine, like the grapevine, was very popular in the Middle East for arbors.) A worm sent by God destroyed the vine, which angered Jonah, but God replied, "Thou hast had pity on the gourd, for the which thou hast not labored, neither

madest it grow; which came up in a night, and perished in a night. And should I not spare Nineveh, that great city, wherein are more than sixscore thousand persons that cannot discern between their right hand and their left hand?" (Jon. 4:6ff.). So Jonah understood God's right to preserve the people of Nineveh, corrupt as they were, who were His own creation. The theme of the Book of Jonah is God's compassion and understanding for the penitent.

The basic subject of the eloquent Book of **Job** is the eternal conflict between good and evil. Why do the just suffer and the wicked flourish? Job is a model man: "There is none like him in the earth, a perfect and an upright man, one that feareth God and escheweth evil" (Job 1:8). Satan, in a wager with God, doubts that Job will be able to sustain his faith when exposed to great torment. So God tests Job with many afflictions. He loses his extensive properties, his wealth, his children, his health. Disaster follows upon disaster; his body is covered with putrifying boils; his suffering continues. Finally even Job's patience begins to waver. But after stern and eloquent poetry from the Lord, Job repents, and God mercifully restores his health and happiness.

Job and His Boils, 15th cent. Italian

The suffering of Job at the hands of God was seen as an allegory of the Passion of Christ in the New Testament. Christ triumphed over the Devil as Job had triumphed over Satan.

PROPHETS

Prophets were major figures in the Old Testament who upheld the Old Law and delivered God's message to man. St. Augustine called the prophets "the heralds of God." They were the religious leaders of Israel, whose task it was to purify and reform the life of their people. Later Christians searched their writings for material which they could interpret as foretelling the coming of Christ. Considered prefigurations of the Apostles, they are often grouped together in Christian art, a row of prophets on the left, a row of Apostles on the right. The four major prophets—Isaiah, Jeremiah, Ezekiel, and Daniel—are similarly juxtaposed to the Four Evangelists. Christian doctrine, expressed in the Nicene Creed, believed that the Holy Ghost "spoke through the prophets." Prophets are usually majestic, idealized figures of great dignity,

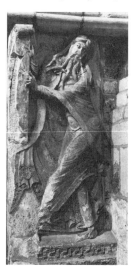

Prophet Isaiah,
12th cent. French

clad in flowing robes, each identified by a scroll with his name or a verse from his writing inscribed on it. They may wear the conical cap of the Jew, a medieval identification, and carry a phylactery (a rectangular box containing passages from scripture instead of a scroll). The number and selection of prophets vary widely, aside from the four major ones. The minor prophets are twelve, among whom Hosea, Joel, Amos, and Jonah are perhaps the most important. Job, David, and John the Baptist may also be included. From the fifteenth century onward they are often accompanied by the sibyls, prophetesses who represent the Greek classical tradition. Grouped together the prophets and sibyls represent Christ's spiritual ancestors.

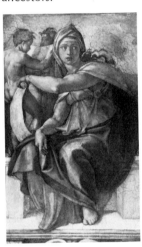

Michelangelo,
The Delphic Sibyl (det.)

RELIGIOUS ARTIFACTS
RELIGIOUS OBJECTS
RELIGIOUS ORDERS

RELIGIOUS ARTIFACTS

The **altar** is a raised table of stone or wood on which sacrificial offerings are placed. It is the "Holy Table" for the celebration of the Eucharist. In Catholic churches the altar is placed in the sanctuary and is the major focal point of the interior. It is placed to face the East, the rising sun, as directed in Ezekiel 43:4.

An **altarpiece** or **retable,** is a decorated panel attached to or set directly behind the altar. An altarpiece usually has The Virgin Mary or Christ as its central theme, with side panels, or wings, containing related events. The wings, often painted on both sides, may be hinged so that the central panel can be covered on occasion. A central panel with two wings is a **triptych;** an altarpiece with one central panel and several side panels or wings is a **polyptych.**

The **altarcloth,** a liturgical tablecloth, covers the top of the altar and extends down both sides. The **corporal** is a smaller white linen cloth upon which the eucharistic bread and wine are consecrated. The corporal is later used to cover blessed bread and wine. An ornamental cloth, usually richly embroidered or of a fine brocade, which hangs at the back of the altar or at the sides of the chancel is a **dorsal.** The decorative panel which covers the front of the altar, the **frontal,** may be of fabric or a sculptured or painted panel. The small square white linen cloth that is used to cover the chalice is the **pall**. It may also be a stiff square of linen covered cardboard which is set directly on top of the chalice. A small white linen square called a **purificator** is used to wipe the chalice and patten after the celebration of the Eucharist. The priest also uses it to wipe his lips and fingers.

RELIGIOUS OBJECTS

The brush or sponge on a handle with which the priest sprinkles holy water for purification is the **aspergillum.** The aspergillum is the attribute of saints expert at exorcising demons.

A **bell** summons the faithful to worship from church towers. A small hand bell, the sanctus bell, rung during Mass, prepares the congregation for Holy Communion. It also announces the arrival of the priest carrying the Sacraments.

Candles symbolize the light brought into the world by Christ, and are used extensively in church services, at shrines and altars, and in processions.

A **censer** is a metal vessel with a pierced lid in which incense is burned during church services. The pungent smoke of the incense represents the prayers of the faithful ascending to Heaven.

The **chalice** or cup is the vessel from which the con-

Chalice of Abbot Suger of Saint-Denis, 12th cent. French

secrated water and wine of the Eucharist is drunk during Holy Communion.

The **ciborium** is the bowl that contains the consecrated eucharistic Host prepared for Holy Communion. A

ciborium is also a canopy raised over the high altar of the church and supported by four columns. It suggests the Ark of the Covenant of the Old Testament.

The **crozier** is an ornate staff resembling a shepherd's crook, which is held by bishops to symbolize their role as shepherds of Christ's flock. It may have evolved from the walking staff used by the Apostles and pilgrims on their long walking journeys. Archbishops, abbots, and abbesses may also carry croziers as symbols of authority.

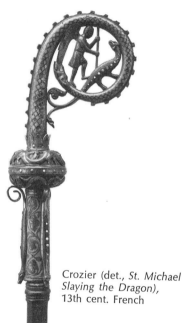

Crozier (det., *St. Michael Slaying the Dragon*), 13th cent. French

Various parts of the crozier have specific symbolic interpretation: the end is sharp and pointed to poke and prod the slothful; the staff is straight to indicate righteous rule; the crooked head is designed to draw souls to the way of God. For this reason, the crozier is always carried with the crook curved outward. The abbot's crozier may be decorated with a white pennant. In general, a crozier represents authority, mercy, and correction of vice.

The **cruet,** a small, pitcherlike vessel with a stopper, holds the water or wine of the Eucharist. It is the symbol of redemption.

The **ewer and basin** are used for washing the priest's hands during the celebration of Mass at the Eucharist and at other church services, and are symbols of purity. (*See also Instruments of the Passion, Mary.*)

A **monstrance** is usually a work of great beauty, a footed transparent container for the Host or sacred relics. It is placed on the altar for adoration and prayer.

A **paten** is a shallow circular dish of metal on which the bread is placed for the Eucharist, and represents the dish used at the Last Supper.

A **pyx** is the vessel, usually boxlike, which holds the consecrated Eucharist. It is generally used by the priest to carry Holy Communion to the sick.

A **reliquary** is a small box, casket, or shrine designed to hold sacred relics.

*Arm Reliquary,
12th cent. German*

A **rosary** is a string of beads divided into sets to assist the memory at prayers and devotions to the Virgin. It is said to have been designed by St. Dominic with a prescribed order of prayers, and may be his attribute.

The meditations of the Rosary are called Mysteries and refer to major events in the life of Mary and Jesus. **The Five Joyful Mysteries** celebrate happy events: the Annun-

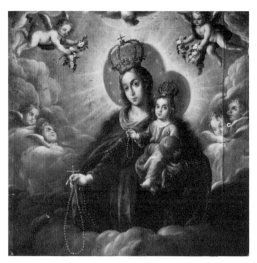

Virgin of the Rosary, 18th cent. Mexican

ciation, the Visitation, the Nativity, the Purification in the Temple, and Christ Found in the Temple. **The Five Sorrowful Mysteries** recall Christ's sufferings: the Garden of Gethsemane, the Flagellation, the Crowning of Thorns, the Road to Calvary, and the Crucifixion. **The Five Glorious Mysteries** celebrate Christ's triumphs after death: the Resurrection, the Ascension, the Descent of the Holy Ghost at Pentecost, the Assumption, and the Coronation of the Virgin.

A **tabernacle** is literally a temporary dwelling. In the Old Testament it was a curtained tent which contained the Ark of the Covenant, a portable shrine. In the Christian church a tabernacle is the small houselike receptacle, set in the center of the altar, which holds the vessels— the pyx and the ciborium—that contain the consecrated Host.

RELIGIOUS ORDERS

As Christianity developed, so did the organizations of the Church. A hierarchy was formed with the **Pope** at

the head. He presides over the Vatican like a king and wears his crown, the triple tiara, on special occasions. The **College of Cardinals** is the ruling body which chooses the Pope. Cardinals, appointed by the Pope, are next in rank to him, and are called the Princes of the Church. Both clergy and laymen are eligible for the honorary position. Cardinals wear red robes and flat broad-brimmed red hats, sometimes with tassels. An **archbishop** is a member of the clergy in charge of arch-dioceses, which may be composed of several satellite dioceses.

A **bishop** is in charge of a number of local parishes forming a diocese, and presides over a cathedral. He is identified by a miter—a tall, stiff, elongated triangular hat—and a crozier. A **priest** is in charge of one parish, often with other priests to assist him. The priest wears a cassock, a long-sleeved, fitted garment reaching to the ankles.

The **regular clergy** are those who have joined a particular religious order and are bound by the rules of that order. They can usually be distinguished by their habit, a long, loose garment with long cuffed sleeves and a hood. It is tied at the waist with a leather belt or rope. Formerly the tonsure was another identifying feature of the cleric. The tonsure, a haircut with a simulated bald spot surrounded by a narrow circular band of hair, was required as a reminder of Christ's Crown of Thorns. A **monk** is a religious who lives a contemplative life in a monastery; a **brother,** or **friar,** is one who lives in the world.

Nuns, women in communal religious life, also wore habits. Until recently, their robes and coifs, elaborate headdresses, were of great variety and style.

RELIGIOUS ORDERS IMPORTANT IN CHRISTIAN ART:

Augustinian. This order was named after St. Augustine and based on his Rule, which was general and flexible. Many Augustinians were mendicants and teachers. Their habit was a black robe with leather belt.

Benedictine. Known as the "black monks" because of their black habit, the order was founded by St. Benedict in 530 at Monte Cassino, in Italy. The Abbey, destroyed in World War II, had been the symbolic center of Western monasticism. The monastery was conceived as a close community of men ruled by the abbot, a spiritual father. A monk's vocation was a lifetime commitment, a common life equally divided between contemplation, prayer and manual work as ordained in the Rule of St. Benedict, with emphasis on liturgy and education.

One of the greatest Benedictines was Pope Gregory the Great, who sent monks to England and Northern Europe in the sixth century, where they established abbeys that spread Christianity and classical knowledge. The order was loosely organized and other orders formed out of it. The reformed Benedictines wear white robes. The **Cistercians** were founded by St. Bernard of Clairvaux in France in 1115. The **Carthusians** are another reformed order of Benedictines, founded by St. Bruno in the twelfth century. They also wear white habits.

Carmelite. This order claims Elijah, the Old Testament prophet, as its founder. The habit is brown with a white cloak. Mendicant friars, the Carmelites moved from Mount Carmel in Jerusalem to Cyprus in 1238 and thence throughout Western Europe. Known as the White Friars, they were prominent educators, establishing abbeys in Oxford, Cambridge, Paris, and Bologne.

Dominican. An order of friars dedicated to their founder, St. Dominic. A Castilian nobleman, St. Dominic wandered about southern France in the twelfth century converting the stubborn Albigenses by his eloquence and example. The first house for women converts was founded by St. Dominic in 1206, with an establishment for men in Toulouse following shortly. The order grew rapidly in size and power. The fundamental vocations of the order are study and preaching, with vows of poverty. Their habit is a long white garment with a black hooded cloak over it. A scapular, a long, flat piece of cloth, hangs from the shoulders beneath the cloak and symbolizes the yoke of Christ.

Franciscan. St. Francis of Assisi founded this order in 1211. Its basic tenets are humility, love of poverty, devotion to others, and a joyous religious fervor. The habit is brown or grey, with a rope with three knots for a belt; bare or sandaled feet complete the costume.

Jesuit. The Society of Jesus was founded by the Spanish nobleman St. Ignatius Loyola in 1540. Today the largest order of the Roman Catholic Church, its primary interests are missionary work and teaching. Training is long and rigorous. Their usual costume is a long black garment with a white collar, although according to the rule there is no fixed habit.

SACRAMENTS
SAINTS
SHAPES
SIBYLS

SACRAMENTS

The Seven Sacraments were instituted by Christ to be formal visible means for the bestowal of grace. A sacrament is the outward sign of inner grace conferred by God. The sacraments themselves are symbols of grace conferred, and the sacramental act is the major symbol accepted in the church. The traditional sacraments:

Baptism is the act of purification and regeneration by water in which the heathen becomes a Christian. The symbol for baptism is three fishes. (*See Saints, John the Baptist, Jesus Christ.*)

Confirmation supplements baptism, strengthening the faith of the Christian. It consists of the laying on of hands and anointing. The dove, or seven flames, is the confirmation symbol.

Holy Communion, or the Eucharist, is the consecration of the bread and wine into the body and blood of Christ. A ceremonial reenactment of the Last Supper, its symbol is the Host.

Confession and **Penance** are acts of confessing and atoning for sins committed against God and man.

Matrimony, the sacrament of marriage, is often symbolized by two joined hands with IHS above them (*see Initials*).

Holy Orders is the term for the act of ordination in which a man or woman is admitted to the ministry of the church. A cup or chalice with a Host resting on a Bible is the symbol for this sacrament.

Extreme Unction or the Anointing of the Sick is the final sacrament. The priest anoints the dying person with holy

oil on his eyes, lips, ears, hands, and feet. It is the final act of absolution for past sins, the consecration of one's illness to God, a strengthening in the last suffering or a recovery of health. The symbol is a dove with an olive branch in its mouth.

SAINTS

Saints are the heroes of the Christian church, the human intermediaries between man and God. Interwoven with the life of Christ, the lives of the saints span the centuries, create the fabric of Christian church history, and are an important part of Christian iconography.

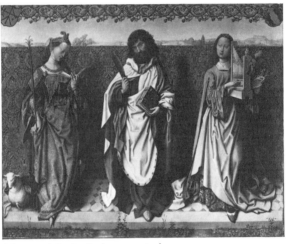

Master of St. Bartholomew, et al.,
Sts. Agnes, Bartholomew, and Cecilia

Being declared a saint, **canonization** (i.e. being included in the canon of the Mass), is a lengthy process, investigated and controlled by Rome. Every trade, every town, every church, every occupation, had its own patron saint, and these ecclesiastical specialists with their attributes appear throughout Christian art. The saints included here are those most prominent in art throughout the Christian era, regardless of current beliefs about their historical authenticity.

Hagiography is the study of the lives of saints, a specialty of the Bollandist order of Brussels.

A saint's **attribute** or symbol is his trademark of identification. General attributes for saints, held in the hand or close by are:

Ax, lance, or club—instruments of martyrdom
Book and/or pen—for learned scholars
Church building—for founders of churches and monasteries
Crown or other royal emblem—for royalty, or victory over sin and death
Crucifix or cross—exceptional sanctity
Flag or banner—for military service
Halo or nimbus—sanctity
Lily and rose—virgin martyr
Lion—for hermit saints (if winged, for St. Mark)
Miter or pastoral staff—for bishops, abbots, or abbesses
Palm, olive branch, or sword—martyrs
Triple tiara or crown—for the Pope
Wolf, bear, or other wild beast—ability to convert the savage pagans

(See also Apostles, Doctors of the Church, Evangelists, Miscellaneous Objects, Religious Objects, and Index.)

Saint Agatha (1 cent., f.d. Feb. 5) was a virgin martyr of Sicily. She rejected the proposals of the Roman consul, and his revenge was to have her breasts torn off. Agatha appears serenely holding her severed breasts on a plate. Since breasts and bells have a certain similarity of shape, St. Agatha was named the patron saint of bell ringers. She is also patroness of wet nurses and jewelers, and protects against fire and volcanic eruptions.

Saint Agnes (4 cent., f.d. Jan. 21), patroness of maidens, was a young and beautiful early Christian martyr. She chose death, with Christ as her heavenly lover, rather than life as the wife of a pagan Roman. As she was being led naked through the streets to a brothel, her hair miraculously grew long enough to cover her body. In the brothel, her virginity was protected by an angel. Since flames would not devour her, she finally died by the sword, and appeared to the mourners at her grave with a lamb at her side. The lamb of purity is her attribute, due to its meekness, as well as pun on her name

(from the Latin *agnus,* meaning lamb). She may be covered with long, flowing hair, with a sword at her side and flames at her feet. She is invoked for chastity.

Saint Ambrose. *See Doctors of the Church.*

Saint Andrew. *See Apostles.*

Altdorfer,
*The Virgin and Child
and St. Anne*

Saint Anne (f.d. July 25) was the mother of Mary and the grandmother of Christ. (*See Mary.*)

Saint Anthony Abbot (c. 251–356, f.d. Jan. 17) was an Egyptian hermit. One of the "desert fathers," he lived a devout life of solitude and self-denial, seeking God through intellectual discipline and physical toil. Although he established no specific order, he is regarded as the father of monasticism. He was constantly assailed by temptations, both physical and spiritual. St. Anthony usually appears as an old bearded monk leaning on a T-shaped crutch (T for *Theos,* God), with a bell attached to frighten away demons. A pig, symbol of lust, may stand at his feet. He is the patron saint of domestic animals.

Saint Anthony of Padua (1195–1231, f.d. June 13) was a Franciscan monk noted for his preaching, scholarship, and miracles. A kneeling ass may accompany him, referring to a miracle performed in Toulouse. A disbeliever scoffed that he would believe in the presence of Christ in the Eucharist the day his ass knelt before the blessed Host. Subsequently, when St. Anthony was bringing communion to a dying Christian, he was met by the ass,

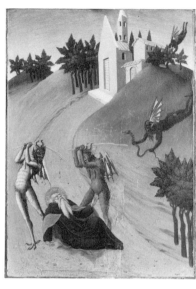

Sassetta,
*St. Anthony
Tormented by Devils*

which did indeed kneel before him. Other attributes are
the lily, a flowering cross, and the Christ Child, a refer-
ence to a vision in which the Child appeared in his arms.
He is invoked to find lost objects.

Saint Apollonia (d. 249, f.d. Feb. 9), an early Christian
martyr was noted for her purity, piety, and charity. She
was tortured by a mob of heathens, having her teeth
pulled out one by one. Stalwart, she refused to denounce

Zurbaran,
St. Apollonia

Christianity, even when threatened with being burned alive. She took the initiative and "of her own accord leaped into the pyre, being kindled within by the greater fire of the Holy Ghost." Appropriately, she is invoked against toothache. Her attribute is a tooth held in pincers. She is the patron saint of dentists.

Saint Augustine. *See Doctors of the Church.*

St. Barbara with Tower,
16th cent. French

Saint Barbara (f.d. Dec. 4), a beautiful young girl, was imprisoned in a tower by her father to prevent her marriage. During her incarceration, Barbara was converted to Christianity and baptized. She had workmen add an extra window to a room in her tower, making a total of three, a reference to the Trinity. When her father questioned her, she replied, "Know, my father, that through three windows doth the soul receive light—the Father, the Son, and the Holy Ghost; and the Three are One." Furious at her conversion, her father beheaded his beloved daughter, and was himself immediately killed in a flash of lightning, and his body reduced to ashes. St. Barbara is the patroness of firemen, fortifications, power arsenals, miners, artillerymen, and explosives in general, and is invoked against thunderstorms. She is a patron saint of architects and builders as well. A tower is her major attribute, and she may hold a peacock feather, a reference to Heliopolis, Egypt, her possible birthplace and the city where the phoenix was reborn.

Saint Bartholomew. *See Apostles.*

Saint Benedict (c. 480–c. 547, f.d. Mar. 21) was the patriarch of Western monasticism. Abandoning a life of ease for the existence of a hermit, he founded a monastery about 529 at Monte Cassino in central Italy. The Benedictine Rule he established set the standards for monastic life throughout Europe. It emphasized prayer and contemplation combined with physical labor, "a school of the Lord's service, in which we hope to order nothing harsh or rigorous." His sister was St. Scholastica, head of the first community of Benedictine nuns. He appears as an abbot with various symbols: a raven, which fed him during his life as a hermit; a broken cup, referring to an attempted poisoning by disgruntled followers; a dove, symbolizing the soul of St. Scholastica, which appeared

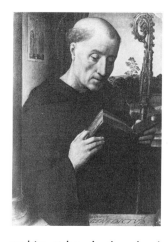

Memling, *St. Benedict*

to him at her death; a book, representing his Rule; or a broken sieve or aspergillum, for sprinkling holy water to ward off the devil. He may hold a finger across his lips, a reminder of his vow of silence. He is the patron saint of coppersmiths, and is invoked against witchcraft.

Saint Blaise (f.d. Feb. 3) is invoked for sore throats, and disease generally. Supposedly an Armenian physician and bishop, he healed many wounded animals. He was tortured as a Christian by having his flesh torn with iron combs—which became one of his attributes. Usually portrayed as an old bearded bishop, he may hold a candle,

or two crossed candles, referring to his dying wish to heal the sick. He is the patron saint of wild animals.

Saint Catherine of Alexandria (d. 310, f.d. Nov. 25) was a virgin princess, a paragon of virtue and wisdom, noted for her eloquent defense of Christianity. She converted fifty prominent heathen philosophers, who were later burned to death. The emperor proposed marriage and imprisoned St. Catherine when she refused. In her cell she was miraculously fed by angels and doves. Christ appeared to her, offering Himself as her bridegroom, and she accepted: "He in sooth is my God, my Lover, my Shepherd, my only Spouse." (This is known as the Mystic Marriage of St. Catherine, with the Infant Christ, held by Mary, placing the wedding ring on Catherine's finger.)

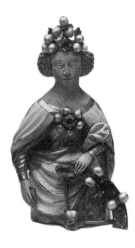

St. Catherine of Alexandria,
15th cent. French

Enraged, the emperor had a special torture wheel designed for Catherine—later called the Catherine wheel —with sharp spikes projecting from the rims to tear her flesh as they turned. The wheels disintegrated and killed many spectators, while Catherine remained unhurt. Finally, Catherine was beheaded, and milk rather than blood flowed from her veins. The spiritual bride of Christ, she appears as a beautiful young queen, holding the sword and palm of martyrdom, a book for wisdom, with the Catherine wheel at her side. She is the patroness of young girls and spinsters, of scholars, schools and universities, preachers, millers, and wheelwrights.

When she steps on a crowned or turbaned man, the male represents either the rejected emperor or heathens in general.

Saint Catherine of Siena (1347–1380, f.d. Apr. 30) was the handsome, spirited daughter of a Sienese wool merchant. Consistently refusing her parents' orders to marry, Catherine spent her early years in seclusion as a Dominican nun. She had many mystical experiences, which she recorded, and received the stigmata. Like St. Catherine of Alexandria, she considered Christ her bridegroom. She worked tirelessly to secure peace between a divided Italy and a divided papacy, converting, nursing the sick, and dictating lively letters of advice to people all over Europe. (She was unable to read or write.) She died in agony, convinced that she was wrestling with demons. Usually dressed in a Dominican habit, she may display the wounds of the stigmata. She often holds a lily, a heart, or a rosary, and supports a crown of thorns instead of a halo. She is the patroness of philosophers and spinsters.

Saint Cecilia (2–3 cent., f.d. Nov. 22) was the daughter of a Roman patrician, raised as a Christian. Betrothed to Valerian, a pagan, she confessed to him on their wedding day that she had consecrated her virginity to God. Her faith converted her husband and his brother, who were martyred for their new faith. Cecilia was to have been stifled in her own bathroom, but the steam and heat proved ineffective. An attempted beheading, with three blows, eventually killed her, three days later. Her house became a church. St. Cecilia was able to hear the singing of angels and to play any musical instrument, and sang to God "in her heart" during the concert at her wedding. She is credited with inventing the organ, her major attribute, and is often crowned with the martyr's wreath of red and white roses with three wounds at her throat. She is the patroness of church music and of musicians.

Saint Christopher (3 cent., f.d. July 25) was a giant from Palestine, who wished to serve the most powerful king in the universe. After seeing his master tremble before Satan, and Satan tremble at the sight of a roadside cru-

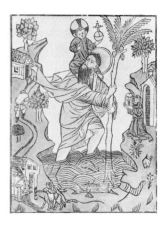

St. Christopher,
15th cent. German

cifix, Christopher set out to find and serve Christ. A hermit converted him and sent him to help travelers ford a raging river. One passenger, a small child who perched on his shoulder, grew heavier and heavier as they crossed the stream. Reaching the other shore, Christopher inquired "Who art thou, child, that placed me in such extreme peril? Had I carried the whole world on my shoulders, the burden had not been heavier." "Wonder not, Christopher," the child replied. "Thou hast not only borne the world, but Him who made the world on your shoulders. I am Jesus Christ the King." (The name Christopher means Christ-bearer.) To prove his identity, Christ directed Christopher to plant his staff in the ground, and the following day it became a mature palm tree.

St. Christopher subsequently cleaned up the brothels in the Middle East, where he was tempted by two women. He converted them, and eventually all three were beheaded.

The patron of travelers, St. Christopher is said to prevent harm from befalling anyone who looks on his image that day. Pictures of him decorate many church walls, and statues of him are erected at crossroads.

Saints Cosmas and Damian (3 cent., f.d. Sept. 22) were Arab twins trained as physicians. Known as "the holy moneyless ones," they practiced free and miraculous medicine. One dramatic feat replaced a diseased leg of a white man with the leg of a dead Negro. Their powers

included "incubation," during which the sick person slept in the church dedicated to them, in hopes of having a favorable dream that would effect a cure. After resisting death by drowning, incineration, and stoning, Cosmas and Damian were finally beheaded. The patron saints of doctors, they always appear together, in red, fur-trimmed robes, holding ointment jars, surgical instruments, or mortar and pestle. They are also the patrons of barbers, surgeons, and the Medici family of Florence (Medici in Italian means "doctors").

Saint Dominic (1170–1221, f.d. Aug. 3) was a noble Spaniard who founded the Dominican Order of mendicant preachers, highly trained priests who lived a monastic life, specializing in preaching and teaching. They were widely influential in the intellectual life of late medieval Europe, producing such outstanding scholars as

Matisse,
St. Dominic

Thomas Aquinas and Albertus Magnus. St. Dominic appears in the black-and-white robes of his order, holding the lily of purity, a book, and a rosary, which he popularized. A star appeared on his forehead at his baptism, and is frequently included in paintings. He may be accompanied by a black-and-white dog with a flaming torch in its mouth, the "Dominicane," an apparition in a dream of St. Dominic's mother that her son would "set the world on fire." Another attribute is a loaf of bread, miraculously produced to feed his starving friars.

Saint Dorothy, or Dorothea, of Cappadocia (d. c. 303, f.d. Feb. 6) is the patron saint of florists, brewers, brides, and midwives. Martyred for her faith, she chose death in order to join Christ in the Garden of Paradise, where fruits and flowers were eternally fresh. On the way to her execution, which took place in December, a skeptic told her to dispatch him some of the heavenly fruit and flowers. After Dorothy's death, a child sent by her appeared at his home, bearing a basket of apples and roses. The skeptic was converted to Christianity as Theophilus and was later martyred.

St. Dorothy (det.), 15th cent. German

St. Dorothy's major emblem is a basket of apples and roses. She may be crowned with the martyr's wreath of roses, and may lead the Christ Child, who carries the basket of fruit and flowers.

Saint Elizabeth, mother of John the Baptist. *See Mary.*

Saint Elizabeth of Hungary (1207–1231, f.d. Nov. 19) has an apronful of roses as an attribute. Daughter of King Andrew II of Hungary and wife of King Ludwig IV of Thuringia, Elizabeth was noted for her charity. While distributing bread to the poor one day, she encountered her

Vanni, *St. Elizabeth of Hungary*

husband, who disapproved of her activity. On his command she hesitantly opened her apron, to find the bread turned into a mass of roses.

Widowed during the Crusades, St. Elizabeth, after providing for her children, joined the Franciscan Order, and ministered to the sick and the poor. She may appear in the nun's habit giving clothes and alms to beggars or caring for the sick. Alternately, as an elegant queen, she wears a triple crown, symbol of her royal birth, her marriage to a king, and her heavenly glorification as a saint. She is the patroness of queens, beggars, and bakers, of Catholic charities, and of the third order of Franciscans. Her body is enshrined at the cathedral at Marburg.

St. Casilda also had the magic gift of turning bread into roses.

Saint Eustace (f.d. Sept. 20) was originally a Roman general named Placidas, serving under the Emperor Trajan. While hunting on the outskirts of Rome, he encountered a stag with a luminous crucifix between its antlers and was immediately converted, along with his wife and two sons. He changed his name to Eustace. Eustace suffered many misfortunes, fulfilling the prophecy of mysterious voices that said, "Thou shalt suffer many things for my sake." Refusing to worship the pagan gods of Rome,

Eustace and his family were martyred by being placed in a large brass bull and roasted to death. He is usually dressed as a Roman soldier, often on horseback, and accompanied by the stag with the miraculous crucifix between his antlers. Other attributes are an oven, or brazen bull. He is the patron of hunters.

Saint Francis of Assisi (1182–1226, f.d. Oct. 4), the most saintly of saints, led his life by following in the footsteps of Christ. The son of a wealthy wool merchant, he turned from a frivolous, earthly life to one of contemplation, renouncing his inheritance in order to devote his life to the care of the poor, the maimed, and the sick. Disinherited by his father, St. Francis "wed Lady Poverty." He and his followers traveled throughout Italy, North Africa, and the Middle East preaching poverty, peace, charity, and penance. By 1221 over five thousand monks and nuns had joined the order, centered in Assisi. Cheerful and fun-loving, St. Francis had magical powers over animals. He tamed the wild wolf of Gubbio, and preached to the birds, who listened without fluttering. He is credited with establishing the custom of the Christmas crib during a Nativity service at Gubbio, near Assisi in 1223. In 1224, while fasting in his mountain retreat, a seraph appeared to him, and stamped the five wounds of the Crucifixion, the stigmata, on his skin. He bore these, continually bleeding and in pain, for the rest of his life, as bodily symbols of his spiritual identity with Christ.

Caravaggio, *Ecstasy of St. Francis*

St. Francis wears a brown habit and knotted rope belt and is barefoot, with the wounds of the stigmata evident. He may hold a lily, a crucifix, or a skull, as well as birds or animals. He is the patron saint of animals, who often surround him as he receives the Infant Christ from the arms of Mary, who hands Him down from Heaven.

Saint Francis Xavier (1506–1552, f.d. Dec. 3), was a pioneer Jesuit missionary and is the patron saint of missionaries. Ordained on Montmartre after studying with Ignatius Loyola, he eventually converted multitudes in India, and died while waiting to enter China. His body is enshrined in India. He is credited with many miracles and conversions. He wears a black cassock and carries a cross, a flame, or a lily.

Saint George of Cappadocia (d. c. 300, f.d. Apr. 23), was a soldier of the Roman army in Asia Minor. A converted Christian, he was beheaded during the persecutions of Diocletian. His cult became popular in the West with the returning Crusaders. According to legend, a dragon threatened the town of Silene in Libya, poisoning the air with its breath. In order to placate it, the citizens had to feed the dragon their tender sons and daughters. Finally the king's daughter was selected for the next meal. St. George, young, handsome, and armed, approached the lair, crossed himself, and slew the dragon. According to another version, St. George first wounded the dragon and had the princess lead it it back into town

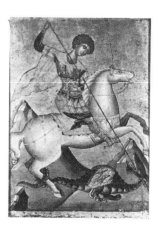

St. George Killing the Dragon, 15th cent. Italian Byzantine

like a dog on a leash, only slaying it when the pagans of Silene agreed to be baptized.

St. George usually wears armor emblazoned with a red cross. His slaughter of the dragon is the symbolic triumph of good over evil, of Christianity over the forces of Satan. He often carries a white banner with a red cross (the Union Jack of England includes a variation on the cross of St. George). He is the patron of armorers, soldiers, and Boy Scouts of England, Portugal, and Germany.

Saint Gregory the Great. *See Doctors of the Church.*

Saint Hubert (d. 727, f.d. Nov. 3) was a Belgian bishop. A local saint of hunters and trappers, his legend merged with that of St. Eustace. He too saw the crucifix between the antlers of a stag while hunting. A stag with the crucifix is his emblem.

Saint Ignatius Loyola. *See Religious Orders.*

Saint James the Great. *See Apostles.*

Saint James the Less. *See Apostles.*

Saint Jerome. *See Doctors of the Church.*

Saint Joachim, father of the Virgin Mary. *See Mary.*

Saint Joan of Arc (1412–1431, f.d. May 30), patroness of France, was born a lowly peasant girl in Lorraine. From an early age she began to hear voices, directing her to help the weak Dauphin of France in his battles against the invading English and their French allies, the Burgundians. Receiving the blessing of the Dauphin and the clergy, she was armed and led her soldiers to victories at Orleans and elsewhere, resulting in the coronation of the Dauphin as Charles VII of France at Rheims. Soon abandoned by him, she was captured by the Burgundians and charged with witchcraft and heresy, and was burned at the stake in the marketplace of Rouen. In 1456 the Church reversed the verdict and declared her innocent, but she was not officially canonized until 1920. Joan of Arc, the Maid of Orleans, appears as an inspiring feminine military leader, dressed in armor, holding the banner of the Annunciation and/or the banner of France, and

sometimes the palm of martyrdom. The fleur-de-lis is her attribute.

Saint John the Baptist (d. c. 24, f.d. June 24) is considered the last Prophet of the Old Testament, since he foretold the coming of Christ, the Messiah, and is also the first saint of the New Testament. Christ's childhood friend and first cousin, John was the son of Elizabeth and Zacharias. The major event in his life was the Baptism of Christ (*see Jesus Christ*). John the Baptist led a hermit's life, and is often pictured as an ascetic, with "his raiment of camel's hair, and a leathern girdle about

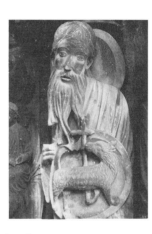

St. John the Baptist,
13th cent. French

his loins" (Matt. 3:4). He may hold a lamb decorated with an explanatory scroll saying Ecce Agnus Dei ("Behold the Lamb of God," John 1:36), another reference to the Baptism. The **Birth and Naming of John the Baptist** shows Zacharias, who had been struck dumb, writing the chosen name of his infant son on a tablet, at which moment his speech was restored to him. In scenes of **The Holy Family** John the Baptist may be included as a young playmate of Jesus, wearing an animal skin and holding a small cross. **The Beheading of John the Baptist** and its variations relate John's disapproval of Herod, the Roman governor, for murdering his brother in order to marry his sister-in-law. John was summarily arrested and jailed. Herod rashly promised Salome, Herodias' seductive daughter, any gift she wanted. Encouraged by her mother, she chose the head of John the Baptist. The

banquet at which Salome danced and entranced Herod, and the decapitation itself, and **Salome Delivering the Head of John the Baptist on a Platter,** all appear often in art. He is the patron saint of missionaries, tailors, and the city of Florence.

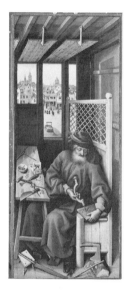

Campin, *St. Joseph,*
The Merode, Altarpiece, right panel
(See Jesus Christ, Mary; Nativity)

Saint John the Evangelist. *See Evangelists.*

Saint Jude. *See Apostles.*

Saint Lawrence (d. 258, f.d. Aug. 10), was a Spanish deacon and church treasurer under Pope Sixtus II. Ordered by the Romans to relinquish the church's wealth, he distributed it to the poor instead, presenting them to the Roman official and saying, "Here is the church's treasure." Lawrence was imprisoned, tortured, and martyred by being roasted on a grill over burning coals. He wears the dalmatic, sometimes decorated with flames, and holds the gridiron, or money, coins, or a purse. He is the patron saint of cooks, and is often paired with St. Stephen.

Saint Louis of France (1214–1270, f.d. Aug. 25), Louis the Pious, embodies the highest ideals of the medieval Christian ruler. King of France at twelve, he was at first aided by his capable mother, Blanche of Castile. He married Margaret of Provence, elder sister of Eleanor of Provence,

Shuctiffime ae beatiffir
martir laurenti. fup
pliater ego peatoz fer
uus tuus.pietatem tuam exozo
ut pzo me fpurciffimo multis
qʒ uiaozum ponderibʒ opprciſo
preces effundere digneris ad ō
nipotentem deum quatinus

St. Lawrence with Grille,
Book of Hours of
Catherine of Cleves,
15th cent. Dutch

wife of Henry III of England, and produced eleven
children. In 1248 he led a crusade, during which he was
captured and imprisoned. During this journey he re-
putedly obtained relics of the True Cross as well as of
the Crown of Thorns. (Sainte Chapelle in Paris was built
especially to house the Crown.) A man of highest in-
tegrity, he was sincerely religious and greatly admired as
an acute statesman, a fair judge, a peacemaker, and a
fine and brave soldier. As a king, he wears armor, a robe
decorated with the fleur-de-lis, and holds a scepter
topped with the Hand of God. Louis may be dressed as
a Franciscan monk, his traveling habit emblazoned with
the Crusader's cross. His attributes are the Crown of
Thorns and the True Cross.

Saint Lucy (d. 304?, f.d. Dec. 13), a noble virgin martyr of
Sicily, is patroness of eyes. Her eyes were of such perfec-
tion, the tale goes, that her fiancé could have no rest
from thinking of their dazzling beauty. Filled with re-
morse, Lucy plucked out her eyes and sent them to him
on a dish, saying, "Now let me live for God." Some ver-
sions say that God replaced the eyes with new ones even
more beautiful; another says that her eyes were put out
as part of her torture by Diocletian's soldiers. She sur-

Cossa, *St. Lucy*

vived the horrors of a brothel untouched, escaped in-
cineration and other tortures, but was finally killed with
a knife thrust in her throat. Her attributes are two eyes
on a plate, the martyr's palm, sword, a rope, and scars on
her neck. A light or lantern may be included as a refer-
ence to her wisdom, as well as a play on her name, from
lux, the Latin word for "light." She is invoked against dis-
eases of the eyes and throat.

Saint Luke. *See Evangelists.*

Saint Margaret (f.d. July 20) was a beautiful shepherdess
of Antioch, the Christian daughter of a pagan priest. She
rejected the proposal of the Roman governor, preferring
Christ as her bridegroom. He denounced Margaret and
jailed and tortured her. Satan visited her in her cell, dis-
guised in the form of a dragon, and swallowed her, but
the cross she held swelled to such dimensions that the
dragon was split in two and she emerged unharmed. On
the way to her beheading, Margaret prayed that all preg-
nant women who appealed to her would be delivered of
healthy babies. She is patroness of childbirth, of women,
nurses, and peasants, and her emblem is the dragon.

Saint Mark. *See Evangelists.*

Saint Martha (1 cent., f.d. July 29) was the sister of
Lazarus, whom Christ miraculously raised from the dead,
and of Mary of Bethany. A paragon of service to the

needy and of domestic virtue, she is the patron saint of housewives and cooks. Plainly dressed, holding a ladle or other kitchen implement, a bunch of keys at her waist, she personifies the efficient chatelaine. A French legend recounts her exile from Palestine and arrival by open boat on the southern coast of France, accompanied by Mary Magdalene. While preaching in Aix, she overcame a dragon by spilling holy water over it. Her other attributes are a dragon or a jar of holy water.

Saint Martin of Tours (c. 315–394, f.d. Nov. 11), established the first French monastery and is a patron saint of France. Born in Hungary and raised in Italy, he was baptized a Christian, in France, about 339, while there as a Roman officer. During a cold night at Amiens, he took his cloak, slashed it with his sword, and gave half of it to a naked beggar. Afterward Christ appeared to him and he resigned his army post to take up a simple hermit's life, but was forced to accept the bishopric of Tours after his hiding place was disclosed by a quacking goose.

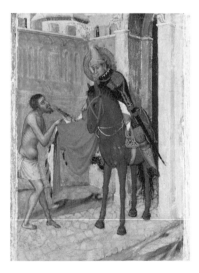

Lorenzetti,
*St. Martin and
the Beggar*

Martin is usually shown on horseback, sharing his cloak with the naked beggar, or he may appear in bishop's robes accompanied by the goose. His relics are in the cathedral at Tours. He is the patron saint of beggars, innkeepers, and tailors.

Saint Mary Magdalene (1 cent., f.d. July 22) is the proto-
type of the penitent sinner. Traditionally she has been
identified with the unnamed prostitute who anointed
Jesus' feet with ointment during the Supper in the House
of Simon (Luke 7:37ff.), perhaps since she is named in
Luke, Chapter 8, which says that Jesus cured her of "seven
devils." One of the faithful women who followed Jesus to
Galilee, she witnessed the Passion, and was the first per-
son present at the Resurrection. According to St. Gregory
the Great, Mary Magdalene is the same person as Mary of
Bethany, Martha's sister. (The Eastern tradition considers
them two different women.) She came from the town of
Magdala, near Galilee, and is said to have lived after the
Resurrection with the Virgin Mary and to have died at
Ephesus. However, a French tradition maintains that
Mary Magdalene with Martha and Lazarus was seized by
infidels, set adrift in a rudderless boat, and carried by
the tides to Marseille—where Mary converted the Gauls
and did penance in the wilderness for thirty years, sus-
tained only by celestial food. After death she was borne
to heaven by angels. She may appear as an elegant lady,
richly attired and holding her attribute, the ointment jar,
or as a thin, wasted hermit, her body cloaked by her flow-
ing hair, accompanied by an angel. She often appears as
one of the three Marys in scenes from the Passion.

Veneziano,
St. Mary Magdalen

Saint Mathias. *See Apostles.*

Saint Matthew. *See Evangelists.*

Saint Nicholas of Myra or Bari (4 cent., f.d. Dec. 6) is today perhaps the most popular saint in Christendom. A bishop of Myra, his charity was legendary. He supplied three bags of gold to three impoverished noblewomen for dowries, averting their fates as prostitutes. (Hence his emblem of three bags of gold, or three balls, later used by pawnbrokers.) He restored to life three little boys who had been killed and pickled in brine. He be-

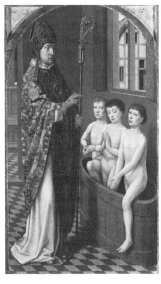

David, *Legend of St. Nicholas* (det.)

came the patron saint of children; presents were given them on his feast day, and he evolved into the person of Santa Claus (from the Dutch *Sinte Klaas,* dialect for St. Nicholas). He rescued sailors from a shipwreck, thus becoming the patron saint of sailors. His remains were stolen by Italian sailors in 1087 and taken to Bari, where they are still enshrined, exuding an oily substance of great medicinal value. St. Nicholas is also the patron saint of travelers, children, captives, bankers, merchants, clerks, and pawnbrokers. He appears as a bishop with three purses of gold, three gold balls, or three boys emerging from a barrel or a ship. He is also the patron saint of Russia.

Saint Patrick (385?–461?, f.d. Mar. 17), patron saint of Ireland, was born in Britain, the son of a Roman official. At sixteen he was abducted to Ireland and enslaved as a shepherd. During six years of slavery and solitude he became intensely religious. Finally escaping to France, he was later ordained a bishop, and returned to convert the Irish. He founded many churches and monasteries, and performed many healing miracles. His most famous miracle was to rid Ireland of snakes and vermin, by inviting a snake to enter a box he constructed. The snake insisted that the box was too small for him, and got in to prove it. St. Patrick slammed down the lid and threw the box into the sea, forever ridding the island of all vermin.

Dressed in bishop's robes, Patrick appears with a snake and a shamrock, flower of Ireland, which he used in explaining the Trinity to the Irish.

Saint Paul. *See Apostles.*

Saint Peter. *See Apostles.*

Carpaccio,
St. Peter Martyr

Saint Peter Martyr (1206–1252, f.d. Apr. 6, 26, or 29). Second in the Dominican order to St. Dominic, St. Peter preached against heresy throughout Italy during a period of great religious upheaval. Appointed inquisitor by Pope

Gregory IX, he violently attacked the heretics, who hired two assassins to kill him en route from Milan to Como. Peter was attacked and repeatedly struck on the head with an ax. His assailants left him for dead, but upon returning found him on his knees reciting the Apostles' Creed. Another version says he had written "Credo" ("I believe") on the ground with his blood. Furious, they stabbed him to death. St. Peter, wearing the Dominican habit, tolerates an ax in his head or a knife in his shoulder. He is the patron of inquisitors and midwives.

Saint Philip. *See Apostles.*

Saint Roch (d. 1337, f.d. Aug. 16). A cross-shaped birthmark convinced St. Roch early in life that he was destined for a religious life. On a pilgrimage to Rome, he tended and cured many victims of the plague, and finally contracted it himself. He was sustained in the forest by his faithful dog, which brought him a loaf of bread daily. Recovering, Roch returned home, but because of the ravages of the plague, he was unrecognized, and imprisoned as an impostor by his uncle. He died in his cell, which was filled with a heavenly light, where a miraculous tablet was found, reading, "All those who are stricken by the plague and pray for help through the intercession of Roch, the servant of God, shall be healed."

School of de la Tour,
St. Roch or St. James the Great

He is invoked against the plague, cholera, and infectious diseases generally, and is also the patron saint of physicians. St. Roch appears as a young pilgrim, staff in hand, his thigh bared to reveal the sores of the plague, his

faithful dog, sometimes with bread in its mouth, at his side.

Saint Scholastica (480–543, f.d. Feb. 10) was the twin sister of St. Benedict and the principal female saint of the Benedictine Order, as well as founder of a nunnery. During their last annual meeting, near Monte Cassino, Scholastica begged St. Benedict to spend the night "so we can go on talking till morning about the joys of heaven." Benedict refused, but a great storm arose in answer to Scholastica's prayers, preventing Benedict from leaving. Three days later Scholastica died. Benedict is said to have seen her soul ascending to Heaven in the form of a dove. He dug her grave himself and was subsequently buried in it with her "so death did not separate the bodies of these two whose minds had ever been united in the Lord" (St. Gregory the Great, *Dialogues*).

St. Scholastica appears as a nun, holding a lily or crucifix, with a dove at her feet or her heart, or flying heavenward.

Saint Sebastian (4 cent., f.d. Jan. 20) was a member of the elite Praetorian guard under Diocletian. The emperor showed Sebastian no mercy when he was discovered to be a Christian, and ordered him to be shot through with arrows. Some stories report that the archers had orders to aim at the least vital parts, in order to prolong the agony. Irene, the widow of another martyr, took pity on Sebastian, nursed his wounds, and healed him. Recovered, he presented himself to the emperor as living proof

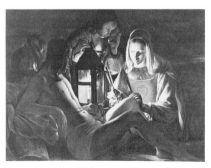

de la Tour, *St. Sebastian Nursed by St. Irene*

of the power of Christ. Diocletian had Sebastian murdered by being battered with cudgels and his body thrown into the main sewer of Rome. It was recovered and buried in the catacombs at the feet of the bodies of Peter and Paul.

Sebastian is represented as a handsome, nearly nude young man, his body tied to a tree or column and pierced with arrows. Sebastian is invoked against plague; his emblem is the arrow. He is the patron saint of archers and soldiers and of pin-makers and potters.

Saint Simon. *See 'Apostles.*

Saint Stephen (d. 35?, f.d. Dec. 26) is the first Christian martyr and the first deacon of the Church. Falsely accused of blasphemy, which he countered by accusing the Jews of having killed "the Holy One," he was given the

Subleyras,
Stoning of St. Stephen

traditional punishment of being stoned to death. Four hundred years later his relics were miraculously discovered and transported to Rome, to be buried alongside St. Lawrence, who moved over and stretched out his hand to welcome his fellow deacon and martyr. The two are often represented together. Stephen's attribute is the stone.

Saint Thomas (Doubting Thomas). *See Apostles.*

Bernini,
St. Teresa in Ecstasy

Saint Thomas à Becket (1118–1170, f.d. Dec. 29), also Thomas Becket and Thomas of Canterbury, excelled in intellectual and knightly accomplishments. After serving as clerk to Theobald, Archbishop of Canterbury, he became a powerful chancellor and advisor of King Henry II. He was ordained in 1162 and appointed Archbishop of Canterbury to replace the deceased Theobald. He refused to bow to Henry's demands, always guarding the prerogatives of the Church against the whims of his king. When in a fit of rage Henry declared his wish to be rid of this "turbulent priest," four knights attacked Thomas during Vespers in the Cathedral at Canterbury and killed him. The building became a popular pilgrimage place, and Thomas was canonized two years after his death.

The most common representation of Thomas à Becket shows him being attacked at the altar with long swords.

Saint Thomas Aquinas (1225–1274, f.d. Mar. 7) was the systematizer of Catholic theology. The son of a noble Italian family of Aquino, near Naples, he was educated by the Benedictines at Monte Cassino, and joined the Dominican order in 1244. Imprisoned by his disapproving family, he was visited by two angels, who gave him a girdle of perpetual virginity. Although seemingly dull and slow-witted—his fellow students nicknamed him the "dumb ox"—he entered the University of Naples at

eleven. His tutor remarked, "You may call him dumb ox, but he will give such a bellow in learning as will astonish the world." Thomas studied under Albertus Magnus in Paris, and taught in Naples and Cologne, where he established a theological school. He concentrated on theological teaching and writing, and has been called the "Prince of Scholastics." His life's work was his *Summa Theologica,* the most complete and important medieval compendium of theology, philosophy based on Aristotle, and canon law. He left it unfinished, saying, "All I have written seems to me like so much straw compared with what I have seen and what has been revealed to me."

He appears as a Dominican monk, with an ox by his side; with a rayed sun emblazoned on his breast; or holding a rayed chalice, a reference to his writings on the Eucharist; holding a book and pen, symbolizing his learning; or with a star. He is the patron saint of universities, centers of learning and Catholic schools.

Saint Ursula and Her Maidens (f.d. Oct. 21). According to the medieval legend, Ursula, an English Christian princess of great beauty and spirituality, agreed to marry Prince Conon, a pagan, on condition that she must first have three years to visit, in the company of ten noble virgins, all the shrines of Christian saints. She also insisted that the prince convert to Christianity. He agreed, and accompanied Ursula to Rome. On their return they stopped at Cologne, which was under attack by the Huns; the barbarians killed all of Ursula's female companions, who by then numbered 11,000. (This multiplication remains a mystery.) Ursula was spared on condition that she marry the king of the Huns. She refused, and was shot with three arrows.

Ursula appears dressed as a princess in elaborate robes, crowned, holding an arrow or pilgrim's staff with white banner and red cross. Her maidens may kneel at her feet, enclosed in the protection of her cloak or disembarking at Cologne. She is the patron saint of chastity and wedlock, drapers and teachers, and is invoked against the plague. (The arrow represents the plague.)

Saint Veronica (1 cent., f.d. July 12) was the woman healed of the "issue of blood" who pitied Christ on his

way to Calvary and wiped the blood from his face with her veil or handkerchief. Miraculously the imprint of his face and the Crown of Thorns was transferred to the cloth, known as the vernicle. (It is also called the sudarium, or sweat cloth.) The relic has been preserved at St. Peter's in Rome since the eighth century. Veronica's attribute is the vernicle; she is the patroness of linen-drapers and washerwomen.

St. Veronica's Veil,
16th cent. Italian

SHAPES

The **circle,** sphere, disc, or ring symbolizes eternity and God as an eternal force, and Heaven because of its perfect symmetry and its unvarying balance. As an emblem for God, it suggests His perfection, His uninterrupted power. Three circles entwined symbolize the Trinity.

The **octagon** is an eight-sided figure, the intervening shape between the circle and the square.

The **pentagram** is a five-sided solid figure, which in Christian art represents the five wounds Christ received at the Crucifixion.

The **square** is the opposite of the circle; it represents earth, and the square halo identifies a living person. The four elements, the four seasons, the four ages of man, the four directions of the compass, are all solid, orderly,

earthly concepts suggesting the order, stability, and gravity of the square.

The **trefoil,** three joined semicircles the shape of a clover leaf, is a variation on the triangle, and similarly represents the Trinity.

The equilateral **triangle** also symbolizes the Trinity. A triangular halo is used to identify God the Father or the Trinity. A circle within a triangle represents the eternity of the Trinity. A triangle combined with three circles is another emblem for the Trinity, incorporating God the Father, God the Son, and God the Holy Ghost.

SIBYLS

According to Greek myth, sibyls were a group of prophetic women two to twelve in number. In Christian art, they are the counterparts of the Prophets, the most important being the Erythraean and Tibertine sibyls. The Erythraean sibyl of Ionia prophesied the Annunciation. The Tibertine sibyl had a vision of a king born to a virgin at the exact moment Christ was born to Mary.

The sibyls are "the voices of the classical world testifying that the Gentiles also had a vision of Christ." Writings attributed to them were gathered into fifteen books. Sibyls are generally beautiful strong women clad in classical draperies, and identified by an accompanying inscription, such as Libya, Delphi, Persia, or Cumae, indicating their place of origin.

TREE

The tree in general represents the cosmos with its cyclical processes and its regenerative blooming. It also represents immortality, growth, and creative power. Because of its tall vertical shape, it symbolizes an upward surge, like the ladder or the mountain, and is looked upon as a link between the world of Heaven and that of Hell. (The roots reach into the underworld of Hell; the trunk is the earthly link to the spreading foliage of Heaven.) The tree also corresponds to the Tree of Life, and the Cross. The tree in the Garden of Eden is seen as a prophecy of the Cross.

The physical condition of the tree indicates its symbolic meaning. A flourishing tree means life, hope, holiness, goodness, and health—positive virtues. A withered or dying tree suggests diminishing forces and death.

On the third day of Creation God brought forth trees and other vegetation. (See also Flowers and Fruits.)

The Tree of Life (arbor vitae) was a decorative and iconographical motif in the ancient Middle East. It is the tree of the immortals, or the tree of living. The Tree of Knowledge of Good or Evil was the tree of mortals, the tree of knowing. Thus when Adam succumbed and ate "the fruit of the tree which is in the midst of the Garden" (Gen 3:3), he deprived man of eternal life on earth. Sometimes when the two trees are represented, the Tree of Life is depicted in bloom while the Tree of Knowledge is dry, withered, and on the verge of death.

The tradition of the Maypole goes back to the idea of tree worship. In an ancient rite, a young tree was planted outside the window of a marriageable girl in order to assure her fertility. The Christmas tree is born of another tree legend, which gained popularity in the nineteenth

century. On the night Christ was born, the trees mirac-
ulously bore fruit and flowers blossomed; the stars
settled on bare trees as decoration, the first Christmas
ornaments. An evergreen pine is used for the Christmas
tree because it was thought by some to have been the
tree that sheltered the Holy Family as they rested on the
flight into Egypt.

The **cedar,** specifically the Cedar of Lebanon (*Cedrus
libani*), is a botanical symbol for Christ (Song of Sol.
5:15). The Cedars of Lebanon were prized and treasured
tall trees that forested the plains and slopes of Mount
Lebanon, and were a source of wealth. The Temple of
Solomon was constructed of cedars from Mount
Lebanon. The palace attached to it, which so impressed
the Queen of Sheba, was called the House of the Forest
of Lebanon.

The **cypress** is an evergreen tree, associated with death
and often planted in cemeteries. Its branches were car-
ried by mourners at funeral processions as a symbol of
death, since the cypress once cut down will never
replenish itself and grow again. It was brought to the
Mediterranean by the Phoenicians, who planted it on the
Island of Cyprus.

The **fig tree,** like the palm and the olive, is one of the
most abundant trees of the Middle East and important
for its fruits, shade, and medicinal uses. It may appear
as an alternative to the apple as the Tree of Knowledge
of Good and Evil in the Garden of Eden, since the Bible
specifically states that Adam and Eve, after the Fall, made
aprons out of fig leaves (Gen. 3:7). Therefore, the fig
has become a symbol of lust; because of its many seeds
it may also be a symbol of fertility.

The **Tree of Jesse** is a decorative device illustrating the
geneology of Christ; it is the family tree of Christianity.
The literal image of Jesse, as a recumbent king with a
tree sprouting out of his side, is based upon the prophecy
of Isaiah (11:1–3). The number of branches and of rela-
tives varies greatly, but principal figures like David, the
son of Jesse, and the Virgin Mary are always included.
Others may be Old Testament kings, the prophets, and

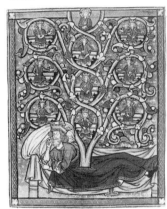

Tree of Jesse,
13th cent. French

sibyls, as well as groups of classical philosophers. The tree generally terminates in the figure of Christ, sometimes surrounded by seven doves, the Seven Gifts of the Spirit. Variations include the Virgin with the Christ Child at the top, or Mary alone.

The **laurel,** an evergreen, stands for victory, eternity, and chastity, evolving from the ancient practice of crowning winners of athletic and intellectual contests with a wreath of laurel. The laurel was the botanical attribute of the Roman Vestal Virgins, dedicated to eternal chastity, and thus is a symbol of chastity in Christian art as well.

The **oak** symbolizes strength and longevity, enduring relationships, and firmness of faith in God. In antiquity, oak leaves were used like laurel to make crowns for civic heroes.

The **olive** tree, because of its abundance, represents God's generosity to his people. The olive branch is widely accepted as a symbol of peace. It represents God's reconciliation with man through Noah. When the dove appears with a sprig of olive in its beak, it may be a general symbol of peace, or more specifically it may represent souls of the dead who have died in peace with God. It is also a symbol of safe travel, since the dove returned to the Ark unharmed.

In Sienese paintings of the Annunciation, Gabriel generally holds an olive branch rather than a lily, since the lily was a symbol of Florence, Siena's enemy during the early Renaissance.

The **palm** tree flourished throughout the Middle East as a Tree of Life symbol. Since antiquity a palm branch has been a symbol of triumph and victory. Appropriately, when Christ was entering Jerusalem the people strewed his path with palm leaves, in defiance of the Romans, who had used the palm as their symbol of victory over the Jews (John 12:13). This is recalled by the distribution of palms in the Christian church on Palm Sunday and by the Jews on Passover. The early Christians appropriated the palm branch as the sign of the martyr. Martyred saints may hold a palm spray as well as their personal attributes, to emphasize their victory over sin and death. Because the palm is evergreen, it has a secondary symbolism as a reminder of immortality.

THE TRINITY

The concept of three persons incorporated in one God is the central dogma of the Christian church. The earliest symbols for the Trinity were abstract: the equilateral triangle, sometimes embellished with rays; an eye enclosed within a triangle, referring to the all-seeing eye of God watching from the Trinity; the triangle enclosing a circle, suggesting the eternity of the Trinity; three interlocking circles to imply equality, unity, and eternity in the persons of the Trinity; or three equal intertwining arches, the triquetra, an early Christian emblem for the Trinity. During the Middle Ages, Latin words were sometimes included with the Trinity symbols. Unitas (unity) and Trinitas (Trinity) were intertwined with the three-circle motif. The three points of the triangle were labeled Pater (Father), Filius (Son), and Spiritus (Spirit). The trefoil, three half-moons within a circle, three small circles within a larger circle, all are familiar symbols of the Trinity, emphasizing triplicity within the unity, three composed into one whole.

Common early Christian symbols for the separate parts of the Trinity were the Hand of God for God the Father, the Lamb or Cross for the Son (Christ), and the Dove for the Holy Ghost. These three were rarely combined into

one image, but one or two might be used in conjunction with a human figure. Another type of Trinity was three persons in human form of identical or varied ages, such as three kings seated on separate thrones. The most consistently popular representation of the Trinity remains that of God the Father, a seated old man supporting in front of him, or on his lap, Christ on the Cross, with the Dove hovering between or above them.

The Baptism of Christ is the principal event in the New Testament where the Trinity appears (Matt. 3:16–17). This is pictorialized with the Hand of God the Father descending from the clouds blessing the human form of Christ. The Dove of the Holy Spirit hovers over the head of Christ.

The visit of the three men to Abraham in the Old Testament was considered as a prophecy of the Trinity, since Abraham saw three figures but addressed only one (Gen. 18:1–3). The three men may appear as identical angels standing before Abraham.

VESTMENTS
VICES AND VIRTUES

VESTMENTS

Garments worn by priests or other ecclesiastics for specific church ceremonies or sacraments are called vestments. They evolved from Jewish ceremonial priests' robes and from civil Roman costume, and are worn over the cassock or habit (*see also Religious Orders*).

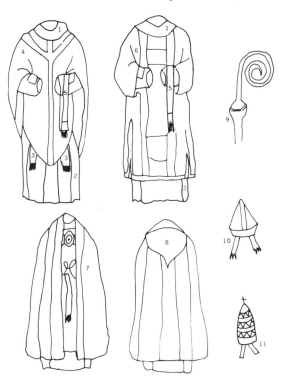

1. Amice 2. Alb 3. Stole 4. Chasuble 5. Maniple 6. Dalmatic
7. Cope 8. Hood 9. Crozier 10. Miter 11. Tiara

Alb. An ankle-length garment of white linen with loose sleeves, representing the robe in which Christ was dressed by Herod's soldiers during the Mocking of Christ. It represents purity, chastity, and joy.

Amice. A rectangular piece of linen, laid across the shoulders, tied in front at the neck as a kind of collar. It represents the cloth used by Herod's soldiers to cover Christ's face.

Chasuble. The last and principal vestment donned by the priest, bishop, or archbishop for the celebration of the Mass. It slips over the head and rests on the shoulders like a poncho. The chasuble represents the robe ordered by Pilate to be placed on Christ as "King of the Jews,"

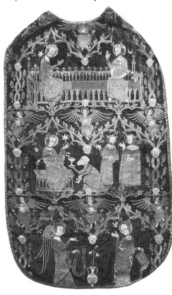

Chasuble back depicting
Virgin Mary enthroned
with Christ,
Adoration of the Magi,
Annunciation,
14th cent. English

and is usually made of fine fabric to match the altar hangings. It also suggests the "seamless garment" for which the soldiers cast lots at Calvary after the Crucifixion. The chasuble suggests protection and charity.

Cope. A full cloak of rich fabric worn mainly at processions, which rests on the shoulders and is fastened at the chest with a strip of fabric or a brooch. It represents dignity, purity, and innocence.

Crozier. *See Religious Objects.*

Dalmatic. A mid-calf-length sleeved tunic, worn principally by deacons, representing salvation, justice, and joy.

Hood. A triangular piece of fabric attached to the neck of the cope. Originally functional, it is now mainly a decorative detail.

Maniple. A narrow strip of fabric, generally embroidered and decorated with three crosses, which is worn over the left forearm by most clergy. The maniple represents the rope with which Christ was bound and led to Calvary during the Passion; it suggests penance, vigilance, and good works.

Miter. A tall, flat hat with two points, usually elaborately embroidered, worn by bishops, archbishops, and some abbots. The two points of the miter suggest the two rays of light that appeared from the head of Moses when he received the Ten Commandments; they also symbolize the Old and New Testaments. **Lappets,** two narrow, fringed streamers, usually hang from the back, and suggest the spirit and the letter of the Bible.

Ring and gloves. Elaborately embroidered, they were worn by bishops. The ring was the sign of the bishop's office, and often carried his seal.

Stole. A long, narrow piece of cloth worn under the dalmatic or chasuble, extending almost to the ankle. Its placement on the body determines the position of the clergy; a deacon hangs the stole from his left shoulder; a bishop drapes it around his neck, letting it fall freely from both shoulders; a priest wears it around his neck, crossed on the chest and held in place by a belt or sash. The stole signifies the power and dignity of the priest. It symbolizes the yoke of Christ, the need to work diligently in order to achieve immortality in Heaven.

Tiara. The triple crown worn only by the Pope. The three crowns refer to the Trinity. (*See St. Gregory the Great, under Doctors of the Church.*)

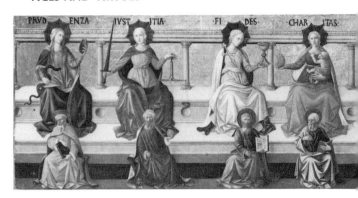

VICES AND VIRTUES

The vices and virtues number seven each, and are often grouped together. They were assimilated into Christian teaching from classical illustration. The struggles between the Vices and Virtues were incorporated into the decoration of Romanesque churches, with the Virtues appearing as majestic armed maidens. During the Gothic period, the Virtues became calm, triumphant women identified by their attributes.

The Seven Virtues are the Christian virtues Faith, Hope, and Charity, with their root in religion, and the cardinal virtues, based on Plato—Fortitude, Temperance, Prudence, and Justice. The cardinal virtues can be learned by training and discipline; the Christian virtues must be acquired through faith. The Virtues may be accompanied by an appropriate saint. **Faith** holds a chalice or cross; St. Peter is at her feet. **Hope** may have wings; she raises her arms and eyes to Heaven, St. James the Great at her feet. Her attribute is the anchor. **Charity** nurses and protects children, and distributes alms to the poor. She holds a flame or a heart, and may have St. John the Evangelist at her feet. **Fortitude** is an armed maiden, draped in the lion's skin of Hercules; a lion, the broken column, and Samson may cluster at her feet. She may hold a club, a sword, a shield, or a globe. **Temperance** holds two vases, or may be pouring from one to another, "an even measure"; or she may hold a clock, a measure of time,

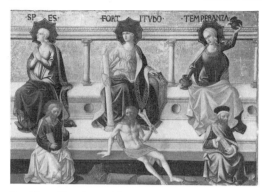

Pesellino, *The Seven Virtues*

or a bridle, all references to balance and restraint.
Prudence may have two heads, in order to look both
ways, and may hold a mirror for self-revelation, or have
a snake at her feet—"Be wise as serpents." Solon, a
Greek poet, humanist, and law-giver, sits at her feet.
Justice holds the scales. She is blindfolded to avoid
corruption and prejudice, and holds a sword to repel
evil. The Roman Emperor Trajan is at her feet. During
the Renaissance the Vices and Virtues were often paired
with appropriate classical gods.

The Seven Vices are synonymous with the Seven Deadly
Sins. Classified as capital or mortal sins, they are the

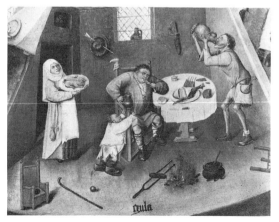

Bosch, *Gluttony* (det., *The Seven Deadly Sins*)

major offenses against God in the Christian Church. The Seven Vices or Seven Deadly Sins are **Pride, Covetousness, Lust, Anger, Envy, Gluttony,** and **Sloth.** They are not usually personified by symbols as the Virtues are but rather can be identified by their actions. A fat man eating and drinking excessively is Gluttony; Venus with Eros often personifies Lust; an elegant figure surrounded with luxuries represents Pride or self-indulgence. Like the Virtues, the number and classification of the Vices may vary. In general, repose, tranquility, and peace surround the Virtues while frantic movement and struggle engulf the Vices.

 YEAR (CHURCH)

YEAR

The Church Year is arranged by the Christian Church within the calendar year to include the religious observances and holy days, beginning with Advent, to tell the Christian story through services paralleling the life cycle of Christ.

Advent includes the four Sundays before Christmas and is a time of repentance and mourning. It prepares for the joyous celebration of Christmas and for the Last Judgment. The Advent color is purple. (The color sequence reflects that of the Court of Rome in the sixteenth century.) No weddings or joyous music are permitted during Advent.

Christmas is the Church's celebration of the birth of the Redeemer, theologically the turning point in human history. The color is white, for celebration.

Epiphany or **Twelfth Night,** on January 6, commemorates the appearance of Christ to the Gentiles in the Adoration of the Magi, his divinity at Baptism, and his first miracle at the Marriage of Cana. The color is green, suggesting Spring. **Septuagesima, Sexagesima,** and **Quinquagesima** Sundays are approximately seventy, sixty, and fifty days before Easter. The color for these days, and for Lent, is purple, the color of penance. **Ash Wednesday** is the seventh Wednesday before Easter and the beginning of Lent. Ashes, from the burned palms from Palm Sunday, are placed on the foreheads of the faithful as tokens of repentance. (**Mardi Gras,** Fat Tuesday, is the day before Ash Wednesday, a last day of revelry before Lent.) **Lent** lasts forty days (not including Sundays), corresponding to the forty days spent by Moses, Elijah, and Christ in the desert. Church decorations are removed

or covered; no marriages are performed; the mood is one of sorrow.

Holy Week reenacts the Passion, beginning with **Palm Sunday,** which commemorates Christ's entry into Jerusalem. Palms, strewn in His path as symbols of victory, continue to decorate the church and bless the congregation. **Maundy Thursday** services include the reenactment of Christ's washing of the disciples' feet as an act of humility during the Last Supper.

For **Good Friday** and the Crucifixion vestments are black, the color of evil and death. **Holy Saturday** symbolizes the day Christ spent in the tomb. Man is entombed with Christ and is reborn again with him through baptism, traditionally performed this day. Vestments and hangings are white.

Easter, the first Sunday after the full moon following March 21, the spring equinox, is the pivotal day of the church year, determining other movable feasts of the church calendar. (It is named after the English goddess of Spring, Easter, whose festival was celebrated at this time.) The Resurrection is celebrated with lilies, elaborate church decorations, and white or gold vestments.

The Feast of the Ascension, forty days after Easter, commemorates Christ's ascension into Heaven. The colors are white or gold. **Pentecost,** or Whitsuntide, fifty days after Easter and ten days after the Ascension, celebrates the Law given to Moses, as well as the descent of the Holy Ghost upon the Apostles, giving them the gift of tongues. The color is red, symbolizing the tongues of flame in which the Holy Spirit descended. **Trinity Sunday** falls a week after Pentecost; the rest of the year until Advent parallels the growth of Christianity, with green vestments and hangings.

Z
ZODIAC

Z

The letter Z stands for Zion, the symbolic name for Jerusalem, the Promised Land of the Old Testament, and therefore for Heaven.

ZODIAC

The Zodiac is a symbolic wheel of life. (In Greek, zoe means life and *diskos* means wheel.) Its circular form, divided into twelve constellations similar to the months, describes the annual cycle of the sun and the seasons. The stars in the zodiacal zone are arranged into constellations suggesting animal forms. The signs of the zodiac in art were often combined with the corresponding Labors of the Months, to suggest the omnipotence of God through time and space.

Knoblochtzer, *Zodiac*

Signs of the Zodiac and Labors of the Months

MONTH	LABOR OR ACTIVITY	ZODIAC SIGN
January 20– February 18	Feasting, indoor life	Aquarius (waterbearer)
February 19– March 20	Indoors, warming by fire, tending vines in winter landscape	Pisces (fish)
March 21– April 19	Planting vines	Aries (ram)
April 20– May 20	Bucolic spring landscape	Taurus (bull)
May 21– June 21	Knights at play, falconry, sporting, boating	Gemini (twins)
June 22– July 22	Sheep shearing, haying	Cancer (crab)
July 23– August 22	Harvesting, cutting corn	Leo (lion)
August 23– September 22	Threshing, field work	Virgo (virgin)
September 23– October 23	Vintage month	Libra (scales)
October 24– November 21	Sowing winter wheat, village fairs, animal sales	Scorpio (scorpion)
November 22– December 21	Winter preparations butchering, preparing flax	Sagittarius (archer)
December 22– January 19	Rest, revelry	Capricorn (goat)

SELECTED BIBLIOGRAPHY

ILLUSTRATIONS:
Sources and Credits

INDEX

SELECTED BIBLIOGRAPHY

Appleton, Leritt, and Bridges, S. *Symbolism in Liturgical Art.* New York: Scribners, 1959.

Attwater, D. *The Penguin Dictionary of Saints.* London: Penguin Books, 1965.

Butler, A. *Lives of the Saints.* London: Thurston and Attwater, 1956.

Chase, M. E. *The Bible and the Common Reader.* New York: Macmillan, 1973.

Cirlot, J. E. *A Dictionary of Symbols.* New York: The Philosophical Library, 1972.

Davidson, G. *A Dictionary of Angels.* New York: The Free Press, Macmillan, 1967.

Didron, A. N. *Christian Iconography: A History of Christian Art in the Middle Ages,* 2 vols. New York: Ungar, 1965.

Ferguson, G. *Signs and Symbols in Christian Art.* New York: Oxford University Press, 1961.

Hughes, R. *Heaven and Hell in Western Art.* New York: Stein and Day, 1968.

Grabar, A. *Christian Iconography: A Study of Its Origins.* Princeton, N.J.: Princeton University Press, 1968.

Jameson, A. B. *History of Our Lord As Exemplified in Works of Art.* London: Longmans Green, 1892.

———. *Sacred and Legendary Art.* Boston: Houghton Mifflin, 1895.

———. *Legends of the Madonna.* Boston: Houghton Mifflin, 1896.

———. *Legends of the Monastic Orders.* Boston: Houghton Mifflin, 1895.

Male, E. *The Gothic Image.* New York: Harper, 1958.

Morey, C. R. *Christian Art.* New York: W. W. Norton, 1958.

New Catholic Encyclopedia. New York: McGraw-Hill, 1966.

Panofsky, E. *Studies in Iconology: Humanistic Themes in the Art of the Renaissance.* New York: Harper and Row, 1962.

Schiller, Gertrud. *Iconography of Christian Art.* Vols. I, II. Greenwich, Conn.: N. Y. Graphic Society Ltd., 1971.

Voragine, J. de *The Golden Legend.* New York: The Arno Press, 1969.

Warner, Marina. *Alone of All Her Sex.* New York: Wallaby, Pocket Books, 1978.

White, T. H. *The Bestiary, A Book of Beasts.* Translation of 12th c. Latin Bestiary. New York: Putnam, 1960.

SOURCES AND CREDITS

p. iii Crozier (det., *St. Michael Slaying the Dragon*), 13th cent. French, enamel on copper, The Metropolitan Museum of Art, Gift of J. Pierpont Morgan, 1917, New York.

p. x H. Knoblochtzer, *Zodiac,* 15th cent. German, woodcut, by permission of the Harvard College Library, Cambridge, Mass.

p. 2 *Seraphim,* mosaic, Baptistry (det., Dome), Il Duomo, Florence, Alinari—Art Reference Bureau.

p. 3 *Saint Michael,* 19th cent. American, New Mexican wood carving, Taylor Museum of the Colorado Springs Fine Arts Center.

p. 5 *Fall of Babylon,* 14th cent. German, Mss., f. 26v., The Metropolitan Museum of Art, The Cloisters Collection, New York, 1968.

p. 6 G. A. Guardi, *Tobias and the Angel,* 18th cent. Italian, oil, The Cleveland Museum of Art, Mr. and Mrs. William H. Marlatt Fund.

p. 7 Matteo di Giovanni, *Judith with the Head of Holofernes,* 15th cent. Italian, tempera on panel, Courtesy of the Indiana University Art Museum, Bloomington.

p. 8 Thomas Hart Benton, *Susanna and the Elders,* 20th cent. American, oil and tempera on panel, The Fine Arts Museums of San Francisco, California Palace of the Legion of Honor.

pp. 10, 11 *Apostles,* 13th cent. French, stone sculpture, south porch, Chartres Cathedral. Copyright, James Austin, Cambridge, England.

p. 13 *St. Paul on the Road to Damascus, and Escaping from the City in a Basket,* 12th cent. Sicilian, mosaic, Palazzo Reale, Capella Palatina, Palermo, Alinari—Art Reference Bureau.

p. 17 E. Hicks, *The Peaceable Kingdom,* 19th cent. American, oil, The Abby Aldrich Rockefeller Collection, Colonial Williamsburg, Va.

p. 18 Toulouse-Lautrec, *Coqs,* from Jules Renard, *Histoires naturelles*, Paris, 1899, Harvard College Library, Department of Printing and Graphic Arts, Cambridge, Mass.

p. 22 *Lamb of God (Agnus Dei Plaque),* 12th cent. French, Champlevé enamel, courtesy of the Art Institute of Chicago.

p. 25 *Phoenix,* 12th cent. English, Harley Ms. 4751, f. 45, British Museum, London.

p. 27 *The Unicorn in Captivity,* 15th cent. French, tapestry, The Metropolitan Museum of Art, The Cloisters Collection, Gift of John D. Rockefeller, Jr., 1937, New York.

p. 28 J. Perelin, *Church, von der Kurst Perspectiva,* 16th cent. German, woodcut, The Metropolitan Museum of Art, Rogers Fund, 1922, New York.

p. 33 P. Gauguin, *The Yellow Christ,* 19th cent. French, oil, Albright-Knox Art Gallery, Buffalo, New York.

p. 36 *St. Ambrose or Augustine,* 15th cent. French, wood-carving, The Metropolitan Museum of Art, Gift of J. Pierpont Morgan, 1917, New York.

p. 37 *St. Augustine,* 14th cent. Flemish, Ms. 399, f. 299v., The Pierpont Morgan Library, New York.

p. 38 *St. Gregory,* 10th cent. German, ivory, Kunsthistorisches Museum, Vienna.

p. 39 A. Dürer, *St. Jerome in His Study,* 15th cent. German, engraving, Courtesy Museum of Fine Arts, Boston, Gift of Mrs. W. Scott Fitz.

p. 43 S. Botticelli, *The Madonna and Child of the Eucharist,* 15th cent. Italian, oil, Isabella Stewart Gardner Museum, Boston.

p. 44 *Matthew, Book of Kells,* 9th cent. Celtic, f. 28v., by permission of the Librarian and Board of Trinity College, Dublin.

p. 45 *Lion of St. Mark,* 16th cent. Venetian, limestone sculpture, The Metropolitan Museum of Art, Rogers Fund, 1913, New York.

p. 46 *St. Luke Painting the Virgin,* 15th cent. Italian, Ms. 944, f. 75v., The Pierpont Morgan Library, New York.

p. 47 N. Poussin, *St. John on Patmos,* 17th cent. French, oil, courtesy of The Art Institute of Chicago.

p. 49 *Hours of Ferdinand V and Isabella of Spain,* 15th cent. Belgian, Purchase, The Leonard C. Hanna Jr. Bequest, The Cleveland Museum of Art.

p. 54 C. Crivelli, *Madonna and Child,* 15th cent. Italian, oil, Pinacoteca, Milan, Alinari—Art Reference Bureau.

p. 57 *God* (det.), 12th cent. English, Ms. 791, f. 4v., The Pierpont Morgan Library, New York.

p. 59 J. Della Quercia, *Creation of Adam,* 15th cent. Italian, marble, main door, Basilica of St. Petronia, Bologna, Alinari—Art Reference Bureau.

p. 61 Pol, Jean, and Herman de Limbourg, *The Court of Heaven,* 15th cent. French, The Belles Heures of Jean, Duke of

Berry, Mss. f. 218, The Metropolitan Museum of Art, The Cloisters Collection, Purchase, 1954, New York.

p. 61 *Hell Mouth,* 12th cent. English, Ms. Cotton Nero, c. IV, f. 39v., Winchester Psalter, British Museum, London.

p. 67 *Instruments of the Passion, Mass of St. Gregory,* 15th cent. Flemish-Burgundian, oil, Courtesy Wadsworth Atheneum, Hartford, Conn., Ella Gallup Sumner and Mary Catlin Sumner Collection.

p. 68 *Christ As Good Shepherd,* 3rd cent. Italian, ivory, The Louvre (Archives Photographique), Paris.

p. 69 *Christ Pantocrator,* 12th cent. Sicilian, mosaic, Cathedral, Cefalù Alinari—Art Reference Bureau.

p. 69 *Christ in Majesty with Symbols of the Four Evangelists,* 12th cent. Spanish, fresco, Courtesy, Museum of Fine Arts, Boston, Marie Antoinette Evans Fund.

p. 70 F. Walther, *Christ of the Apocalypse* (det., *Sermon of St. Albertus Magnus),* 15th cent. German, oil, The Metropolitan Museum of Art, The Cloisters Collection, 1964, New York.

p. 70 *Christ, Savior of the World (Salvator Mundi)* (det.), 17th cent. Swiss, pottery stove, The Metropolitan Museum of Art, Rogers Fund, 1906, New York.

p. 71 Geertzentot St. Jeans, *Nativity,* 15th cent. Flemish, oil, Courtesy of the Trustees, The National Gallery, London.

p. 71 *Annunciation to the Shepherds* (det.), 12th cent. French Royal Portal, Chartres Cathedral, Marburg—Art Reference Bureau.

p. 72 A. Mantegna, *The Adoration of the Shepherds,* 15th cent. Italian, tempera, The Metropolitan Museum of Art, Anonymous gift, 1932, New York.

p. 73 John of Hildesheim, *Journey of the Magi,* 15th cent. German, woodcut, The Metropolitan Museum of Art, Bequest of James C. McGuire, 1931, New York.

p. 73 *The Circumcision,* 15th cent. Flemish, wood sculpture, Smith College Museum of Art, Northampton, Mass.

p. 74 Giotto, *The Presentation of the Child Jesus in the Temple,* 13th cent. Italian, oil, Isabella Stewart Gardner Museum, Boston.

p. 75 *Flight into Egypt,* 12th cent. French, limestone capital, Cathedral St. Lazare, Autun, Marburg—Art Reference Bureau.

p. 76 G. D. Tiepolo, *Flight into Egypt,* 15th cent. Italian, engraving, The Metropolitan Museum of Art, Purchase, Estate of Florence Waterbury, 1970, New York.

p. 76 *The Miracle of the Palm Tree,* painted, 15th–16th cent. Spanish, wood relief, The Metropolitan Museum of Art, Rogers Fund, 1938, New York.

p. 77 Raphael, *The Alba Madonna,* 15th cent. Italian, oil,

Courtesy of the National Gallery of Art, Washington, Andrew Mellon Collection, 1937.

p. 77 F. de Zurbaran, *The Holy House of Nazareth,* 17th cent. Spanish, oil, The Cleveland Museum of Art, ·Purchase, Leonard C. Hanna Jr. Bequest.

p. 78 G. di Paolo, *The Child Disputing in the Temple,* 15th cent. Italian, oil, Isabella Stewart Gardner Museum, Boston.

p. 79 *Baptism of Christ,* 13th cent. French, gilded bronze with Champlevé, Limogas, enamel, Courtesy Museum of Fine Arts, Boston, Francis Bartlett Fund.

p. 80 Duccio, *Temptation of Christ on the Mountain,* 13th cent. Sienese, oil, Copyright, The Frick Collection, 1937, New York.

p. 80 B. Strozzi, *The Calling of Matthew,* oil, 17th cent. Italian, Worcester Art Museum, Worcester, Mass.

p. 81 *Sermon on the Mount,* 14th cent. Italian, Mss. 115, Bibliotheque Nationale, Paris.

p. 82 El Greco, *Christ Driving the Money Changers from the Temple,* 17th cent. Spanish, oil, The Minneapolis Institute of Arts.

p. 82 *The Woman at the Well,* 19th cent. Austrian, pinprick paperwork decoupage, The Metropolitan Museum of Art, Gift of D. Lorraine Yerkes, 1959, New York.

p. 83 P. Veronese, *Feast in the House of Levi* (det.), oil, Accademia di Belle Arti, Venice, 16th cent. Venetian, Alinari—Art Reference Bureau.

p. 83 P. Perugino, *Delivery of the Keys to Peter* (det.), fresco, Sistine Chapel, the Vatican, Rome, 15th cent. Italian, Alinari—Art Reference Bureau.

p. 84 G. Bellini, *The Transfiguration,* 15th cent. Italian, Museo Civico, Venice, Alinari—Art Reference Bureau.

p. 85 *Christ on a Donkey,* 15th cent. German, wood sculpture, The Metropolitan Museum of Art, The Cloisters Collection, 1955, New York.

p. 86 Rembrandt, *Woman Taken in Adultery* (det.), 17th cent. Dutch, oil, National Gallery, London, reproduced by courtesy of The Trustees.

p. 86 D. Bouts, *The Last Supper,* 15th cent. Flemish, oil, St. Pierre, Louvain, Bruckman—Art Reference Bureau.

p. 87 *Christ Washing Feet of Disciples* (det.), 14th cent. Italo-Hungarian, Mss. 360, f. 5, The Pierpont Morgan Library, New York.

p. 88 El Greco, *Christ at Gethsemane,* 16th cent. Spanish, oil, The Toledo Museum of Art, Gift of Edward Drummond Libbey, 1946, Toledo, Ohio.

p. 88 Pol, Jean, and Herman de Limbourg, *The Kiss of Judas,* 15th cent. French, The Belles Heures of Jean, Duke of Berry,

Mss. f. 123v, The Metropolitan Museum of Art, Purchase, 1954, The Cloisters Collection, New York.

p. 89 H. Bosch, *Christ Before Pilate,* 15th cent. Dutch, oil and tempera on wood, The Art Museum, Princeton University.

p.90 *Denial of Peter,* 13th cent. Armenian, Cilicia Gospels, Mss. W539, Walters Art Gallery, Baltimore.

p. 90 *The Flagellation,* 15th cent. German, stained · glass, The Metropolitan Museum of Art, The Cloisters Collection, Purchase, 1932, New York.

p. 91 G. Rouault, *Christ Mocked by Soldiers,* 20th cent. French, oil, Collection, The Museum of Modern Art, New York.

p. 92 L. van Leyden, *Ecce Homo* (det.), 16th cent. Dutch, engraving, The Toledo Museum of Art, Purchase, 1953, Toledo, Ohio.

p. 93 P. Picasso, *Crucifixion,* 20th cent. Spanish, oil on wood, private collection, (c) copyright by Spadem, Paris 1974, Giraudon—Art Reference Bureau.

p. 94 Max Beckmann, *The Descent from the Cross,* 20th cent. German, oil, Collection, The Museum of Modern Art, New York, Curt Valentin Bequest.

p. 94 Michelangelo, *La Pietà,* 15th cent. Italian, marble sculpture, Basilica of St. Peter, The Vatican, Rome, Alinari—Art Reference Bureau.

p. 95 *The Entombment,* 16th cent. Italian, Majolica bowl, The Metropolitan Museum of Art, Gift of V. Everit Macy, 1927, in memory of his wife, Edith Carpenter Macy, New York.

p. 95 *Three Marys at the Tomb,* 14th cent. Italian, Mss. 643, f. 26, The Pierpont Morgan Library, New York.

p. 96 Nicholas of Verdun, *The Harrowing of Hell,* 12th cent. Austrian, enamel, Mosan, Klosterneuberg Abbey, Austria, Marburg—Art Reference Bureau.

p. 97 M. Gruenewald, *The Resurrection,* Isenheim Altarpiece, 16th cent. German, oil, Unterlinden Museum, Colmar, Bruckmann—Art Reference Bureau.

p. 98 A. Dürer, *Noli Me Tangere,* 16th cent. German, woodcut, The Metropolitan Museum of Art, Fletcher Fund, 1919, New York.

p. 99 D. Velázquez, *The Supper at Emmaus,* 17th cent. Spanish, oil, The Metropolitan Museum of Art, Bequest of Benjamin Altman, 1913, New York.

p. 100 Rembrandt, *The Ascension* (det.), 17th cent. Dutch, oil, Alte Pinakothek, Munich, Bruckmann—Art Reference Bureau.

p. 100 G. Doré, *The Pentecost,* 19th cent. French, engraving from *La Bible Sacre,* Beineke Library, Yale University, New Haven.

p. 101 Capital: *Doubting Thomas,* 12th cent. French, lime-

stone with polychrome, Memorial Art Gallery of the University of Rochester, R. T. Miller Fund.

p. 102 B. Murillo, *The Return of the Prodigal Son,* 17th cent. Spanish, Courtesy of the National Gallery of Art, Washington, D.C., Gift of the Avalon Foundation, 1943.

p. 102 Anonymous, *The Good Samaritan,* 19th cent. American, oil, The Abby Aldrich Rockefeller Collection, Colonial Williamsburg, Va.

p. 103 W. Blake, *The Wise and Foolish Virgins,* 19th cent. English, watercolor with pen and ink, The Metropolitan Museum of Art, Rogers Fund, 1914, New York.

p. 104 S. Ricci, *The Marriage at Cana,* 17th cent. Italian, oil, William Rockhill Nelson Gallery, Atkins Museum, Kansas City, Mo.

p. 105 Anonymous, *Healing of the Blind Man,* 12th cent. Spanish, fresco transferred to canvas, San Baudelio de Berlanga, The Metropolitan Museum of Art, The Cloisters Collection, 1959, New York.

p. 106 *Christ Healing the Lame and Halt,* 13th cent. Byzantine, ivory illustrating six miracles: Loaves and Fishes, Raising of Lazarus, Healing the Blind Man, Marriage at Cana, Healing the Paralytic (as illustrated), Healing the Leper. Andrews diptych, Victoria and Albert Museum, London.

p. 106 V. Van Gogh, *The Raising of Lazarus* (after Rembrandt), 19th cent. Dutch, oil, Stedelijk Museum—Amsterdam.

p. 107 D. Vellert, *Christ Stilling the Tempest,* 16th cent. Flemish, stained glass, The Metropolitan Museum of Art, Gift of Mrs. Henry Goldman, 1944, New York.

p. 108 *Miracle of Loaves and Fishes,* Mss. 115, 14th cent. Italian, Bibliotheque Nationale, Paris.

p. 109 *King* (det.), 12th cent. French, west portal, central doorway, Chartres Cathedral, Copyright, James Austin, Cambridge, England.

p. 111 *Last Judgment,* 12th cent. French, tympanum, Cathedral of Ste. Foy, Marburg—Art Reference Bureau.

p. 113 *Liberal Arts* (det.), 12th cent. French, west portal, right doorway. Chartres Cathedral, Copyright, James Austin, Cambridge, England.

p. 116 Giotto di Bondone, *Meeting of Joachim and Anna* at the Golden Gate, fresco, Arena Chapel, Padua, 14th cent. Italian, Alinari—Art Reference Bureau.

p. 117 Master of the Barberini Panels, *The Birth of the Virgin* (det.), 15th cent. Italian, oil and tempera on wood, The Metropolitan Museum of Art, Rogers and Gwynne M. Andrews Funds, 1935, New York.

p. 118 G. de La Tour, *The Education of the Virgin,* 17th cent. French, oil, Copyright, The Frick Collection, New York.

p. 118 J. B. Tintoretto, *Presentation in the Temple,* 16th cent. Venetian, oil, Accademia, Venice, Alinari—Art Reference Bureau.

p. 119 *Betrothal of the Virgin,* 14th cent. Italian, Ms. 115, Bibliotheque Nationale, Paris.

p. 120 R. Campin, *The Annunciation (The Merode Altarpiece),* 15th cent. Flemish, oil on wood, central panel, The Metropolitan Museum of Art, The Cloisters Collection, Purchase.

p. 121 Attributed to Master Heinrich of Constance, *The Visitation,* 14th cent. German, polychromed and gilt wood set with cabochons, The Metropolitan Museum of Art, Gift of J. Pierpont Morgan, 1917, New York.

p. 121 *Nativity,* 13th cent. French sculpture, Jubé Crypt, Chartres Cathedral (Archives Photographiques).

p. 123 *The Lamentation over the Dead Christ,* 15th cent. Italian, enameled terracotta, The Metropolitan Museum of Art, Rogers Fund, 1904, New York.

p. 123 *The Death of the Virgin,* 11th cent. Byzantine, ivory, Worcester Art Museum, Worcester, Mass.

p. 124 *The Assumption of the Virgin* (det., The Ayala Altar), 14th cent. Spanish, tempera, Courtesy of The Art Institute of Chicago.

p. 124 Fra Angelico, *The Coronation of the Virgin,* 15th cent. Italian, oil, The Louvre, Paris, Alinari—Art Reference Bureau.

p. 125 W. Bradley, *Madonna and Child,* 20th cent. American, print, The Metropolitan Museum of Art, Gift of Fern Bradley Dufner, 1952, New York.

p. 125 *Virgin and Child,* 12th cent. French, polychromed oak, The Metropolitan Museum of Art, Gift of J. Pierpont Morgan, 1916, New York.

p. 140 *Biblia Pauperum* (det.), left to right: Moses and the Burning Bush, The Nativity, Aaron and His Flowering Rod, 15th cent. Dutch, The Pierpont Morgan Library, New York.

p. 141 *The Mystic Mill,* 12th cent. French, capital, Ste. Madeleine, Vezelay, Marburg—Art Reference Bureau.

p. 142 *Creation of the Animals,* 12th cent. English, Bodleian Library Bestiary, Ms. Ashmole 1511, f. 6v, Oxford.

p. 142 Michelangelo, *Creation of Eve,* 16th cent. Italian, fresco, Sistine Chapel, The Vatican, Rome, Alinari—Art Reference Bureau.

p. 143 L. Cranach (the elder), *Adam and Eve,* 16th cent. German, oil, Courtauld Institute, Galleries, Lee Collection, London.

p. 144 *Sacrifice of Cain and Abel,* 12th cent. French, pilaster capital from Moutier-St. Jean, Courtesy of the Fogg Art Museum, Harvard University, Cambridge, Gift, Friends of the Fogg.

p. 145 *Noah's Ark,* 15th cent. French, woodcut from *La Mer des Histoires,* The Pierpont Morgan Library, New York.

p. 146 *Abraham and Melchizedek* (det.), 13th cent. French, interior west wall, Rheims Cathedral, Marburg—Art Reference Bureau.

p. 146 Ghiberti, *Sacrifice of Isaac,* 15th cent. Italian, panel, bronze door, Bapistry, Il Duomo, Florence, Brogi—Art Reference Bureau.

p. 148 *Jacob's Ladder,* 14th cent. French, Ms. 638, f. 4, The Pierpont Morgan Library, New York.

p. 149 P. Gauguin, *Vision of the Sermon* (Jacob and the Angel), 19th cent. French, oil, National Galleries of Scotland, Edinburgh.

p. 150 *Joseph Interpreting Pharaoh's Dreams,* 18th cent. American, watercolor, Abby Aldrich Rockefeller Collection, Colonial Williamsburg, Va.

p. 151 *Moses,* 12–13th cent. English, stone sculpture, Yorkshire Museum, York, England.

p. 155 *Samson and the Lion,* 14th cent. German, bronze aquamanile, Courtesy, Museum of Fine Arts, Boston, Purchase, Benjamin Shelter Fund.

p. 156 *King David with the Harp,* 15th cent. German, woodcut, Mss. *Biblia Sacra Germanica,* vol. 1, The Metropolitan Museum of Art, Harris Brisbane Dick Fund, 1931, New York.

p. 158 N. Poussin, *The Judgment of Solomon,* 17th cent. French, The Louvre, Paris, Bulloz—Art Reference Bureau.

p. 161 F. A. Rashid ad-Din, *Jonah Cast up by the Whale, Jami at-Tawarikh* (Compendium of Histories) 15th cent. Persian, gouache, The Metropolitan Museum of Art, Bequest of Joseph Pulitzer, 1933, New York.

p. 162 *Job and His Boils,* 15th cent. Italian, Ms. 682, f. 73, The Pierpont Morgan Library, New York.

p. 163 *Prophet Isaiah,* 12th cent. French, stone sculpture, Ste. Marie, Souillac.

p. 164 Michelangelo, *The Delphic Sibyl* (det.), 16th cent. Italian, fresco, Sistine Chapel, The Vatican, Rome, Alinari—Art Reference Bureau.

p. 166 Chalice of Abbot Suger of Saint-Denis, 12th cent. French, sardonyx, gold, silver gilt, and gems, National Gallery of Art, Washington, D.C. Widener Collection, 1942.

p. 167 Crozier (det., *St. Michael Slaying the Dragon*), 13th cent. French, enamel on copper, The Metropolitan Museum of Art, Gift of J. Pierpont Morgan, 1917, New York.

p. 168 *Arm Reliquary,* 12th cent. German, silver gilt over oak core, Gift of the John Huntington Art and Polytechnic Trust, The Cleveland Museum of Art.

p. 169 *Virgin of the Rosary,* 18th cent. Mexican, oil, The

Ella Gallup Sumner and Mary Catlin Sumner Collection, Courtesy Wadsworth Atheneum, Hartford, Conn.

p. 174 Master of St. Bartholomew et al., *Sts. Agnes, Bartholomew, and Cecilia,* 15th cent. Flemish, oil, Alte Pinakothek, Munich, Bruckmann—Art Reference Bureau.

p. 176 A. Altdorfer, *The Virgin and Child and St. Anne,* 16th cent. German, engraving, The Metropolitan Museum of Art, Gift of Henry Walters, 1917, New York.

p. 177 Sassetta, *St. Anthony Tormented by Devils,* 15th cent. Italian, tempera, Yale University Art Gallery, James Jackson Jarves Collection, New Haven.

p. 177 F. Zurbaran, *St. Apollonia,* 15th cent. Spanish, oil, The Louvre Giraudon, Paris.

p. 178 *St. Barbara with Tower,* 16th cent. French, sandstone sculpture, The Metropolitan Museum of Art, Rogers Fund, 1908, New York.

p. 179 H. Memling, *St. Benedict,* 15th cent. Flemish, oil, The Uffizi Gallery, Florence, Alinari—Art Reference Bureau.

p. 180 *St. Catherine of Alexandria,* 15th cent. French, gold, enamel, and jeweled miniature sculpture, The Metropolitan Museum of Art, Gift of J. Pierpont Morgan, 1917, New York.

p. 182 *St. Christopher,* 15th cent. German, woodblock, The John Rylands University Library of Manchester, England.

p. 183 Matisse, *St. Dominic,* 20th cent. French, paint on ceramic, Chapelle du Rosaire, Vence (French Cultural Services).

p. 184 *St. Dorothy* (det.), 15th cent. German, stained glass, The Metropolitan Museum of Art, The Cloisters Collection, Purchase, 1937.

p. 185 L. Vanni, *St. Elizabeth of Hungary,* 14th cent. Italian, The Lowe Art Museum, University of Miami, Coral Gables, Fla.

p. 186 M. Caravaggio, *Ecstasy of St. Francis,* 16th cent. Italian, oil, Courtesy Wadsworth Atheneum, Hartford, Conn., Ella Gallup Sumner and Mary Catlin Sumner Collection.

p. 187 *St. George Killing the Dragon,* 15th cent. Italian Byzantine, encaustic colors on wood, Yale University Art Gallery, James Jackson Jarves Collection, New Haven.

p. 189 *St. John the Baptist,* 13th cent. French, north porch, Chartres Cathedral (Houvet photo).

p. 190 R. Campin, *St. Joseph, The Merode Altarpiece,* right panel, 15th cent. Flemish, oil on wood, The Metropolitan Museum of Art, The Cloisters Collection, Purchase.

p. 191 *St. Lawrence with Grille,* Book of Hours of Catherine of Cleves, 15th cent. Dutch, Ms. 917, f. 266, The Pierpont Morgan Library, New York.

p. 192 F. del Cossa, *St. Lucy,* 15th cent. Italian, oil, National Gallery of Art, Washington, D.C., Samuel H. Kress Collection, 1939.

p. 193 A. Lorenzetti, *St. Martin and the Beggar,* 14th cent. Sienese, tempera, Yale University Art Gallery, James Jackson Jarves Collection, New Haven.

p. 194 P. Veneziano, *St. Mary Magdalen,* 14th cent. Italian, tempera on panel, Yale University Art Gallery, Gift of Hannah D. and Louis M. Rabinowitz, New Haven.

p. 195 G. David, *Legend of St. Nicholas* (det.), 15th cent. Flemish, oil, National Galleries of Scotland, Edinburgh.

p. 196 V. Carpaccio, *St. Peter Martyr,* 16th cent. Italian, oil, Samuel H. Kress Collection, Philbrook Art Center, Tulsa, Okla.

p. 197 School of G. de La Tour, *St. Roch or St. James the Great,* 17th cent. French, Musee Toulouse-Lautrec, Albi Lavros— Giraudon.

p. 198 G. de La Tour, *St. Sebastian Nursed by St. Irene,* 17th cent. French, oil, Nelson Gallery, Atkins Museum, Kansas City, Mo., Nelson Fund.

p. 199 P. Subleyras, *Stoning of St. Stephen,* 18th cent. French, pen and ink and wash, Yale University Art Gallery, New Haven.

p. 200 G. Bernini, *St. Teresa in Ecstasy,* 17th cent. Italian, marble sculpture, S. Maria della Victoria, Rome, Alinari—Art Reference Bureau.

p. 202 *St. Veronica's Veil,* 16th cent. Italian, gold and enamel medallion, The Metropolitan Museum of Art, Gift of J. Pierpont Morgan, 1917, New York.

p. 206 *Tree of Jesse,* 13th cent. French, from Book of Hours, Ms. 730, f. 17, The Pierpont Morgan Library, New York.

p. 210 Chasuble back (top to bottom): *Virgin Mary Enthroned with Christ, Adoration of the Magi, Annunciation,* 14th cent. English, *opus Anglicanum* embroidery, The Metropolitan Museum of Art, Fletcher Fund, 1927, New York.

pp. 212, 213 Pesellino, *The Seven Virtues,* Italian, oil, left to right: Prudence/Solon; Justice/Solomon; Faith/Peter; Charity/John the Evangelist; Hope/James the Great; Fortitude/Samson; Temperance/Scipio Africanus, Samuel H. Kress Collection, Birmingham Museum of Art, Birmingham, Ala.

p. 213 H. Bosch, *Gluttony* (det., *The Seven Deadly Sins),* 15th cent. Flemish, oil, tabletop, The Prado, Madrid, MAS— Art Reference Bureau.

p. 217 H. Knoblochtzer, *Zodiac,* woodcut, 15th cent. German, by permission of the Harvard College Library, Cambridge, Mass.

Alphabet headings woodcut, 16th cent. Italian, based on designs attributed to Leonardo da Vinci, The Metropolitan Museum of Art, Rogers Fund, 1919, New York.

INDEX

233